IRREVERENT PHOTO TOOLS FOR DIGITAL PHOTOGRAPHERS

Steve Weinrebe

Course Technology PTR
A part of Cengage Learning

COURSE TECHNOLOGY
CENGAGE Learning™

Australia, Brazil, Japan, Korea, Mexico, Singapore, Spain, United Kingdom, United States

COURSE TECHNOLOGY
CENGAGE Learning™

Irreverent Photo Tools for Digital Photographers
Steve Weinrebe

Publisher and General Manager, Course Technology PTR:
Stacy L. Hiquet

Associate Director of Marketing:
Sarah Panella

Manager of Editorial Services:
Heather Talbot

Marketing Manager:
Jordan Casey

Executive Editor:
Kevin Harreld

Project/Copy Editor:
Kezia Endsley

PTR Editorial Services Coordinator:
Jen Blaney

Interior Layout Tech:
William Hartman

Cover Designer:
Mike Tanamachi

Proofreader:
Brad Crawford

Indexer:
Sharon Shock

Cengage Learning is a leading provider of customized learning solutions with office locations around the globe, including Singapore, the United Kingdom, Australia, Mexico, Brazil, and Japan. Locate your local office at: **international.cengage.com/region**.

Cengage Learning products are represented in Canada by Nelson Education, Ltd.

For your lifelong learning solutions, visit **courseptr.com**.

Visit our corporate Web site at **cengage.com**.

For product information and technology assistance, contact us at
Cengage Learning Customer & Sales Support, 1-800-354-9706

For permission to use material from this text or product, submit all requests online at **cengage.com/permissions**. Further permissions questions can be e-mailed to **permissionrequest@cengage.com**.

Gorilla Glue and Gorilla Tape are registered trademarks of The Gorilla Glue Company, Inc.
Sensor Swab Plus is a trademark of the Filter Connection, LLC.
Photoshop is a registered trademark of Adobe Systems.
VueScan is a trademark of Hamrick Software.
Xara Xtreme is a trademark of Xara.
Knoll Light Factory is a product of Red Giant Software.
Cool fx, Photo fx, and the DOMKE U.S. Post Office Shoulder Pad are all products owned by Tiffen.
Potable Aqua is a registered trademark of Wisconsin Pharmacal Co., LLC.
The UPstrap shoulder strap is a registered trademark of UPstrap, Inc.
Rocket-air is copyright Giotto's Industrial Inc.

All other brand names and product names mentioned in this book are trademarks or service marks of their respective companies. Any omission or misuse (of any kind) of service marks or trademarks should not be regarded as intent to infringe on the property of others. The publisher recognizes and respects all marks used by companies, manufacturers, and developers as a means to distinguish their products.

All images © Cengage Learning unless otherwise noted.

Library of Congress Control Number: 2009933315

ISBN-13: 978-1-59863-995-7

ISBN-10: 1-59863-995-1

Course Technology, a part of Cengage Learning
20 Channel Center Street
Boston, MA 02210
USA

Printed in the United States of America
1 2 3 4 5 6 7 12 11 10 09

*This book is dedicated to all photographers,
for roads traveled and for journeys home.*

About the Author

Steve Weinrebe is a photographer, Photoshop instructor, and author. During decades as a professional photographer, Steve produced work for numerous Fortune 500 companies, and photographed for thousands of ads, magazines, and catalogs. Steve has also produced an award-winning children's video, and has won a Videographer award for instructional work on Photoshop.

Because of his teaching and writing on photography and Photoshop, Steve has been featured on radio podcasts and in magazines. Steve also writes tutorials for photography websites and online newsletters. His previous book, *Adobe Photoshop & the Art of Photography* (Cengage Learning), is a textbook that introduces Photoshop to photography students.

Steve holds degrees in both philosophy and business. Besides traveling to teach photo workshops, Steve teaches Photoshop at his Adobe Training Center, Imaging R & R, in Princeton, NJ.

Contents

Chapter 1
Irreverent Studio Tools 1

Chapter 2
Irreverent Location Tools 35

Chapter 3
Irreverent Travel Tools 67

Chapter 4
Irreverent Tools for Nature and Landscape Photography 99

Chapter 5
Irreverent Portrait Tools 135

Chapter 6
Irreverent Still-Life Tools 165

Chapter 7
Irreverent Video Tools 189

Chapter 8
Irreverent Photoshop Tools 207

Chapter 9
Irreverent Digital Tools
 235

Chapter 10
Irreverent Tools for All Photographers
 257

Index
 277

Introduction

Photography has undergone more than one upheaval in recent years. Although the traditional photography business has come under pressure, micro-businesses are flourishing in the new era of inexpensive digital cameras and inkjet printers, photo sharing websites, and print-on-demand. Besides the new "micro-studios," artists, photo hobbyists, and students of photography are benefiting from digital cameras, inkjet printers, and online resources. Photographers in general are able to supply themselves with an array of high-priced, proprietary equipment.

But, in reality, after the necessities are acquired, the cost to outfit a budding business or hobby is still quite high. If you're selling "dollar stock," or are photographing playgroups to give or sell portraits to families, there is a point at which you have the knowledge and desire to flesh out your photo gear, but not the desire to chew up your savings or dip into debt to do so. Whether in good economic times or in bad, photographers have to be wily because it's likely you could best use your money for paying the rent or going on a vacation. That is why irreverent photo tools are so important.

I don't believe you have to spend a lot of money to take great pictures. In fact, I'd like to poke a hole in the notion that photographers need to break the bank and flesh out their roster of photo tools with high-end photo gear. Much of that traditional gear is advertised by mainstream photography and digital imaging media, and sold through traditional photo marketing channels. But there's another path the intrepid photographer can take that will pave the way for great photography and not break the bank.

I've always been very pragmatic about photo tools, and generally disrespectful of marketing text that claims to produce foolproof pictures, because your eye, your knowledge, and your ability are your best assets, regardless of the tool. Showing off your photo equipment should never be more important than showing off your pictures. Let the equipment be secondary to technique and inspiration.

Nothing teaches like experience, and I know from experience that a walk through a local or big box hardware store, an Army & Navy store, or even an office supply store, will

reveal just as many excellent and life-saving photography tools as any trip to a camera store. Tools I've included in this book—tools like the hayfork handle, light bulb changer, staple gun, and cardboard tube—will hopefully underscore that point.

I say, save your money and have some fun. As I mentioned, if you are itching to spend money, spend it on expensive camera lenses. You won't regret it. Meanwhile, have some fun and be creative with the tools I've included in this book. You'll put your camera and lenses through their paces and possibly shoot something that you never would have if you stuck to traditional photo tools and photo techniques.

The Philosophy of This Book

Philosophy is an interesting word, especially for me because, among the things that I've acquired along the way in life is a degree in philosophy. If anything, the study of philosophy taught me to question things. It's that questioning, especially the questioning tradition, that has led to my irreverent exploration of photography tools.

When I talk to photographers who are more excited about their equipment than their photos, I am reminded of Plato's story of people in a cave seeing the world only as shadows on a wall, not seeing the actual objects drawing the shadows. A photo tool is simply a tool to help make a photograph. If you can get something for a few dollars at the hardware store that gets the job done, or make a photo tool from items around the house, you can be just as successful, and accomplish the same task, as the photographer who spends a fortune on traditional photo industry tools.

This book began as a series on my blog. As the series grew, I found I took great joy in sharing the tools, techniques, and experiences I've acquired during decades in my profession. The idea to expand the blog into a book was also inspired by some of the alternative lifestyle catalogs that were published at the time I began my own career, catalogs that broke ground in the way people used things.

I should mention: No one paid me any money to use any of the tools in this book. There is a mix of found objects and items that you can buy. I have included tools I already have, or scrounged stores for useful, non-traditional photo tools. If I felt I had exhausted a particular subject in a chapter, I took walks through the local or big box hardware stores for inspiration. Also, I have tried to include tools that have many uses or pertain to many types of photography and not ones with specific needs. I have even more irreverent, non-traditional tools than I've included, tools so unusual, or for one use only, that they didn't make the final cut.

Some of the tools in this book may even smack of traditional photo tools, and you might wonder what is irreverent about them. The irreverence comes either from the way I use them, or from the fact that they aren't used in traditional photography as much as they

should be. If I can steer my readers toward best practices for photography by demonstrating something they should be using but aren't, I've also accomplished my goal to nudge you in the right direction.

And speaking of the right direction, thanks to my editors—Kevin Harreld and Kezia Endsley—for their expertise, encouragement, and guidance in helping me to write this book.

How to Use This Book

The photo tools in this book are divided into chapters that cover the different types of styles or genres photographers generally work with. Within each chapter, the tools aren't in any specific order of importance, except that sometimes discussing one tool does logically lead to another tool that follows the same purpose as the first.

Because photography is an innovative art, and the needs of photographers vary, there is a lot of crossover between the chapters. For that reason, if you are a portrait photographer, for example, don't just read the chapter covering irreverent portrait tools, because you'll surely find other useful tools in other chapters. By all means, start with the chapter that appeals to your style or genre of photography most, but then browse through all the chapters and explore the book throughout.

Besides traditional still photography tools, I've included a chapter on video as well. The convergence of still and video cameras, which I've been enthusiastic about for years, has left many photographers with a still camera that shoots video, but not with a lot of actual tools for videography. In Chapter 7, "Irreverent Video Tools," I've included inexpensive and innovative ways to shoot video techniques with a digital SLR or point-and-shoot camera that shoots video.

Once you take digital pictures, you'll want to work with them in post-production on the computer, editing, altering, and improving the images. To that end, I've included two chapters on digital tools, one chapter specifically for editing in Photoshop, and one chapter that covers miscellaneous digital tools.

And please, because many of these tools are designed to be used outdoors, be sensitive to the environment and dispose of any tools, or residual material from making any of these tools, properly.

Resources for Help

Any book dealing with anything digital may have the need for updates or corrections. Please visit my blog, www.modestudio.us, to look for updates, additions, and corrections. Leave a comment there as well with stories about your own irreverent photo tools.

Book Summary

You'll find the following chapters in this book:

- Chapter 1, "Irreverent Studio Tools," includes tools that studio photographers can use, including work surfaces, tools to make and improve tabletop sets, and so forth.

- Chapter 2, "Irreverent Location Tools," covers tools that help photographers meet the challenges that come from shooting on location.

- Chapter 3, "Irreverent Travel Tools," discusses tools you'll need to help pack light, keep equipment dry and clean, and more, while traveling for photography.

- Chapter 4, "Irreverent Tools for Nature and Landscape Photography," includes tools to chart the path of sunlight, tools to carry equipment, and other tools to help photographers shooting outdoors.

- Chapter 5, "Irreverent Portrait Tools," covers tools that help when photographing people, including lighting and makeup tools, among others.

- Chapter 6, "Irreverent Still-Life Tools," discusses many tools useful for photographing props and products.

- Chapter 7, "Irreverent Video Tools," includes tools to help still photographers shoot video with their video-capable digital SLR or point-and-shoot camera.

- Chapter 8, "Irreverent Photoshop Tools," discusses nontraditional ways to use Photoshop to edit your photography.

- Chapter 9, "Irreverent Digital Tools," covers software and photo-editing tools useful for all photographers, and includes Windows and Mac tools.

- Chapter 10, "Irreverent Tools for All Photographers," includes miscellaneous tools that don't fit into a specific genre but that all photographers might find useful, or at least should be aware of.

1

Irreverent Studio Tools

Over the past 30-odd years, six different, moderately cavernous photo studios have been my workplace and photoplay ground. I have bonded with each of them and felt like my guts were yanked each time I had to move. But with each move I have carried along an ever increasing, and ever evolving, amount of studio gear—the stuff that photos are made of. I'm not talking about props, though there is that Martian alien model and some other assorted props, which, however dated, seem to always lurk at the back of the cabinets and drawers. (See Figure 1.1.) No, I am talking about those irreverent studio tools—all the tools that serve a purpose in making still or moving images that didn't originate from typical photographic equipment sources. Honestly, I have a great deal of respect for every bit of photography equipment I have in the studio, as I do for the studio itself, but these tools may be less obvious to a photographer learning to take pictures.

Because the studio is where I check in each morning, the studio is a good place to begin discussing irreverent photo tools. As a youngster, like most aspiring photographers, I pored over the monthly photo magazines looking at equipment reviews, or at the advertisements for the latest cameras and lenses. To a lesser extent I browsed over the assorted widgets that were being marketed as must-haves of the month. Going professional changed all that. The realities of getting the job done, as any professional knows, change the game as far as what a photographer actually needs to accomplish the task.

One reality I had to confront early in my career is that often a photo shoot happens very, very suddenly. For commercial work, even if you have bid on a job far in advance, often clients wait to the last minute to say, "Okay, I need it, and I need it *now*." For fine-art or personal projects as well, be ready or you can miss great photo opportunities.

Figure 1.1
A small studio set with props and a seamless paper background.

Copyright © Steve Weinrebe, Getty Images

The tools that follow may be essential to you, or you may find they are something you would need only once in a lifetime. Because photography studios are ever evolving and chameleon like in nature, these tools may not be for every photo shoot. If you have the space, store them all. In my experience it takes only one use to make an irreverent photo tool a key player in accomplishing photography in the studio. Studio photographs are works of architecture—they are built from concept to completion with a dose of serendipity along the way. One of these tools may save the day in an unexpected way, or trigger an idea for yet another irreverent tool that you'll create or buy for yourself.

Kitchen Cabinets

Unless you are using your living room as your photo studio, you should consider putting up some cabinets and a dedicated work surface in your studio. You need the cabinets because you may want to keep your lenses and miscellaneous camera gear, flashes, and other lighting equipment, props, and tools in a place other than your camera bag or on the floor. If you don't want to spend a fortune on custom cabinetry or prefabricated worktables designed for artists, you can save a considerable sum by buying used kitchen cabinets, or purchasing a new prefabricated cabinet ready for assembly. (See Figure 1.2.)

I purchased my studio cabinets many years ago from Ikea—simple, clean lines, no hardwood, and no glass. I have installed them in three different studios. Two of those installations I did myself with just the instructions, a power drill, and power screw-

Figure 1.2
Prefabricated
kitchen
cabinets make
excellent
storage in a
photographer's
studio.
*Copyright ©
Steve Weinrebe*

driver, and the help of a friend to hoist and hold the cabinets in place. Another time I hired a handyman to put them up at a reasonable price. I have certainly gotten years of use out of them and they still look good. Look for simple white cabinets, or another neutral color, since you don't want any color reflecting or bouncing into your studio photographs.

An essential part of your set of kitchen cabinets will be the counter. Get a set of cabinets with a counter without a sink cutout if possible. You'll need a work surface because you will want a place to set your camera and lenses, charge your batteries, use a screwdriver or cutting tool, and generally do simple chores without getting on your hands and knees. (See Figure 1.3.)

Used cabinets could be a good solution as well. Do local searches on eBay or Craigslist and you'll find people who are renovating and selling their old cabinets. You may be surprised how many people want to sell their cabinets in your area, where you can go with a power screwdriver, take them down, and bring them home in the bed of a rental van. You can always paint them white or gray if the color isn't right. And if you really want cherry wood cabinets in your studio, the studio police aren't going to knock on your door because you don't have white cabinets in your photo studio, I promise.

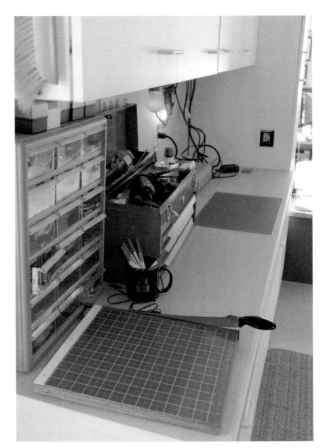

Figure 1.3
Counter space, along with cabinets in the studio, becomes an important work surface. Here I have an assortment of other irreverent photo tools on the counter waiting to be used.

Copyright © Steve Weinrebe

Gardener's Kneepad

My current studio floor is concrete. So was the floor in my last studio. My studios prior to that had mostly wooden floors typical in city lofts—wide planks with gaps and pits and leftover staples and bits of hot glue. None of these surfaces is a joy to kneel on. I use a gardener's kneepad when kneeling in the studio because, unless your studio is in a carpeted living room (which can work for a studio, believe it or not), your floor is hard and unforgiving. (See Figure 1.4.)

Gardeners are smart people—they know things. Gardeners are on their hands and knees a lot and use the kneepad even in soft soil where there might be stones and unevenness. Besides the advantage of softening up the floor for your knees, like a gardener you'll be able to keep your clothes clean as well.

Sometimes I use the kneepad when I'm crawling under my desk grappling with wires behind my computer, or any time I need to kneel on the floor for an extended period.

Figure 1.4
A gardener's kneepad will help save your knees from temporary or permanent injury.
Copyright © Steve Weinrebe

I've tried my son's athletic kneepads (the Rollerblade type) but felt like I was wearing a pair of glasses on my knees. The gardener's kneepad is great—you can just throw it in front of you as you kneel (add some rock and roll music and grab a karaoke microphone for dramatic effect). Mine is soft and rubbery with just enough cushion. (See Figure 1.5.) Some that I see in stores are quite hard and aren't much better than kneeling on a plank.

Figure 1.5
Have a kneepad near enough that if you want to kneel you can just grab it, and you won't be tempted to do without.
Copyright © Steve Weinrebe

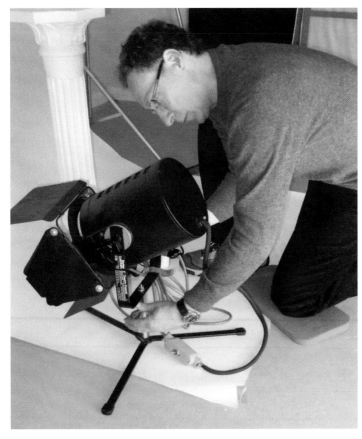

> **Tip**
>
> Be sure to unwrap your new kneepad outdoors, because the plastic that some kneepad manufacturers use smells awful until it's aired out.

> **Tip**
>
> If you get a gardener's kneepad that's green like mine, be sure to get it out of the way if you are shooting anything reflective, or you'll end up with green highlights in your subject.

Pocket Level

This black pocket level is a handsome photo tool that fits with all my black photo gear, although the last one I purchased is bright yellow, making it easier to find if I drop it. I use this to level my small and medium format cameras, tabletops, and still-life platforms that I build on top of tabletops. (See Figure 1.6.)

At least one of my cameras has a spirit level built into it—a circular level with a bubble that needs to be centered within the circle—but it's not very useful if you want to look up or down with your camera. This small pocket level can be placed along any flat surface on your camera, opening up loads of possibilities for what plane you want to level to.

I keep one pocket level in the studio, a key chain level clipped to my camera bag, and a third in a gadget case. (See Figure 1.7.) Although the level is part glass and liquid, I've

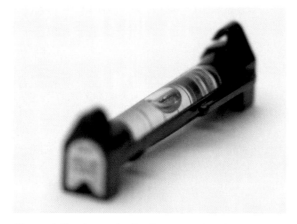

Figure 1.6 This pocket level is easy to lay down on any size flat surface, from the top of a camera to a tabletop.
Copyright © Steve Weinrebe

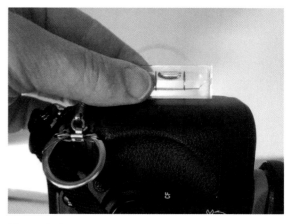

Figure 1.7 This level has a key chain attachment. Put it on your keys or attach it to your camera bag and it will always be with you.
Copyright © Steve Weinrebe

never had one break. But check Chapter 2, "Irreverent Location Tools," for some suggestions of simple impact-resistant containers that you could use for a pocket level.

Why always keep a pocket level at hand? This is one of the essential studio tools. If you set up a still-life set on a table that isn't level, you may have to adjust your camera so that the camera isn't level, and instead the camera's angle matches the table's angle. You'll spend an hour arranging objects in the set only to have them start falling over because the table isn't level. Now you'll have to level the table, and then move the camera as well. You're better off always starting with a level surface and a level camera. Since few floors are perfectly level, it's likely you'll need this in your sets.

If you're shooting outdoors please take the time to level your camera. (See Figure 1.8.) I always push my students to level the horizon line. If you have to do that in software after you take the picture, you're going to have to crop the picture to have a level horizon. Start with a level horizon and you won't have to crop the image.

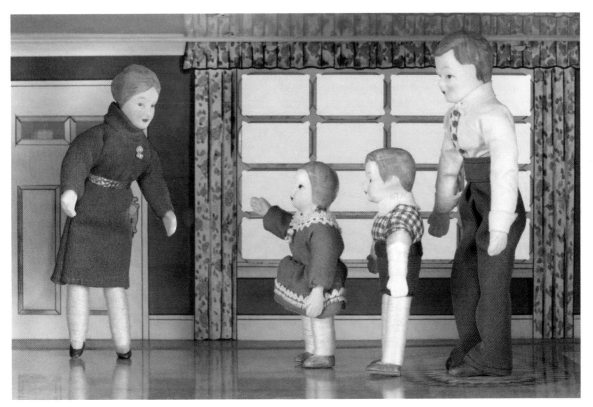

Figure 1.8 Keep your horizon line level when taking pictures with architectural details, or landscape pictures with a horizon line, so that you won't have to crop into your image. Because this set has straight vertical and horizontal lines in the prop dollhouse, I used a pocket level to straighten both the camera and the tabletop set.

Copyright © Steve Weinrebe, Getty Images

Barbell Weights

Maybe you have some barbell weights in your basement collecting dust? Dust them off and bring them into the studio. They make great substitutes for sandbags, and can help stabilize light stands and booms. Olympic-size barbell weights are 51mm, about 2 inches, in diameter, plenty of room to fit over and around the sections of most light stands. I shimmy mine down to the bottom of the stand, just above the three legs, and let the weight rest there. Even lightweight stands become very substantial this way. (See Figure 1.9.)

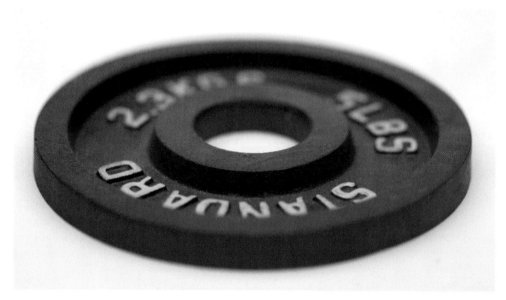

Figure 1.9

These barbell weights fit well on light stands, making the stands sturdier and less prone to tipping over.

Copyright © Steve Weinrebe

I have found that a 10-pound weight is especially useful because it is light enough for most people to pick up with one hand. Barbell weights are already painted a matte black, making them a perfect non-reflective staple in studio sets.

The only major difference between Olympic barbells and the more generic standard style barbell is the diameter of the bar. The common size for less professional, consumer-oriented barbells is 1 inch in diameter. Weight plates for these bars have only a 1-inch-diameter center hole and aren't suitable for slipping over stands in the studio. But they are great for hanging onto and counterbalancing boom stands.

The trouble with boom stands is that the amount of weight needed to keep the stand balanced varies greatly and depends on the length of the boom, what the boom is holding, and how far from center the boom is extended. Most booms come with a single clamp-down weight that often isn't enough to keep the boom upright. Either Olympic or standard weight plates can be used individually or doubled up to hang from the end of boom stands. I've had good success with bungee cords wrapped around and through the weight's center hole for hanging the weight on the boom, as shown in Figure 1.10.

Figure 1.10
A barbell weight plate helps to balance a boom on a stand. This boom has a convenient hook on the end, perfect for hanging counterweights.
*Copyright ©
Steve Weinrebe*

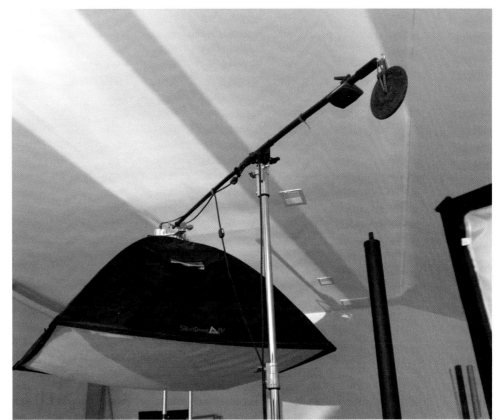

Sawhorses

Whether you prize clutter or neatness, tabletops of various types probably abound in your photo studio. The most flexible tabletops are made from combining a pair of sawhorses with a flat surface to throw on top of them. Whether wooden or prefabricated plastic, sawhorses are terrific tools to keep around. When assembling a studio set, the location of a tabletop is generally dependent on what's going on in the rest of the studio at any given time. So it's incredibly convenient to grab the nearest pair of sawhorses, roughly position them where you need the photo set, and then put a tabletop on them. Sometimes I place a case or box on top to raise the tabletop up higher, depending on the point of view I want. Clamp the background paper to your tabletop, place lights around the set, position the camera, and away you go. The sawhorses really are anchors, of sorts, to the everyday tabletop set. (See Figure 1.11.)

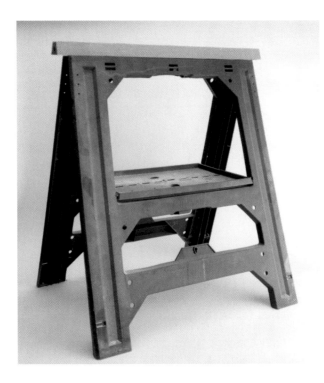

Figure 1.11
Prefabricated plastic sawhorses are durable and collapsible.

*Copyright ©
Steve Weinrebe*

For truly inexpensive sawhorses stop into any big or small hardware store and purchase a set of sawhorse brackets and the stuff that sawhorses are made of: a couple of 10-foot lengths of two-by-four wood, some nails, and a saw. Some stores will even cut the wood for you. These brackets come in sets with instructions on the lengths to cut. Mine are 36 inches long and 30 inches high. To get the height to 30 inches, a good height for a studio tabletop, the legs are each cut to 26 inches with the rest of the height made up by the top of the sawhorse. (See Figures 1.12 and 1.13.)

While either type of sawhorse can be hung from a hook on the wall, what I like about these wooden, more traditional-style sawhorses is that they can be stacked one on top of the other. That saves a lot of floor space if you have a small studio or are working out of your home.

True Story

I developed some great habits on one of my first photography jobs, on the evening shift at a department store's photo studio. I would arrive at 6 PM and work my way through the shot list for the upcoming Sunday circulars and newspaper advertisements. Some items involved kitchenware and there was always a refrigerator stocked with fresh props. I learned quickly to photograph anything that involved food props first so that I could spend the rest of the evening eating them while working down the shot list.

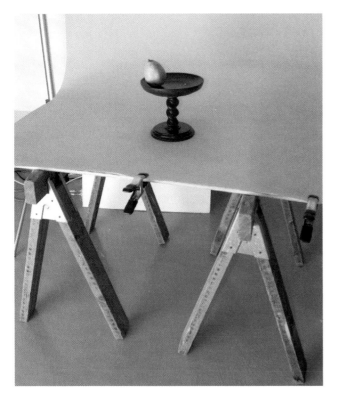

Figure 1.12 Make-your-own sawhorses, made from metal brackets and two-by-fours wood, are inexpensive and durable. Position the sawhorses, add a tabletop and some background paper, shake and stir, and you have a photo set.
Copyright © Steve Weinrebe

Figure 1.13 A still-life photographed on a set built from wooden sawhorses, a piece of plywood, and some background paper.
Copyright © Steve Weinrebe

Hollow-Core Door

After sawhorses, a hollow-core door should be one of your first studio purchases. Whether your photo studio is a 5,000-square-foot loft or a 500-square-foot basement, you need to be able to set up and break down quickly. You need tables to put things on during a photo shoot, and then get out of the way if you need a different arrangement. One day you may be photographing a person's portrait, another day a group shot; or one day a screwdriver and another day a studio set built as a hardware store. Either way you will need maximum flexibility and ease of setup. Head to a lumberyard or hardware superstore for a good selection of hollow-core doors. (See Figures 1.14 and 1.15.)

As part of a photo set, hollow-core doors are incredibly sturdy. Properly supported you could easily stand on one. At $1\frac{1}{3}$ inches in thickness the doors are narrow enough to fit an A-clamp onto, and a 6.5-foot door is fine for a wide seamless background if you cut out the corners of the 9-foot roll. Anything wider gets in the way of lights because you cannot move the lights close enough to the subject for side lighting. (See Figure 1.16.)

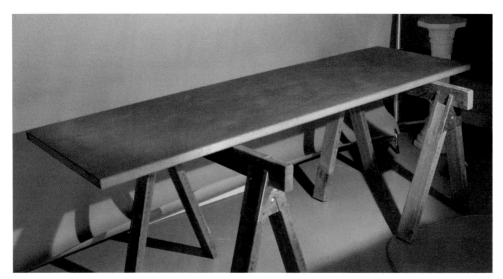

Figure 1.14
A hollow-core door makes for a sturdy and lightweight tabletop.

Copyright © Steve Weinrebe

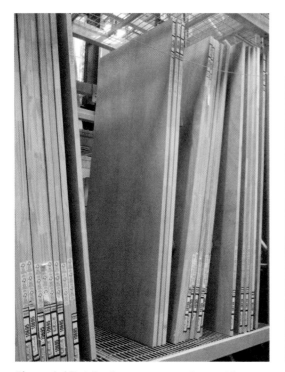

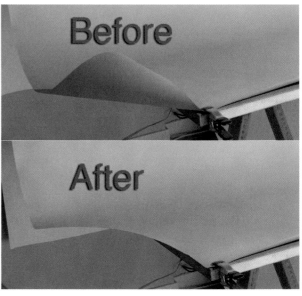

Figure 1.15 A hardware superstore has a wide array of sizes to choose from when selecting hollow-core doors for tabletops in the studio.
Copyright © Steve Weinrebe

Figure 1.16 Cut out the corners of a 9-foot roll of background paper to more easily fit the standard dimensions of a hollow-core door tabletop.
Copyright © Steve Weinrebe

Tip

If you are using a hollow-core door as part of a photo set, throw a piece of rubber carpet padding, the type that's thin and keeps carpets from sliding on wood floors, over your sawhorses before you position the hollow-core door. When working around the set positioning lights or props, you can easily bump into the work surface and disturb all your carefully arranged items. You can buy a length of rubber carpet padding at any carpet store, and then cut it into small strips and squares for different tasks. (See Chapter 2.)

Plywood

Plywood makes for a very sturdy tabletop and has the advantage that it can be easily cut to size. Its rough unfinished side makes it less prone to sliding around in a photo set than a hollow-core door. Plywood can be heavy though. Plywood can be bought in varying thicknesses and each has advantages and disadvantages. Quarter-inch plywood is light and is easy to pick up and position, but it is prone to warping. Thicker plywood such as three-quarter-inch plywood retains its flatness but is heavy. Even smaller pieces of the thicker plywood can be heavy. Consider your needs and how willing you'll be to lift a heavy piece of wood with rough edges. (See Figure 1.17.)

Figure 1.17
Plywood makes for a sturdy and very inexpensive tabletop.

*Copyright ©
Steve Weinrebe*

Keep thicker plywood boards cut to about 3 feet by 3 feet or 4 feet by 4 feet, in the studio for sturdy tabletop sets where you may need to creep the lights in close to the sides. In such a case you don't want a wide hollow-core door getting in the way because you may want to work closely around the subject. You can buy small sheets of plywood that have been precut at the big-box hardware chain stores.

I sometimes use thinner plywood boards for the advantage of being able to drill holes through them to run an electrical wire through and below the tabletop, or to poke up a support to hold a prop in place. (See Figure 1.18.)

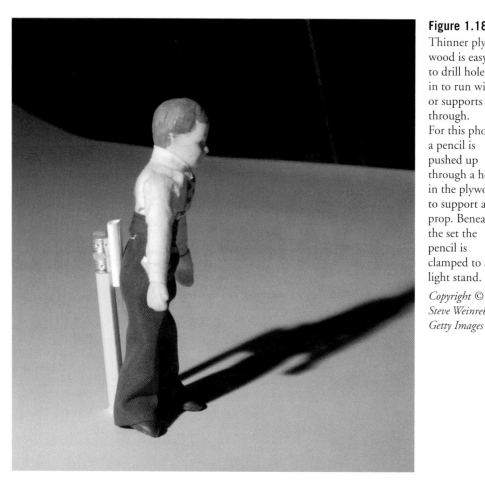

Figure 1.18
Thinner plywood is easy to drill holes in to run wires or supports through. For this photo a pencil is pushed up through a hole in the plywood to support a prop. Beneath the set the pencil is clamped to a light stand.
Copyright © Steve Weinrebe, Getty Images

Tip

If your plywood tabletop is warped, just use a shim under it to level the board. The shim could be as simple as folded up cardboard. Use two shims so the tabletop doesn't wobble. Then use the pocket level mentioned previously to level the work surface.

Gatorboard

Somewhere along my journey as a professional photographer I was introduced to gatorboard, which goes by the brand name Gatorfoam. If you call up your local art supply store or do a web search for gatorboard, you'll come up with plenty of options to purchase some. Like the more traditional foam-core boards (brand name Fome-Cor), gatorboard is available in white or black. The black gatorboard can be used as a gobo or to cut a "cookie" for still or video lighting. If you simply need a sturdy surface that it easy to cut to size, white gatorboard will probably do very well. (See Figure 1.19.)

Figure 1.19
Gatorfoam,
the brand name
of gatorboard,
is lightweight
and comes in
white or black
finishes.

*Copyright ©
Alcan
Composites
USA, Inc.*

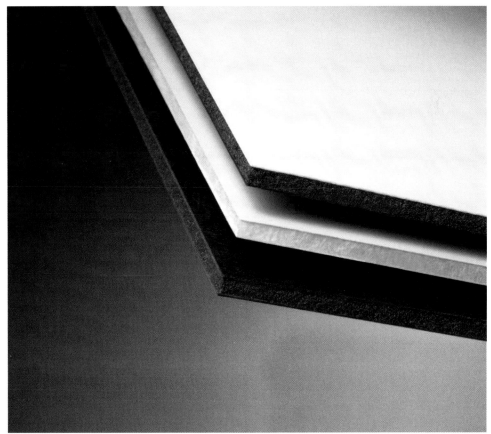

Gatorboard has a foam interior similar to foam-core boards, but the surface is actually made from wood pulp, making the board exceptionally strong. Gatorboard is a staple for framing and silk screening, but for photographers Gatorfoam and its easier-to-cut sibling Gatorlite offer an excellent solution for work surfaces and set surfaces, and they are lighter and easier to cut than plywood, and sturdier than matte board or foam core. (See Figure 1.20.)

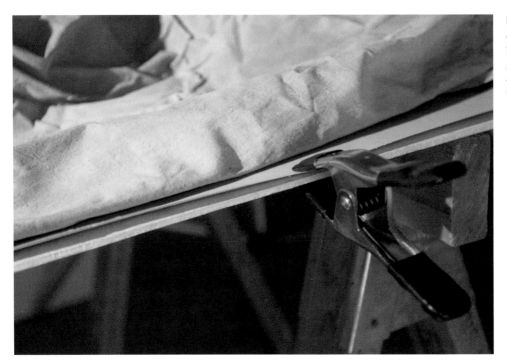

Figure 1.20
Gatorboard is both durable and light-weight, and can be easily cut.

*Copyright ©
Steve Weinrebe*

Paint Cans

Shooting down at something in the studio is especially difficult. You may have to get up on a ladder and crane your neck to see through the camera, an angle that is hardly comfortable. You might especially need to light whatever you are shooting down onto, whether it is a person, a product, or a flower. That means positioning lights on light stands around the subject and out of the way of the camera. If you want to sidelight the subject at all, you've got a problem, because if what you are shooting is on the floor, the lowest position your lights can assume is limited by how low your light stands will collapse.

To solve this problem, use a platform raised up on paint cans. The approximately 8 inches that you'll gain is often enough to bring the subject up to a reasonable height for lighting your set. If you are photographing a person, use four paint cans to support a piece of plywood and drape your background over the plywood. For a small product or prop, two paint cans with a piece of glass or a foam-core board should be enough for your photo set. (See Figures 1.21 and 1.22.)

For small sets, if I want no shadow on a product or prop, I lay the item down on glass propped up by the cans and place a piece of background paper on the floor under the paint cans. I tape white paper onto the cans using white paper tape (see "White Paper Tape" later in this chapter) to prevent any reflections from the can's label. Paint cans are structurally very sound, so they don't have to be full; they can be any old paint can from your garage or cellar. (See Figures 1.22 and 1.23.)

Figure 1.21 Paint cans can be used as feet for a raised set. Wrap them with paper to prevent unwanted reflections if shooting through glass.
Copyright © Steve Weinrebe

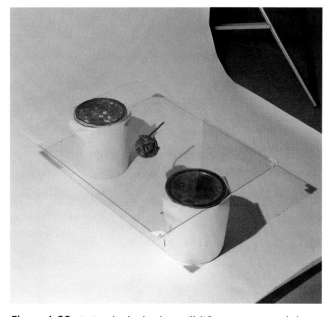

Figure 1.22 A simple shadowless still-life set to surround the subject with white: white paper, two paint cans, and a sheet of glass.
Copyright © Steve Weinrebe

Figure 1.23
Use paint cans to raise up a floor set to get a better angle with your lights, as I did for this studio photograph of maple tree seeds.
Copyright © Steve Weinrebe

Hot Glue

The hot glue gun is an essential irreverent photo tool for every photographer's toolkit. In fact, just the ability to bond things together is very important for photography. Photographers should have a variety of glues and tapes in their tool chest and hot glue is just one of them. A special advantage of hot glue is that it will bond together many different kinds of surfaces quickly: wood, foam board, plasterboard, plastic wood, Plexiglas, glass, metal, cloth (to a point), and the list goes on. There's a small safety factor too in that if you drop a dollop of melted glue on your arm, you likely won't end up in the hospital, and it'll hurt a lot less than landing a hammer on your thumb. (See Figure 1.24.)

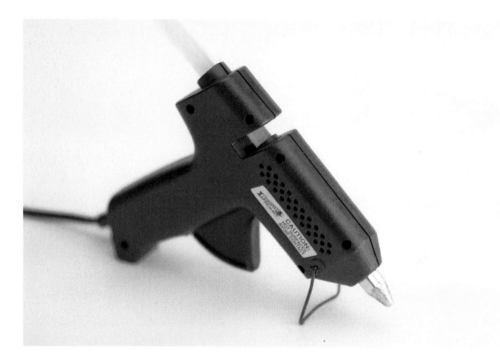

Figure 1.24
Hot glue can be fast, sticky, and then removable, making it perfect as a studio tool.

*Copyright ©
Steve Weinrebe*

Have lots of hot glue sticks handy when using a hot glue gun and be aware that there are different grades of glue and glue guns, so read the packaging carefully. If you want quick-dry hot glue, that's fine, but if you want to take your time positioning something or are working in a cold environment, then look for a slower drying hot glue. Some glue guns heat to a higher temperature than others making for stickier glue, but the higher heat may be a problem if you're using it to bond a flammable material like cloth.

You can use hot glue to bond together props using the surfaces that are hidden from the camera (as long as you don't mind potentially damaging the items). Hot glue can be a semipermanent way to position foam-core boards for reflectors. When you're building

sets in the studio, hot glue can hold boards or sheets of material in place until you get a hammer or screwdriver in hand. Some glue guns heat to a higher temp than others. Use a lower temperature model when gluing cloth or other materials sensitive to temperature. (See Figure 1.25.)

Figure 1.25
Hot glue bonded two two-by-fours together to make the four-by-four that was used to raise up the tabletop in this photo set.
Copyright © Steve Weinrebe

True Story

Some years ago when these handy, and relatively safe, gadgets were becoming popular, I visited a friend's studio near mine at the time in Philadelphia. He was working on a project that involved a room set, in which he was going to place a subject (a guitar player, if I recall correctly) into the set for an advertisement. The room included walls, floor, and molding, and he had built the set in a day or two. I asked him how he did that so quickly and he said he put half of it together with a glue gun. I was fascinated by the notion that a set of that scope could be built without hammer and nails throughout. The glue gun had been used to position wall board against studs before a few screws were placed, and the molding was applied entirely with the glue gun—brilliant. My friend held up the hot glue gun and shrugged his shoulder—many photographers can be modest. I was amazed at how handy a hot glue gun can be. I ran out and purchased one and have used it in my studio frequently.

White Paper Tape

Tape is an absolutely essential irreverent photo tool and comes in a variety of useful materials with varying amounts of stickiness and dispensing ability. I'm not referring to traditional gaffer's tape, which, while an essential tool in any photo studio, is hardly irreverent. Other types of tape are nontraditional and you may think don't have a place in the studio—but they most certainly do.

White paper tape is the first tape that I'll discuss because it is my hands-down favorite tape to keep on hand. If you had to back me into a wall and ask me what kind of tape I could *not* live without in the studio, expecting me to say "gaffer's tape," I would instead say "white paper tape." (See Figure 1.26.)

The nature of white paper tape is that it:

- Is easy to tear one handed

- Is great for sealing a roll of seamless background paper, or for taping the background paper to the floor for positioning

- Can be written on (even with pencil)

- Can be used to mark cue spots on the floor to let models know where to stand

- Can be taped to your hip to mark and remember the height of something, like a tripod

- Can be taped to a tripod or light stand to remember its position before changing it, if you want to be able to return to that exact first position, for example when a client says, "Let's try one from higher up," but you know you had it right the first time

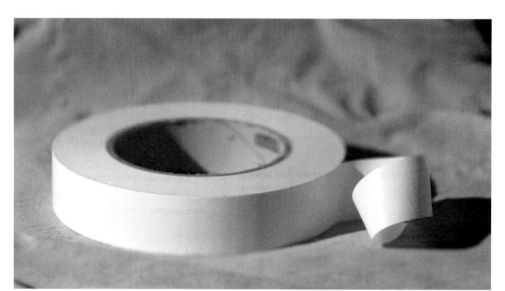

Figure 1.26
White paper tape is an indispensable tool for the studio. It can be easily torn, and repositioned.

Copyright © Steve Weinrebe

- Can be a temporary label, or even a permanent label

- Is removable, even from paper

- Is resealable (at least a few times) if used to hold something closed

- Can be used to cover spots or labels on an object in the scene

- Is hard to find, except at an art supply store

In fact my studio floor has spots of white paper tape that look a little like crop circles (those large landing pad marks that Martians cut into corn fields). The patterns of white tape on the studio floor mark different photo sets: where the legs of light stands should be positioned, where the legs of the tripod should be positioned, where the large camera stand should be pushed up against, and so forth. You can use this tape to mark anything on the floor or the wall. The tape is exceptionally sticky and will bond to most surfaces, but it can be peeled away and often used again. (See Figure 1.27.)

Figure 1.27
White paper tape can be used to make semipermanent marks on the studio floor to help reposition light stands and tripods.

Copyright © Steve Weinrebe

Tip
While white paper tape is repositionable, when left too long, it can dry out and be hard to remove. Without scientific testing, in my experience after a few months the tape can be hard to remove. But after a few weeks it is often easy to remove, depending on the surface, and still sticky enough to reapply.

I like the 1-inch width of this tape. You can find it at office supply retailers and art supply stores, but don't be surprised when you find that you could buy a couple of nice bottles of wine for the price of a roll of this tape (or one *really* nice bottle of wine). Don't be frugal and only buy the half-inch width. The 60-yard length of a typical roll is nice, but a half-inch isn't enough width to have room to write on, or have the strength to tape shut a roll of background paper. Though it's pricey, because the tape is repositionable, you can reapply it several times for uses like taping closed a box or marking a spot on the studio floor.

> ### Tip
>
> You can write on white paper tape with a black permanent marker to make instant, clearly visible labels. And though the tape can be torn, you may want to use scissors for a cleaner look when using it for labels, or to tape shut something a customer might see such as a print envelope.

Packing Tape

Exceptionally strong, packing tape can be a permanent solution to holding together parts of a studio set, or holding together paper elements such as background paper or cardboard reflectors. In fact, this tape bonds so tightly, you wouldn't want to use it on anything made out of paper that you would care became damaged if the tape were removed. Of course that's why it is used for sealing packages.

You'll want to use packing tape with a dispenser. The dispenser is easy to load tape into and allows for a one-handed swipe when taping something together. More often than the one-handed swipe, you'll pull a length of tape from the roll and then across the serrated cutting edge. This way you can apply the tape with your hands. The most important feature of the dispenser is that it prevents the tape from falling back onto the roll and sticking to itself. (See Figure 1.28.)

I have two packing tape dispensers—one generic and one name brand—and keep a six-pack of tape in the cabinet at all times. I often grab the generic dispenser over the branded one because it is lighter, making it a bit easier to wield. The brand name dispenser that I have does have a better cutting blade though. But if I had to choose which to be stranded on a desert isle with, it really wouldn't matter to me; I like both dispensers.

Figure 1.28
Packing tape, with a good dispenser, makes for a powerful tool in the studio.

Copyright © Steve Weinrebe

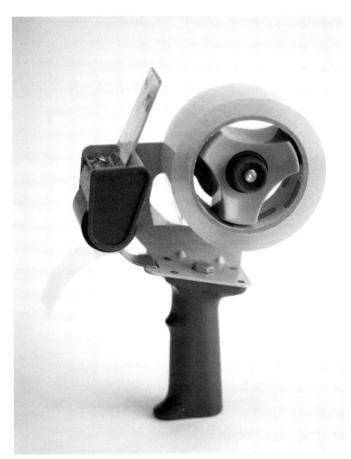

Tip

A smart assistant once taught me that the best packing tape to buy for use in the photo studio is the generic variety, the less expensive house brand sold by the office supply or general-purpose store where you purchase the tape. Name-brand packing tape tends to be stronger, and so is more difficult to cut along the serrated edge of the tape dispenser. When using packing tape, you'll generally want to tear off a piece quickly. The generic tape seems thinner and tears more easily so that when you are done with your "swipe" of the tape dispenser, the tape is more likely to tear along the serrated blade. Also the name-brand tape seems to jam more frequently, probably again because it's thicker. And the more expensive name-brand tape doesn't seem to have the same "instant stick" ability as the generic brand.

This is not a tape to use for repositioning, or to write onto for labels, and because it is nearly invisible when applied, except for reflections in its glossy surface, you wouldn't want to use it for marking spots on the wall or floor. This tape is one of your most permanent solutions for holding something closed or holding items together. Packing tape is perfect to hold rolls of background paper closed. While both paper tape and gaffer's tape can be susceptible to moisture in the air causing paper rolls to pop open over time, packing tape will never fail to hold the roll shut. For such uses, though, you'll need to cut the tape to open the paper roll or box because it is most certainly not repositionable.

Unlike paper tape, packing tape is inexpensive. Good thing too, because if you have ever used this tape, you have probably ended up, at one point or another, with a ball of it stuck together, and to yourself, that you gratefully shake into a waste can. (See Figure 1.29.)

Figure 1.29
Packing tape is strong enough to hold shut large rolls of background paper and is moisture resistant so it won't lose its grip.

*Copyright ©
Steve Weinrebe*

Tip

As tempting as it may be, don't use your teeth to tear apart packing tape. I have accidentally bonded the tape to my lips, and have seen assistants do the same in a moment of rushed work. Removing the tape from skin, especially lips, can be an unpleasant experience.

Besides taping paper items together, you can make a reverse ball with packing tape to remove lint from a photo subject's clothing, or from a cloth background or green/blue screen. Just cut off roughly a 6-inch piece of tape and fold it back onto itself into a cylinder with the sticky part outward. The 6-inch piece, when rolled up, should be large enough to fit around two fingers. You can then gently tap the tape onto the clothes or cloth, and lint sticks to the tape instantly. Slide the cylinder of tape around your fingers for a fresh section.

Another excellent use for packing tape in the studio is to hold a model's clothes in place to smooth out wrinkles in jackets or dresses. I've photographed many television newscasters and executives, and often the sport jacket, depending on how their arms are positioned, can bulge from their shirt. A reverse roll of packing tape, assembled as I described in the lint removal technique above, can be placed under the jacket to better pull the jacket onto the subject's shirt, removing both wrinkles and drop shadow. This few seconds of taping can save you an hour of Photoshop retouching. (See Figure 1.30.)

Figure 1.30
Use packing tape to hold together cloths such as a jacket or a dress, for neatness in a portrait shoot. Here a piece of packing tape holds a lapel to a shirt, preventing the lapel from bunching up. The camera won't see this angle; the tape will be hidden behind the lapel.
Copyright © Steve Weinrebe

Duct Tape

I mentioned this chapter to a photographer friend and he blurted out, "Oh, things like duct tape!" I'm not surprised that duct tape was the first irreverent tool to come to mind because it is something that is by definition designed for a purpose far from anything photographic. Regardless of the name given to this type of tape, every photographer should have a roll of duct tape stored away in the studio. (See Figure 1.31.)

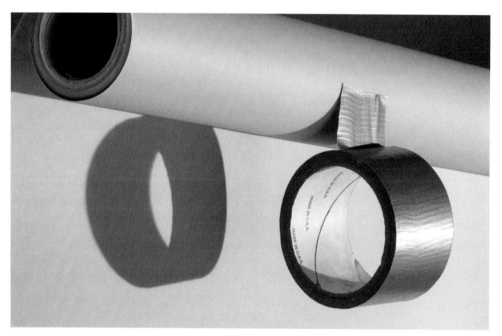

Figure 1.31
Duct tape is inexpensive, sticky, and works well for short-term adhesive needs.

Copyright © Steve Weinrebe

Duct tape is a cloth-based tape that has a waterproof surface. It is exceedingly sticky, which makes it sometimes difficult to tear smoothly. If you tear an arm's length of the tape to run across a surface, such as to tape a background to the floor, it sometimes twists and bonds onto itself before you can apply it. This often leads to curses and frustration, and you can't even throw the tape in a waste basket with any satisfaction because it generally sticks to the side instead of plopping to the bottom. Good old gaffer's tape is also cloth based but will generally not twist around and bond to itself. So if you can't manage your photo need with duct tape, you may need to revert, with reverence, to gaffer's tape.

What you can do to help tear lengths of duct tape is stick the end of it to any surface, such as a work table, pull out the length, then tear it and grab both ends with your two hands. Keeping duct tape stretched out in this way will generally keep it from twisting back onto itself and becoming useless. (See Figure 1.32.)

Figure 1.32
Stretch out duct tape in a way that you can grab both ends before the tape becomes twisted.

*Copyright ©
Steve Weinrebe*

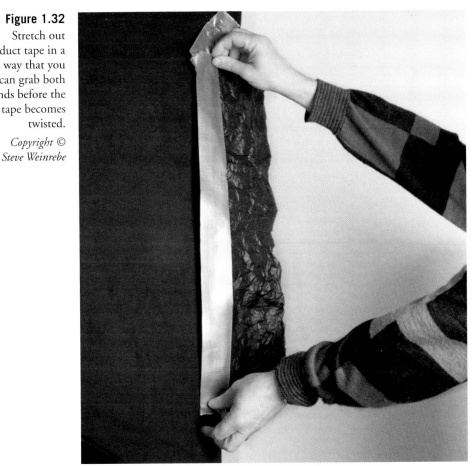

Tip

Use duct tape sparingly. Duct tape can leave residue on whatever you apply it to, and if left too long will dry out and, along with the residue, leave crumbs of dried adhesive on your equipment, the floor, or the photo set. Speaking of equipment, I recommend you never use duct tape on equipment. While both traditional gaffer's tape and the less traditional paper tape work well as markers or labels on equipment, they will dry out over time and become difficult to remove. But duct tape is the worst offender here and you'll risk leaving sticky adhesive or dried adhesive to your equipment, either of which can cause a cascading set of problems. For example, if you use duct tape to mark a tripod leg so that you can remember the length of the tripod leg's extension to return to during a photo shoot, and the tape leaves a residue on the tripod leg's surface, when you collapse the tripod, the adhesive can become smeared into the inside of the tripod's frame causing the leg to bind the next time you extend it. Better to use paper tape for such needs, as it can be removed without residue, as long as it hasn't been left on for too long.

Another trick with duct tape is to use it as if you were wrapping a bandage around something, by holding the roll in your hand and pulling the roll along, or winding it around something while the tape pulls off the roll and adheres onto your intended surface.

In the studio duct tape can be a poor man's gaffer's tape. As long as you play by the rules you can use duct tape for most typical taping needs: holding a reflector to a light stand; taping cloths for neatness in a portrait shoot (as discussed with packing tape); taping background paper closed, to the floor, or to a wall; making markers for light stands, camera stands and tripods; holding cords in place or onto the floor to prevent people from tripping; and so forth.

Duct tape rules:

- Don't leave duct tape on any surface for any longer than you need to

- Don't use duct tape on surfaces that need to be returned to a pristine condition

- Keep duct tape away from sunlight or hot lights, or even moderately warm modeling lights because the tape will wilt or separate

- Avoid using duct tape on cords because if the tape wraps around the cord, it can be very difficult to remove

- Like most types of tape, with the possible exception of paper tape, avoid using duct tape on skin

- If using duct tape to hold shut rolls of paper or boxes, replace the tape with packing tape or white paper tape as soon as possible or the paper rolls or boxes will pop open

Staple Gun

A staple gun can be a quick way to hold something together in the studio when you don't want to use tape or glue and want a semipermanent solution. Notice I use "semipermanent" frequently to describe goals in the photo studio. That's because you need permanence while setting up for and producing your photographs, but then you want to take your set apart without too much difficulty. The staple gun is the kind of tool that can help you meet that goal. (See Figure 1.33.)

Typically, I may want to tighten black velvet onto a board for a backdrop. Neither tape nor hot glue will hold black velvet, at least not for long. A staple gun does a fine job here because I can hold down the velvet with one hand (and maybe one knee as well), and staple the velvet to the board with the other hand. Tacks and a hammer would take two hands, and push pins might pull out. Staples are a much better solution. When you are done, be sure to pull the staples with pliers or use a flat head screwdriver to gently pry them out. (See Figure 1.34.)

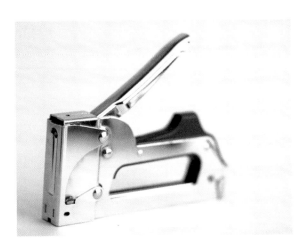

Figure 1.33 Use a staple gun to hold together materials in the studio.
Copyright © Steve Weinrebe

Figure 1.34 Use a staple gun to staple backgrounds onto a board, to keep the background from shifting or wrinkling.
Copyright © Steve Weinrebe

Acetone and Heptane

The active ingredient in nail polish remover is acetone. Photographers need to keep some acetone in the studio largely to solve one of the problems mentioned previously—tape residue. Acetone will dissolve most types of tape residue, greasy film, or grime, paint, writing from markers, and so forth. It is fine to use on most surfaces and evaporates almost instantly. This attribute make acetone a great solvent to remove the residue left from labels on products. Typically, when photographing a prop or product, you may need to remove a label. Wiping any traces of label paste with acetone can go a long way toward making the product or prop look cleaner for photography. (See Figure 1.35.)

Tip

Consider using disposable rubber gloves when using acetone to clean residue. If you are holding a wad of paper towels or a cleaning cloth soaked with acetone, the solvent will dissolve the natural oils in your skin and leave your skin very dry. Rubber gloves protect your hands and, since the perfume-scented acetone leaves an odor, disposable gloves can simply be tossed in the trash along with the cleaning cloth. Disposable gloves can be bought in either latex or non-latex. (See Figure 1.36.)

Figure 1.35 A bottle of nail polish remover, which is comprised of acetone. While acetone is a solvent that is typically used to remove nail polish, acetone can also remove many nuisance substances like tape residue.

Copyright © Steve Weinrebe

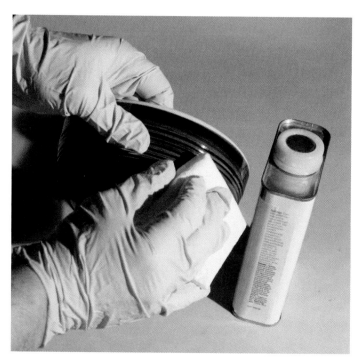

Figure 1.36 Use disposable rubber gloves when using acetone or heptane. I find the gloves prevent my skin from drying out from the solvent. You can buy latex or non-latex disposable gloves. Here I'm removing label residue from a prop. Acetone can be purchased in cans at the local hardware store.

Copyright © Steve Weinrebe

Nail polish remover is often found in the home and is easy to purchase in drug stores or grocery stores. It is inexpensive and usually perfumed. Most often it is used, as the name suggests, to remove nail polish. But if you have some nail polish remover in the medicine cabinet, you may consider moving it instead into your photo studio since acetone has some valuable uses for the photographer. You can also purchase acetone at a hardware store in a can resembling those that are used for paint thinner or paint stripper. That should give you an idea of how powerful and potentially hazardous a chemical acetone is.

One example of how you can use acetone, as I mentioned, is to remove unwanted residue on surfaces. When you use tape or wax on a hard surface like metal or glass, and a residue is left after removing the adhesive, use acetone to remove the residue. Fold over some paper towels and dribble a little acetone onto the wadded-up towels. Then wipe the surface with gentle strokes. If the surface you're wiping is painted, check the cloth you're wiping with to make sure no paint is coming off the surface. If you see any color on the cloth, suggesting the acetone is removing the surface's color, then stop.

Avoid breathing the fumes. Better yet, use a respirator—one rated for the fumes of chemicals like acetone. Because acetone is a solvent, heed any warning labels on the product and avoid any uses that aren't recommended, and definitely avoid spilling acetone in the studio.

Regardless of how well acetone can clean up most surfaces, don't use acetone on plastic surfaces because it will permanently mark the plastic, including permanently removing any glossy finish. Acetone is fine, though, for removing tape or label residue on metal or glass but heptane is the solvent to use on plastics. You can purchase heptane at an art supply store or a hardware store in the commercial form of Bestine. Even still, always test the solvent on a hidden area or on a piece of test material to see if it will mark the surface or not.

True Story

I was producing a series of photographs for a bottled spring water company, during which we had to remove the label from a gallon-sized plastic jug of spring water. It was the art director on that photo shoot who showed me how damaging acetone can be on plastic, and that heptane in the commercial form of Benzine could be used to remove the label residue without creating permanent smears in the plastic. However, plastic is porous enough that the heptane we were wiping on the outside of the jug could seep into the water rendering the water undrinkable. This may be something to remember if you are using heptane on thin plastic if the plastic is in any way a food container.

Paper Towels and Glass Cleaner

This irreverent dynamic duo may seem obvious, but I can't stress enough that you need to have these tools on hand in the studio at all times. Other than plain water, glass cleaner makes for a gentle general-purpose cleaner that works on many surfaces. Besides cleaning anything made from glass, you may need glass cleaner just to remove a build-up of dust from a surface. Photography is very unforgiving for dust and dirt, and unless you want the dust or dirt to show as part of your picture, you will need to clean it off. (See Figure 1.37.)

Figure 1.37
Always keep a roll of paper towels and glass cleaner in the studio easily available to grab quickly.

Copyright © Steve Weinrebe

If you have a spill, you won't want to run around your studio—whether it's in a building, loft, house, or apartment—looking for paper towels to wipe up the mess. I have a "five second rule." That is, if there is a spill, I want to be wiping it up within five seconds—faster if possible. Keep a roll of paper towels and some glass cleaner on your counter, up front in a cabinet, or anywhere that is always within easy reach.

Tip

If you want to clean dust or dirt off of your computer display, keyboard, phone, scanner, or any surface involving electronics, always spray some glass cleaner onto the paper towels, or a lint-free cloth, first and then wipe gently with the towels or cloth. If you spray a computer display directly the cleaner will immediately start dripping toward the edges of the screen in into the interior of the display. By dampening the cloth with the cleaner first, you won't allow any moisture to get near the electronic parts of the item you're cleaning.

Fire Extinguisher

Having recently replaced the batteries in my smoke alarms, a twice-yearly ritual, I thought I would give the spotlight to this essential tool for any photography studio, whether your photography workspace is in a city loft or a suburban basement. It is a no-brainer to store a fire extinguisher where it can be grabbed in the event of a mishap. If you do not have a fire extinguisher within quick access of your lighting equipment, you should put a sticky note on your computer display to remind you to get one. Any small or big-box hardware or general-purpose store will sell residential-sized fire extinguishers for you to buy. The extinguisher's charge can last for years, but I periodically check the pressure gauge to make certain the arrow points toward Full. (See Figure 1.38.)

I hope you never have to use a fire extinguisher in your studio, but, in the words of an old friend, it is cheap insurance.

Figure 1.38

A household fire extinguisher, easy to keep handy and spot in an emergency.

*Copyright ©
Steve Weinrebe*

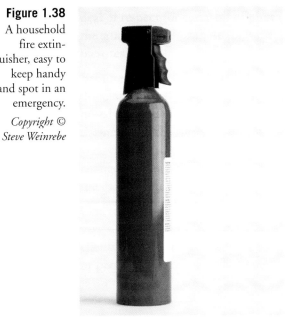

2

Irreverent Location Tools

Packing equipment to go on location for photography can be a daunting process. Lists don't help very much because every location shoot has different requirements depending on locale, subject, time of day, and so forth. The inclination is to just bring everything under the sun, in other words every piece of equipment you own, so you don't forget anything.

I'll distinguish "location" photography from "travel" or "landscape" photography because location work is usually a different animal. I'm writing of the type of photography generally produced for editorial or advertising projects, stock photography, or student commercial art portfolios. In other words, photo shoots where you need to be in control of a set on location, in essence be able to recreate a studio situation on location.

Your location might be a living room, a public institution, a concert, an office, or a street setting. Indeed, I've had photo shoots in all of those, plus hospitals, parking lots, beaches, swimming pools, hotels, helicopters, strawberry fields—the list goes on and on. With few exceptions I have assembled a core roster of photo equipment that has worked well for most locations. From that core assembly of equipment, each location might demand an additional tool or two to be packed for the shoot, but in any case the photographer's goal is to be prepared so that your work isn't interrupted by the lack of an essential photo tool. (See Figure 2.1.)

In all the assembly of equipment that location photographers must tote on location, there is an array of photo tools that does not look like traditional photography tools and that wasn't purchased at photography-oriented stores. These tools vary in size and importance, but I wouldn't be caught on location without them. Much can go wrong on a photo shoot. If you are on your home turf, you'll likely have a backup for something broken, or a tool to fix it. On location you have what you have brought with you.

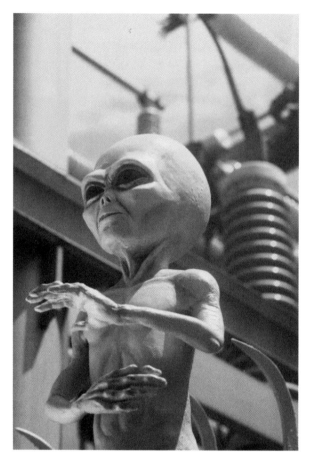

Sometimes you can scrounge, but remember that you'll have camera equipment to think about and that you can't just leave your gear on a street corner to run to grab some paper towels because the puppy you're photographing for a magazine just slobbered on your lens. Be realistic and cover yourself, not just with the expected and obvious photo gear, but with some of these irreverent location tools as well.

While you're reading this chapter, remember that some of these tools could certainly be used in the studio or for other purposes and genres of photography. If anything, location work is often about being resourceful, and that's a good idea anywhere and anytime when taking pictures.

Reusable Furniture Sliders

Furniture sliders, in their modern incarnation, are indispensable. They are constructed from a slippery plastic that is very solid and scratchproof. The surface of these sliders seems permanently slippery, as if oiled, yet has no dampness and leaves no residue. (See Figure 2.2.)

Figure 2.2

Furniture slid-
ers come in
many sizes and
can make mov-
ing heavy fur-
niture, or
props, a simple
chore.

*Copyright ©
Steve Weinrebe*

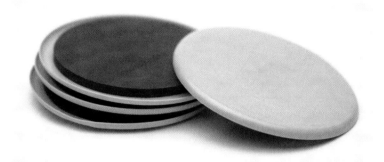

The early advertisements for furniture sliders, showing elderly women moving gargan-
tuan pieces of furniture single handedly, won me over. At first I purchased furniture
sliders for some household furniture. We have furniture sliders under the piano legs, for
instance, so that the piano won't dent the floor if we want to move it aside. As time went
on I frequently found a use for small stick-on furniture sliders. Then, I began using
small stick-on sliders in the studio under some heavy equipment that didn't have cast-
ers, and which I frequently had to move. The small stick-on sliders would have easily
earned a spot in the previous chapter on studio tools, except these handy plastic disks
have an even more important role on location, making up for a second pair of hands.
(See the following sidebar.)

True Story

Ideally a photographer would never go on a location shoot without bringing along a
photo assistant to help get the job done painlessly and on time. But unless you're in a
position to pick and choose your work, not all location photography projects have a
budget, or are on a scale, that allows for hired help. Besides budget constraints, shooting
digitally removes the need for an extra pair of hands to load film into camera bodies or
film backs. Smaller, more contained lighting equipment (like mono-block or portable
flash heads), light carbon fiber tripods, and soft, padded camera cases can make location
photography a manageable one-person job. But beware of the customer or art director
who says he or she will be your assistant, and that he knows how to open light stands and
roll cords. A photographer I know handed his art director client, who insisted upon being
his assistant for a photo shoot, a brand new camera to hold onto. The art director sum-
marily dropped the camera, damaging it beyond repair. It was an accident, but the moral
of this story is that no one will take care of your equipment on location like you will,
except for a hired assistant. If you don't have a professional assistant, do the work yourself
and don't rely on just anybody present, no matter how good the intentions.

For your location bag of tricks, include at least one set of reusable furniture sliders. The reusable sliders have a foam rubber padding on the top side of the slider to grip whatever you place on top of them. The object you move presses into the foam padding, which shapes itself around the object. (See Figure 2.3.)

There are several brands of furniture sliders on the market. Ideally, keep some large and some smaller reusable sliders in your carry bags. These sliders open up possibilities for what can be moved or rearranged on location. Want to move a heavy wooden desk out of the way? No problem. Need to bring a heavy prop or product into your location set for a photograph? Also no problem. You will have to lift up a corner of whatever you're moving to place the sliders under the bottom, but even heavy objects can usually be tilted enough to get a slider under each corner, and away it goes. (See Figure 2.4.)

Figure 2.3 Small reusable furniture sliders are placed under the feet of a large table to make moving it a cinch. Place reusable furniture sliders under anything heavy to move it out of the way, or to position something heavy for a photograph. Just remember to take the sliders out before you take your picture.
Copyright © Steve Weinrebe

Figure 2.4 I used furniture sliders to move a heavy antique chest into position for this photograph of one of its detailed carvings. Without furniture sliders it would have taken two people to move the chest.
Copyright © Steve Weinrebe

Rubber Carpet Padding

Here's an irreverent tool I've taken to in recent years—rubber carpet padding. This is thin rubber that you can purchase by the yard from a carpet store. In fact, you only may need a yard of it and, as long as you can find a free salesperson, you can be in and out of the carpet store in minutes. This padding may come in brown rubber foam surrounding a strong fiber mesh, a blue waffle-cut foam, or some other incarnation. (See Figure 2.5.)

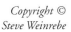

Figure 2.5

Rubber carpet padding is inexpensive, can be cut to size, and has a strong grip to keep cases and other things from sliding around.

Copyright ©
Steve Weinrebe

Whether you have a pickup truck with a plastic liner, or a van or SUV with a carpeted rear compartment, I'll bet you've had items slide around that you wish didn't slide around. Cameras and computers are sensitive to shock, so even if you have good equipment cases, you'll want to prevent them from sliding around when you turn a corner. Simply place rubber carpet padding down first to keep your equipment cases from sliding around the bed of your car. I cut the padding into roughly 6-inch by 12-inch rectangles that can be easily laid down beneath a case, box, or anything else heavy enough that its weight might cause it to shift when driving. (See Figure 2.6.)

Once on location, you might have a rolling cart or some cases stacked in an airport cart for check-in. As soon as you place one case on top of another, even if it's a laptop case,

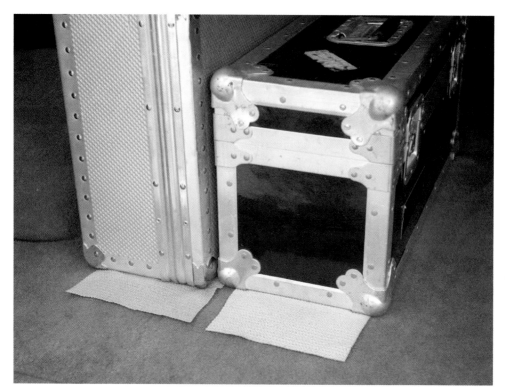

Figure 2.6
Keep rectangles of rubber carpet padding in the bed or trunk of your car so that you can lay them down when packing your equipment. The rubber will prevent just about anything from sliding around on a carpet, or on a hard plastic truck bed liner.

*Copyright ©
Steve Weinrebe*

and you start moving the cases around, you're at risk that one of the cases is going to slide off or get jostled enough to fall to the ground. Again these swatches of carpet padding come to the rescue. They're certainly light enough to pack one for each case. When stacking cases, you'll want to throw a piece of the rubber padding on top before you place your next case down.

Ugly Cases

When you go on location, don't advertise the fact that you have something to steal; hide your gear with ugly cases. Unless you have an entourage of assistants standing guard, and even if you do, your equipment is in danger of being stolen. If having people see how cool your equipment cases look is what gives you thrills, well, just do a web search with words like "stolen camera" to see how many results you get, and you might think differently. (See Figure 2.7.)

Camera cases do look handsome. Camera bags are made to look like something that would be worthy of holding your exceptional digital camera. Larger cases are made from aircraft aluminum or rugged black cloth with padded sides. Plywood cases with rounded steel corners scream "video equipment" to anyone who has watched enough television

Figure 2.7
Use an unassuming case, or shell for a case, to hide the fact that you have expensive camera or computer equipment inside. This case was purchased at an Army-Navy store and is large enough to hold another, nicer case inside.
Copyright ©
Steve Weinrebe

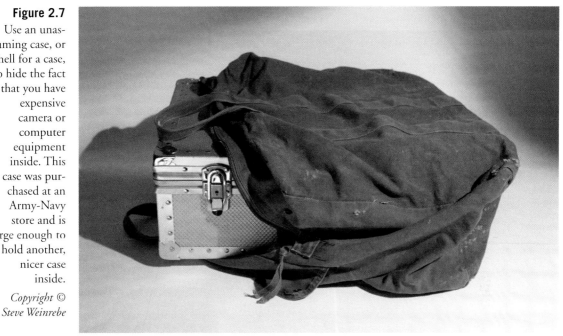

to have seen how movies are made. All these cases are expensive to buy in their own right, not to mention the equipment they hold. And just like shopping for camera gear, advertising and camera store displays make beautiful camera cases look like an essential purchase for any photographer. Heck, you just spent $5,000 on a camera body and some lenses: why not spend a few hundred on a suitable case that looks like it should hold such expensive gear?

But wait—camera cases are not jewel cases. You're not trying to let people, especially thieves, know what you have inside. You likely (and hopefully) won't be wearing your cameras if they are stolen. You'll be distracted talking to someone, or you'll step away for a few minutes, or the cases will be sitting by the luggage counter in the airport while you jog from your gate to baggage claim. Those brief unattended moments are when photography equipment is at risk of theft, because the case looks like something expensive and isn't being watched over, if only for just a few seconds. (See Figure 2.8.)

Borrow a page from urban bicycle enthusiasts who know how often bikes are stolen, and who will take a $1,000 Italian racing bike and, without a second thought, cover it with black permanent marker, brown paint, and duct tape, to make the bike looks as worthless as possible to any prospective thief. I've always admired the avid bicyclists I've seen do that. The bike isn't pretty, but its functionality isn't altered and more importantly it doesn't attract thieves.

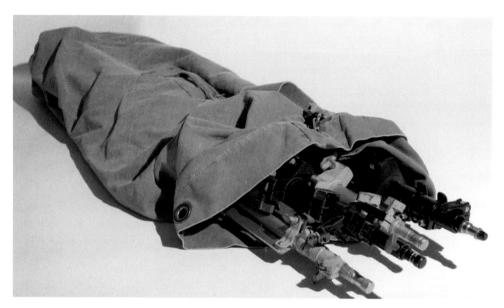

Figure 2.8
A simple duffle bag can camouflage light stands, and could even accommodate an expensive tripod, camouflaging the gear from thieves.

Copyright ©
Steve Weinrebe

True Story

Be careful of leaving valuable equipment in your car, even if it's hidden from view, when you park your car at a camera store. I know an experienced photographer who parked his van outside a camera store to run in and buy something. When he returned to his van and climbed into the front seat to start the car, he realized someone was in the back of the van. As he climbed out the car, the thief, who had broken into the rear door of the van and had been rummaging through it, jumped out of the van and ran down the street. Apparently this wasn't the first time cars parked outside the store were targeted for theft.

The interesting part of the story is that my friend chased the thief several city blocks until they were both so exhausted that the thief stopped, catching his breath, and turned around to face my friend. They both put up their fists and my photographer friend, polite and mild mannered but not afraid of a fight, started yelling at him, "Why would you do that? That's my livelihood!" Panting for breath they yelled at each other until the yells died down. The thief told him that he was hungry, hadn't eaten, couldn't get a job, had more problems than you can shake a stick at, and so forth. My fine photographer friend, still angry as a hornet but rational as well, took the thief to the nearest restaurant and bought him a hamburger.

Water Jug

Sometimes the best photo tools are the simplest to make. Why carry a weight on location when you can carry an empty container and then fill it on location with a readily available, and relatively heavy, substance? Plastic water jugs are easy to find and inexpensive considering the use. A gallon of water weighs 8.33 pounds, close enough to a 10 lb. weight that it will serve a similar purpose. Even better, gallon water jugs have a handle, making them easy to attach to tripods, light stands, or booms with a bungee cord. (See Figure 2.10.)

Any convenience store or grocery store sells gallon jugs of spring water, and you can drink the water or pour it out, so that you have the empty jug to store with your location gear. If you routinely buy spring water to drink, consider buying some gallon jugs and simply recycling the jug as a photo weight. Either way you should keep a couple on hand to bring with you as a lightweight alternative to carrying sand bags or steel weights.

Figure 2.9 You never know where you'll be when shooting on location. Protect any equipment you travel with by storing it in ugly cases in your car, or in unattractive luggage for air or rail.
Copyright © Steve Weinrebe

Figure 2.10 A gallon water jug, when empty, is light and easy to transport. On location, you can fill it to use as a weight or counterweight.
Copyright © Steve Weinrebe

Even with your camera on a tripod, *camera shake,* which can ruin an image capture, can still come from a variety of factors including wind, camera movement from your finger pressing the shutter, or vibration from the mirror flipping up at the moment of exposure. A cable release, or timed release (self-timer), can solve the "finger on the shutter" problem. Locking up the mirror can solve the "mirror vibration" problem. But wind is a tough one. You can stand upwind of the camera and block the breeze from the camera during the exposure, and that can help quite a lot, but you really want the sturdiest tripod possible, and if at all possible some extra weight on the center axis.

Photographers use tripods to stabilize a camera, and many photographers think the stability comes entirely from the three legs—that if the three legs of the tripod are touching solid ground, then there will be no camera shake. But it's usually the *torque,* the twisting of the center axis of the tripod, that causes motion blur in an image. Because most cameras have flat sides, wind can easily exert enough pressure on the camera to twist your camera during the exposure, causing some motion blur.

Tip

Test your tripod for susceptibility to torque vibration in this way. Without a camera on the tripod, extend the legs of the tripod all the way and place it on the floor or ground. Make sure all parts of the tripod are tightened. Then press down with both hands on the top of the tripod and twist clockwise and counterclockwise. If your tripod moves visibly without much effort from your twisting motion, you're at considerable risk from motion blur in even light breezes.

To add stability to your tripod, weigh it down from the center axis. Any method of attaching a weight will help, but the water jug weight comes in handy here. Once filled with water, the weight of the jug hanging from the center post of your tripod will go a long way to stabilizing your camera. If you're in a very windy situation and the wind is causing the jug to swing back and forth, lower it so that it is just touching ground but still pulling down on your tripod's center of gravity. (See Figure 2.11.)

In fact, unless wind is a necessary element to your photo shoot, waving flags or sailboats for example, the wind is your enemy on location. Raise a light stand with flash head, and open an umbrella or soft box at the top, and even the lightest wind can tip it over or swing it in the wrong direction. Photo sandbags are a traditional weight to hold down lighting outdoors, but they're heavy items to tote on location. Empty water jugs, filled on location, add stability to a stand or tripod and lighten your load as well. In extreme weather, though, you may need someone holding each stand or need much heavier-duty equipment—and of course you'll need to check the weather report. (See Figure 2.12.)

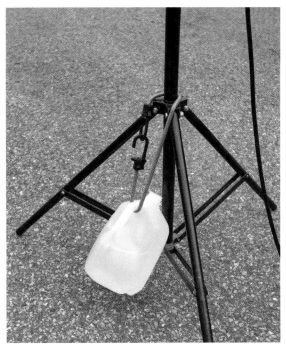

Figure 2.11 Use a bungee cord to attach a water jug to a tripod to make it more solid, and to help prevent camera shake.

Copyright © Steve Weinrebe

Figure 2.12 Attach a filled water jug to a light stand with a bungee cord when shooting outdoors with umbrellas or soft boxes. The weight of the jug at the bottom of the stand adds stability.

Copyright © Steve Weinrebe

Milk Crates

Milk crates are used in the dairy industry for stability in transport, durability, and ease of carrying. Those attributes make milk crates an excellent photo tool to carry photography gear, such as cords, hardware, drop cloths, cloth backgrounds, and spray cans; and gaffer tools like spring clamps, counterweights, tripod accessories, and so forth. (See Figure 2.13.)

Because of the popularity of milk crates as storage containers, retailers caught onto the idea and you can purchase plastic milk crates online or at retail stores that specialize in selling storage or containers. Whatever milk crate you buy, make certain it is substantial, and if possible look for a milk crate that is commercial quality and made to stand up to the rigors of working on location. Conduct an online search for "milk crates" and

you'll likely come up with several options to locate or purchase one or two of these terrific storage tools.

If I'm bringing anything that needs electric power to a location photo shoot, I make sure to bring lots of extension cords, including extras of whatever type I may need. That means extra power cords for computer and display, flash units, battery chargers, and extension options for all of the above. A power strip or two can't hurt either if there is a possibility of a power surge that might damage any equipment. (See Figure 2.14.)

For extension cords, consider carrying some 25-foot heavy-duty cords, as well as at least one 50-foot and one 100-foot cord, just to make sure you can pull power from the nearest outlet, even if that outlet is not conveniently located. (See Figure 2.15.)

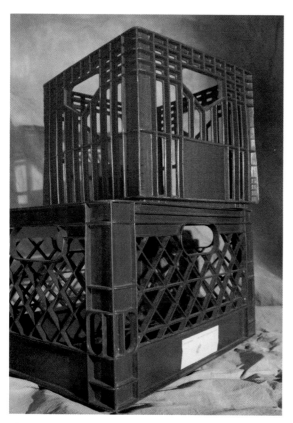

Figure 2.13 Milk crates come in many different colors and various sizes. They are very useful for carrying cords and other necessary gear on location.

Copyright © Steve Weinrebe

Figure 2.14 Good use of a milk crate for carrying essentials on location: extension cords, gaffer's tape, a triple socket adapter, and a tripod head.

Copyright © Steve Weinrebe

Medicine Bottles

Empty prescription medicine bottles are the first of a trio of small but strong storage tools that I recommend and that work great for location photography. These tight-lidded marvels make great storage for spare bulbs and small parts. (See Figures 2.16 and 2.17.)

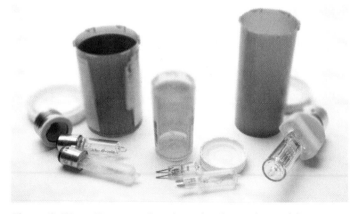

Figure 2.16 Empty medicine bottles make solid containers for storing and protecting spare halogen bulbs.
Copyright © Steve Weinrebe

Figure 2.17 Different-sized medicine bottles can be used for different storage needs.
Copyright © Steve Weinrebe

After years of being toted around in an equipment case, the cardboard wrapper that's typical of replacement bulb boxes becomes frayed and torn. Even new bulb (a.k.a. lamp) packaging is not strong enough to withstand pressure from a tightly packed equipment case, and by the time you need the spare bulb, you may find it cracked. Halogen bulbs last a long time, but they do burn out. If you rely in any way on spare bulbs, even for just your flashlight, you should carry some empty prescription bottles to store them in your cases for location work.

Tip

You may not need me to tell you this, but for privacy's sake please remove any labels from the prescription bottles that you'll use to store your spare bulbs and small items for photo shoots. Even if the bottles are outdated or belong to someone else, removing the labels is wise policy. Besides, the empty prescription bottles look more professional without labels.

35mm Film Container

This tool and the next are throwbacks. Forget how they were used then; this is how you can use them now. If you have any 35mm film lying around, you might consider throwing out the film and saving the container. If you use film for any reason, holiday snapshots with the old film point-and-shoot or whatever, always save those handy film containers. If you know any photographers who were working professionally prior to the early 21st century, ask them if they have any film containers lying around that they can give to you. (See Figure 2.18.)

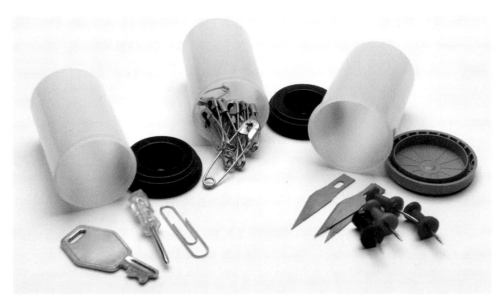

Figure 2.18
Film containers make excellent storage for very small photo items.

Copyright © Steve Weinrebe

Besides being perfect for holding quarters for parking meters, something any urbanite may have discovered, the rigid construction and snug pop-top of plastic film containers make them excellent recyclables for photo storage. For small, sharp items like pins and tacks, adapter screws, photo slaves, and anything else you might want to protect for travel on location, film containers are handy tools. I have film containers that I've kept small photo items in for so many years, it's hard to believe these sturdy receptacles were built for two-time use only—holding unexposed film, and then holding exposed film on the way to the photo lab. Then again, film was a delicate substance, sensitive to light and humidity, and it made sense for the manufacturers to give film such excellent packaging. Let's take advantage of that and, in an irreverent way, use them for something completely different.

Gaffer's tape is a very traditional photo tool, but a roll of the tape is too large to store easily in most gadget bags. If you are just carrying a shoulder bag or photo backpack, wrap some gaffer's tape around a film container and throw that in your bag. A few feet should be enough for a quick job taping a neutral gray card to a tree, or to manage whatever your end use for the tape might be. (See Figure 2.19.)

Figure 2.19
Bring small quantities of gaffer's tape in even a small camera bag by wrapping a few feet of tape around a film container.
Copyright © Steve Weinrebe

Slide Boxes

The next throwback item is the slide box. If you took pictures in the pre-digital era, or your parents did, you might have a few, or a few hundred, slide boxes stored away. I'm not talking about the paper ones. Those aren't rigid enough to be useful storage for going on the road with your photo gear. Plastic slide boxes with clear or frosted lids make excellent storage for an array of necessary photo items from levels to loupes. (See Figure 2.20.)

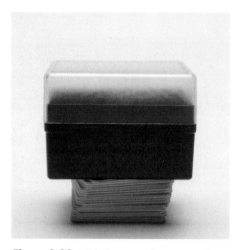

Figure 2.20 Slide boxes are large enough to store pocket levels or loupes, as well as other small photo gadgets.
Copyright © Steve Weinrebe

Figure 2.21 Label slide box lids with a permanent marker so you can easily grab what you need from your case. Use cotton balls, or other padding, to keep fragile items from breaking during transport.
Copyright © Steve Weinrebe

I carry my pocket level in one of these slide boxes, stored in a case along with other photo gadgets. I put some cotton in the bottom of the slide box for extra cushion and to prevent the level from bouncing around. I wrote "Level" on the frosted lid with a permanent marker. I have other slide boxes in the same case marked "Loupe," and "Slaves," for a photo loupe (magnifier) and photo slaves for flash units. I also carry spare batteries, AA and AAA, in slide boxes. Because the boxes are flat, they stack well in a travel case. Small and lightweight, they become protected mini-compartments in a camera case. (See Figure 2.21.)

If you can lay your hands on some slide boxes, you'll find uses for them. If you don't have any, try an online auction or used-item website. If you have a photo lab in your hometown, or as a service in a local store, ask the lab personnel if they have a few lying around that they might give you.

Caution Tape

Caution tape makes for great signage. You can't miss it. Even if you are colorblind, the high contrast of the diagonal black and yellow stripes will alert you that there is something you should take care about. On a location photography shoot, that "something" might be an extension cord running along the floor, or the legs of a light stand or tripod. You might not want someone entering a room that you're shooting in, and if they see caution tape blocking their way, they'll most likely take heed and stop. (See Figure 2.22.)

I've talked about other types of tape for different uses, but caution tape isn't so much for taping as it is for seeing. In fact, the caution tape that I have isn't sticky enough to keep a cord down on a carpet very well, so I use strips of gaffer's tape to hold the cord down, and then run caution tape along the entire length of the cord.

People will trip over cords; that's the danger. As a photographer taking pictures on location, whether it's an executive's office or Aunt Hattie's living room, you're in charge. You're responsible for managing the environment and making sure nobody and nothing get damaged. Taping cords down to prevent people from tripping and using caution tape to alert people that there are cords on the floor, or that there may be an area they shouldn't wander into, is good policy and will make you look more professional. (See Figure 2.23.)

You can purchase caution tape from most hardware stores and online. If you are using it to tape down heavy-duty extension cords, get at least 2-inch tape, and preferably 3-inch caution tape.

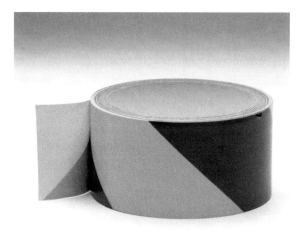

Figure 2.22 Caution tape can be used to cordon off an area or to cover an extension cord on the floor.
Copyright © Steve Weinrebe

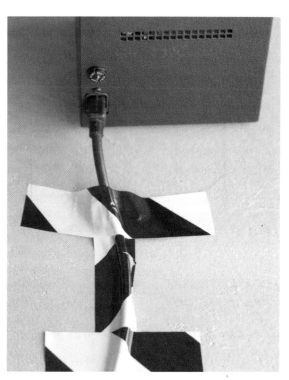

Figure 2.23 Tape down your electrical cords to protect both people and your equipment.
Copyright © Steve Weinrebe

Folded Foam Core

One of the photo studios I wrote about at the beginning of the book was in a loft in an industrial building. Beneath me was a busy framing shop that did much of the framing and shipping for the area's art galleries. The framing shop used to sell me individual pieces of foam core whenever I needed a fresh piece for a reflector, and one day while purchasing a piece, I was taught a neat trick by the framer I was speaking to.

The trick was this. Score a piece of foam core down the length of the board, but when doing so, cut through only one side of the board. Because foam core has two paper faces with foam in the middle, by cutting through only one paper face, the board is still held intact by the other paper face. Then stand the board up on end, and with the uncut side facing you, bang the side opposite the cut with your fist. Actually you may only need to hit it with your fingers, but either way the board will fold along the cut, held together very well by the uncut side of the board. (See Figures 2.24 and 2.25.)

Figure 2.24 Foam board can be cut along one side, making it easy to fold. Here the fold is used to help stand the reflector up, to fill in shadows for a still-life of colored chalk.

Copyright © Steve Weinrebe

Figure 2.25 Carry folded foam-core pieces on location for lightweight and inexpensive reflectors, to bounce sunlight into shadows. A foam board reflector bounced daylight into this outdoor still-life of chalk, lifting up the shadow detail in the photograph.

Copyright © Steve Weinrebe, Getty Images

Cutting foam core this way gives you a lightweight, dirt cheap, and sturdy lighting reflector. You can even score the board a few times for an accordion fold or other types of folds, but just being able to fold a larger sheet in half makes foam core a size that can fit into the lid of a large gear case, or into a suitcase or a car seat. If the board gets dirty or yellowed, replace it with a new piece.

I generally buy foam core in 32-inch by 40-inch boards. That's an excellent all-purpose size for studio reflectors—unless you need larger, 8-foot boards for full-figure people photography. For location shooting, though, I cut the 32-inch boards for folding as described, or into smaller pieces. Even the smaller pieces can be taped back together along one side for a similar one-sided fold like I described. Because the board is rigid, you can bend it and stand it up on end. It will support itself as long as it isn't too windy. Once unfolded, the sheet can be clamped to a light stand for a reflector. (See Figure 2.26.)

Figure 2.26
Tape the foam core on the side opposite the cut to reinforce the hinge. The sheet of foam core can be opened on location and clamped to a stand for a reflector.
*Copyright ©
Steve Weinrebe*

Tip

For location shooting, consider packing some folded boards inside the lids of your gear cases. If any of your cases have removable foam in the lid, pull out the foam and lay some foam core, sheets of color light gels, foil, diffusion material, and anything else that you can get away with fitting in there.

Aluminum Foil

The other day I opened up one of my hoop disk reflectors for a photo shoot and a quantity of silver paint shot into the air and down my lungs—yuck. It was clearly time for that old reflector to go into the circular file. I grabbed a roll of aluminum foil and pulled out a few sheets, taped it to some foam core, and went about my work. (See Figure 2.27.)

Aluminum foil makes excellent silver reflector material for a host of reasons. It's highly reflective, yet very heatproof. Aluminum foil has a shiny side and a duller side, so you can choose the quality of reflectance that you want. I like the duller side of the foil.

Typically, if aluminum foil is simply smoothed out and taped to a surface such as foam core to be used as a reflector, the foil is just too shiny and you'll risk getting a hot spot in your image. Let's think about what reflectors are; they reflect the light based upon how mirrored or soft the surface is. If you use a plain white reflector such as a sheet of foam core, the bounced light is very soft. (See Figure 2.25.)

But let's go the other direction. Since we're talking about location tools, very often you want to bounce light from a distance and in that case a reflector that has a more reflective surface may suit you better. Aluminum foil has a very reflective surface, but you may not want to bounce so much light into your subject that you wash out the shadows. A way to control that reflectance is to crumple up the aluminum foil and then unfold and flatten it. By crinkling the foil first, the reflected light becomes more scattered. You'll want fine crinkles throughout or the foil will reflect stripes of light where any broad crinkles are. (See Figure 2.28.)

Figure 2.27 Aluminum foil makes great reflector material and can be manipulated for different reflectance qualities.
Copyright © Steve Weinrebe

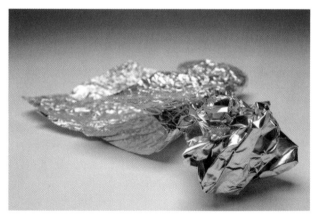

Figure 2.28 Crinkle aluminum foil so that its reflectance diffuses for a less intense bounce of light. The duller side of the foil will slightly soften the intensity when using the foil as a reflector.
Copyright © Steve Weinrebe

Once you've crinkled and flattened the foil, tape it to some foam core. Aluminum foil tapes very easily, but be gentle because the foil will rip easily as well, especially when it's been crinkled. If you have trouble working with the foil without its ripping, or if you'll be in a very windy environment, consider using a heavy-duty oven foil that's been milled to a greater thickness. (See Figures 2.29 and 2.30.)

Figure 2.29
Tape the foil to a reflector and bounce the light toward your subject as needed.
Copyright © Steve Weinrebe

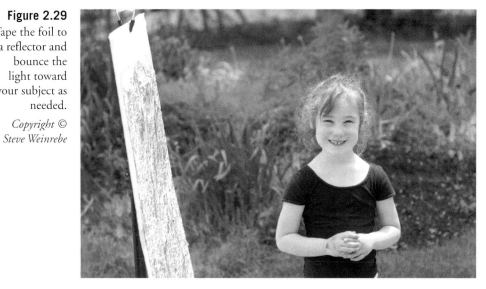

Figure 2.30
The photo on the left has more fill light in the shadows from the aluminum foil reflector. The photo on the right has a softer, less high-key fill light from white foam core.
Copyright © Steve Weinrebe

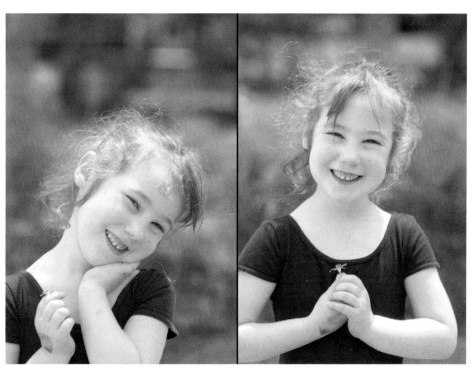

Use the foil taped to a surface such as foam core to bounce light toward your subject. Try moving the reflector around because you'll get a better idea of all your options for filling in the shadows if you see how different positions, distances, and angles change the quality of the reflected light. (See Figure 2.30.)

Tip

Be aware of the color of whatever reflector you use, because that is the color of the light that will bounce into your subject. If you want to bounce a color, you can go to a crafts store and purchase colored foil, but more likely you want to bounce light into the shadows that's the same color temperature as the light that is illuminating the overall scene. Old pieces of foam core can get a yellow tinge to them that will bounce yellowish light into your subject. Be careful of cloth reflectors as well, because, unless you plan to produce black-and-white photographs, cloth such as white sheets often has a bluish or cool cast it, which will also affect the color of the reflected light.

Tip

If you own any soft boxes or umbrellas to diffuse your light, you may have some that are new, and some that are older. The older soft boxes or umbrellas may have become weathered and even gotten yellowish from age. Don't throw them out! I use older soft boxes or umbrellas when I specifically want a warm quality to the light. Usually for portraits I'll use the older soft boxes and umbrellas because that aged tint mellows the light temperature to the warm side, while I'll use my newer soft boxes or umbrellas for product, still-life, or high-key corporate portraits.

PVC Tube

PVC, or polyvinyl chloride, helped revolutionize the plumbing industry. PVC is lightweight and can be cut and glued together for a water-tight seal. For the photographer, PVC makes for some interesting possibilities. Because PVC tubing is sold in a 4-inch diameter and at 10-foot lengths, the tubing makes an excellent transport container for background paper or rolled canvas backdrops. You can even purchase snap-on end caps, called *plugs*. (See Figure 2.31.)

The PVC tubing can be cut with a PVC saw, also available at hardware stores. For a very clean cut, use a power miter saw with a masonry blade. If you aren't bringing a 107-inch roll of background paper (generally called a 9-foot roll, although 107 inches works out to a shade less than 9 feet) on location, but instead are using a 53-inch (4.4-foot) roll, simply cut a 10-foot length of the PVC tubing in half. The two 5-foot lengths you'll

end up with give you sturdy and water-resistant containers for a couple of 53-inch rolls of background paper.

Fifty-three-inch rolls of background paper are generally plenty large enough for the background in simple head-and-shoulder portraits, especially if you're using a telephoto portrait lens such as an 85mm or 105mm lens (or zoom equivalent). But if you're going on location to photograph a full-figure or near full-figure portrait, or a small-group portrait, you'll need a 9-foot roll of background paper. Generally, you want to place the paper far enough behind the subject that your lights don't cast a shadow on the background and any ripples in the background go soft, or out of focus. You may even want to throw a light on the background for a backlight vignette, or for a high-key background look against white paper, again needing wider paper so you can create some distance between your subject and the background. You especially don't want to have the background's edge peeking into your frame, although unwanted edges can be fixed with digital post-processing.

Tip

If you're dealing with a really large location set for which you need a paper background, stand a 9-foot roll of paper up against a wall with the base of it about 6 to 8 inches away from the wall. It'll help if you have an extra pair of hands for the next part. Roll the paper vertically along the wall as far over as you need it, cut it, tape it to the wall, and then tuck in the loose part at the bottom. That'll give you a little sweep, or curl, at the base of the paper along the floor line. If you need a full sweep for a full-figure image, roll another length of paper along the floor and tape it to the first piece. You can retouch seams out of the image in digital post-production.

Use cable ties to attach the PVC tube to your car's roof rack as a temporary or permanent container for carrying 9-foot rolls of paper on location. If you don't have a roof rack, you might be able to rent one. If the PVC tube extends beyond the back of your car, be sure to tie a red ribbon onto the end for safety. (See Figure 2.32.)

Figure 2.32
I used cable ties to secure a PVC tube to the roof rack of my car. Use end plugs to secure the roll of paper during transport to keep the paper background clean and dry.

Copyright ©
Steve Weinrebe

Chalk

I was at a rock-and-roll concert the other night (yes, I still indulge) and was amused to see that the rows for seating were marked on the floor with chalk. By the end of the night, the chalk numbers were nowhere to be seen. That's the nature of chalk—it's relatively harmless, writes on most textured surfaces, and is easily removed. (See Figure 2.33.)

Figure 2.33
Chalk can be used as an all-purpose, and removable, marker when on location.

Copyright ©
Steve Weinrebe

When shooting outdoors, I use chalk to mark spots on cement or pavement for light stands or tripods. More than once I've photographed a storefront or restaurant exterior where I needed to shoot from the street for the best angle of view. Unless I was able to have the street cordoned off (which for still photo shoots is just about never), I would have to run up to the sidewalk with the tripod when a car would come. Understandably, when I got the angle down and framing right for the photograph, I would mark the street with chalk just in front of each tripod leg. That way I could return to the spot and place the tripod down exactly where I had it before the car came along.

There's an old saying: "Give someone a hammer, and suddenly a lot of things will look like they need nailing." A variation on that would be, "Give someone a piece of chalk, and a lot of things will look like they need to be marked." I stash a box of chalk in one of my location bags or, if I'm traveling light, put a stick of chalk in a small plastic bag just in case I need it. Sidewalk chalk would sound like a good choice, but for marking tripod and light stand positions, you can't get close enough to the legs with the chubby sticks of chalk that children use, and the standard school-room variety works best. (See Figure 2.34.)

Chalk can also be used on location to help you, or your assistants, spread out your lighting setup. If you're doing a sunrise shoot and you need to set up a tripod and a couple of fill lights, for example, sketch out the setup on the ground for positioning of the lights, and even the lighting ratios, and you or your assistant have a template for the morning's setup.

Figure 2.34
Bring some chalk on location to mark out tripods and light stands. Here, a tripod's position is temporarily mapped out on the pavement with chalk markings.

*Copyright ©
Steve Weinrebe*

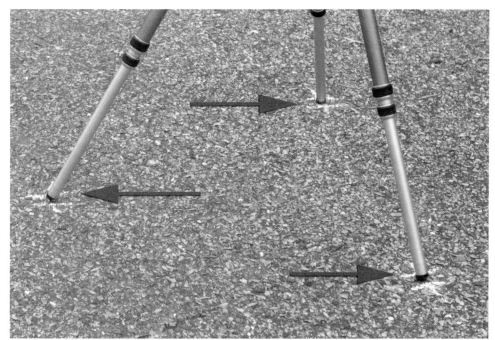

Tip

If you're going to be photographing outdoors on location, on a surface that can't be easily written on, you have a few options to mark spots for your tripod or light stands besides just throwing rolls of gaffer's tape on the ground for markers. You can buy powdered chalk in a squeeze dispenser from your local hardware store. Generally used for string markers, powdered chalk comes in a variety of colors including orange, red, blue, and black, so pick whatever color will contrast well with your work surface. If you're shooting on grass, try orange garden stakes. You can use orange, yellow, or white spray paint on grass if you're just marking out where to place your equipment, but you don't want to spray the paint close to the legs of your tripod or stands. The garden stakes can be placed to hug the ground right at the tips of your stands, and can be used in sand as well. (See Figure 2.35.)

Figure 2.35 When shooting outdoors on a soft surface, use chalk powder or garden stakes to mark your tripod position, in case you have to move as I did when a horse in this photo came over to smell my camera bag.
Copyright © Steve Weinrebe, Getty Images

Black Flags

When a light source is visible from your lens, you're at risk of getting *flare* in your image, which is a bright patch of unwanted highlights, sometimes in the shape of your lens aperture. The sun is a good example of a light source that typically causes flare in a photograph. Sometimes flare, also known as lens flare, is desirable and there are some digital solutions to adding flare to images that didn't have it in the first place. But usually you don't want the flare that is coming into your frame because it is distracting in an image and reduces contrast in whatever portion of the image the flare is covering. In fact, sometimes lens flare covers a broad portion of an image, isn't initially obvious in a preview, and intrudes on an area of your photograph that's much too large to retouch.

One obvious way to get rid of flare is to frame your subject so that any dominant light source is out of the camera's field of view. Another typical way to shield the lens from stray light sources is with the use of a lens shade. And yet another way is to use what's referred to as a *flag*, or sometimes called a *gobo*, a flat black piece of material placed in the path from the light source to the lens. (See Figure 2.36.)

Now there's nothing terribly irreverent about using a flag when lighting a photograph, but I have a suggestion for a flag that will be a throwback for many photographers. If you ever used a 4×5 view camera back in the day when film dominated photography, you probably used 4×5 film holders. Film holders have a dark slide on either side that the photographer pulls out to reveal the film to the shutter before exposure. Those dark

Figure 2.36

Use any rigid black material to flag the light from your lens. Black matte board and dark slides work well.

Copyright © Steve Weinrebe

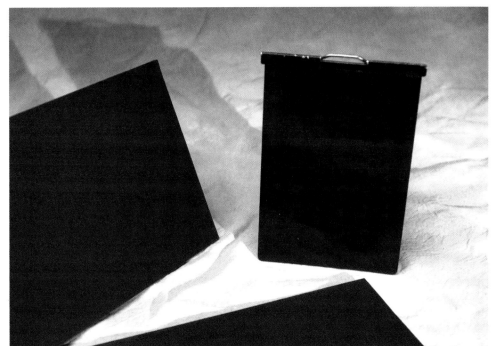

slides make great flags. If you don't have any old film holders collecting dust, you can easily buy 4×5 film holders from an online auction or for-sale website.

After you set up your lights for location or studio shooting, and after you position your camera, peek into the front side of your lens. If you can see a highlight from one of your light sources, you're at risk of lens flare. That highlight in your lens is what you want to block with a flag. Technically, you can use anything to block unwanted light from hitting your lens. I have stood, or had an assistant stand, to block a light and prevent unwanted flare during an exposure. You can even use your hand. I like dark slides from large format (like 4×5) film holders because they are thin and lightweight, are rigid, are a good size for still photography, and easily clamp to a light stand. (See Figure 2.37.)

You can hold dark slides easily since they have grips on one end. As I mentioned, what you want to get rid of is that reflection in your lens, because if you can see the reflection of a light in your lens, that means your lens can see the light as well, and if you don't see the reflection in your lens, it's blocked from your lens.

One way to be certain your flag is in the correct position is to look into the lens until the unwanted light source is no longer reflected. Sometimes you'll need to wave the flag back and forth to see if the reflection disappears. Look through the viewfinder, or at a live preview, while you're doing this because you want to make sure you're blocking the light but don't have the flag in your frame.

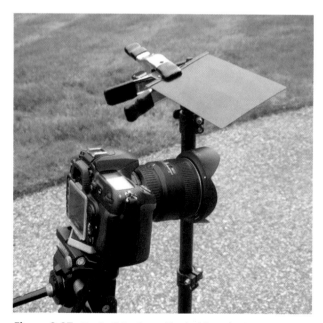

Figure 2.37 Dark slides from film holders can be clamped to a light stand and moved into position to block light from your lens. Here I used two A-clamps to hold the flag to a light stand.
Copyright © Steve Weinrebe

Tip

Wide-angle lenses are the most difficult lenses to flag light coming from unwanted light sources. Because of the wide field of view these lenses have, the lens shades are necessarily small so that they aren't visible in the frame. The wide field of view makes it harder to both crop light sources out of the frame, and to flag light sources from hitting the lens. Sometimes you have to make a tradeoff between the position of the light and the position of the lens. If you can't position a flag in the right spot close to the lens, to block the sun from hitting the lens, try a slightly different angle on your subject. A slight shift in camera position might be enough to get the light source out of view of your lens.

The other method to position the flag is to watch for the shadow of the flag as it prevents the light from hitting the lens. This latter method is especially easy when the sun is the offending light source. You can even wave your hand above the lens to find the best spot to shade the lens before positioning the flag.

> **Tip**
>
> If the sun is the light source you're trying to block, sometimes all you need to do is wait until a small cloud covers, or flags, the sun. That small cloud might reduce the intensity of the sun just enough to prevent lens flare while still allowing for plenty of light for your exposure.

Black Foil

I've mentioned aluminum foil, and I've mentioned black flags. Put the two in a camera case and shake, and what do you get? Black aluminum foil, of course. I've carried a roll of black foil in one of my location cases for as long as I can remember. Black foil isn't something most still photographers are going to run into because this material is usually found in the video category of online photo retailers. Don't let that deter you though. Get a roll and keep it in your location kit. (See Figure 2.38.)

Rosco and LEE are two manufacturers of black foil. LEE's is called Black Foil, and Rosco makes a brand of black foil called Cinefoil. (See Figure 2.39.) You'll find these brands from many online camera stores. Whether you'll find black foil on a store shelf near you depends on your location, but if there is a professional camera store or

Figure 2.38 Black foil is a sturdy, matte black, malleable material that should be an essential addition to any photographer's location kit.

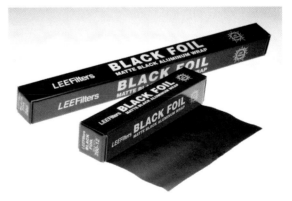

Figure 2.39 LEE is one manufacturer of black foil. The foil comes in two widths, 12-inch and 24-inch, sold in rolls.

Copyright © LEE Filters USA

film/video supply house near you, it's worth a call. Both Rosco and LEE sell black foil in 12-inch and 24-inch widths, in rolls. The rolls come in dispenser boxes with a saw-tooth edge for tearing.

Black foil may be a photographer's most chameleonic tool—that is, a tool that can be molded and adapted to a tremendous number of uses. One use would be for a black flag, although I still prefer a dark slide for its strength and small form factor. As a large flag (or gobo) though, to control light coming from a light source, black foil works great. For example, you can use tape to attach the foil to the side of a light bank. (See Figure 1.32 back in Chapter 1.)

One endearing quality of black foil is that it is very heat proof. Besides as a flag to control unwanted light from hitting your lens or your photo set, uses for black foil include barn doors, or as a snoot. Barn doors act like flags, tied to a light head, to control the direction of the light. A *snoot* is a poor-man's spotlight, simply a cone attached to a light directing the light into a small pool of illumination. (See Figures 2.40 and 2.41.)

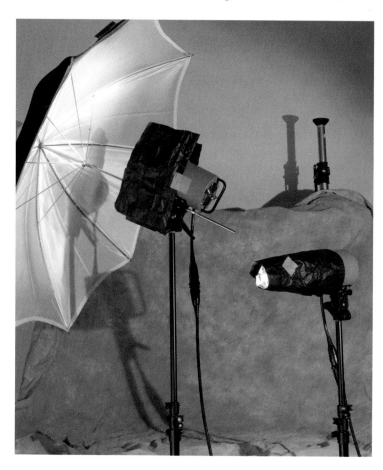

Figure 2.40
Control the direction and spread of light by attaching sheets of black foil to one or two sides of a light to create barn doors, or use a cone of black foil as a snoot.

*Copyright ©
Steve Weinrebe*

Figure 2.41
A pool of light created by a black foil snoot illuminates these small props. The black foil packs easily for location, and can make a faux spotlight.
Copyright ©
Steve Weinrebe

You can also use black foil as a "cookie" or cucoloris. A *cookie* is a tool to create mottled light, such as light spilling through tree branches and leaves, by shining a light source through a sheet with random-sized and -shaped holes cut out. For a cookie you'll likely want the larger 24-inch-size roll of black foil. Position your light far enough back from the cookie to create a spotlight effect. If there is too much light spilling around the cookie, you can use more black foil as barn doors to constrain the light to the area of the cookie. (See Figures 2.42 and 2.43.)

Figure 2.42
Use black foil to create a dappled sunlight look with a cookie.
Copyright ©
Steve Weinrebe

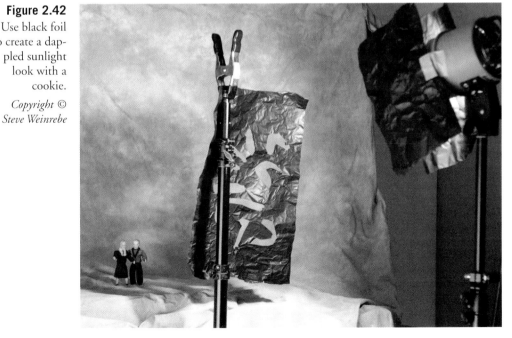

Figure 2.43
The dappled light in this photo was created with a light source shining through black foil with cutouts, also known as a *cookie.*

Copyright © Steve Weinrebe

3

Irreverent Travel Tools

Unlike studio or location photography, travel photography usually means carrying less and enjoying more. Just the word *travel* evokes a sense of newness and adventure that is unlike most photography projects. You may be traveling to take pictures, traveling for work, or traveling "just to see." In all instances, fascinating and often beautiful images will present themselves to your camera, waiting to be captured. You only need the eye, the right equipment, and the willingness to press the shutter button. (See Figure 3.1.)

You may be flying to another continent, or bicycling outside your city or town, but either way you'll want to travel light, and still have everything you need when you arrive at your destination. Travel photography often becomes very integrated into the entire daily experience of traveling. Your luggage may be a hodgepodge of cameras and socks, lenses and toiletries. If you're traveling to another country, you may need socket adapters and chargers for anything electrical. Some of the storage tools in Chapter 2 on location photography might help you with carrying small items when traveling.

Needs for travel photography are going to vary somewhat depending on your destination. Traveling to a Caribbean island, or to a wilderness or wildlife sanctuary, offers different photography opportunities than traveling to a city. You may be doing all three, as is often the case. Before a trip, there is always a frenzy of organization: setting the voicemail message and email notices, making sure bills are paid and friends and relatives are notified. I suggest you assemble an assortment of tools that will serve you well on most trips. Then, when a destination has specific issues that might make photography challenging, add to your equipment whichever tools will help you on that particular trip. The less you have to remember, the better so that if you grab your camera bag and look through the pockets while on the plane, you'll have everything with you that you wanted to bring.

Figure 3.1
The Taj Mahal photographed when traveling in India. Some digital post-production in Photoshop took care of the reflecting pool, which, at the time of the photograph, wasn't reflecting anything.

Copyright © Steve Weinrebe, Getty Images

My best advice from all my experience producing travel photography, whether for myself or for clients, is to travel light. Spend some time learning how to pack well. Have things you may need to grab quickly packed in a place you can get to quickly.

These days, with luggage weight and count restrictions, travelers are often forced to make choices of what to bring and what to leave. Photographers are pressed to decide whether to bring those wonderful prime lenses or to bring a zoom lens instead. You may start thinking you'll only be shooting wide-angle shots, and so can leave the gargantuan 500mm lens home, easing your burden. These are tough choices, compounded by the ever-present risk of theft or loss when traveling. You want to bring your best equipment, but if you're robbed, or your neck strap breaks while leaning over a waterfall, do you want to lose the camera with the two-hundred-dollar lens or the two-thousand-dollar lens? And do you need the two-thousand-dollar lens if your pictures are getting posted on a photo-sharing website, and not printed as wall-sized murals? Again, these are tough choices.

Before your leave for your travels, you'll make these decisions of what to bring and how to pack. Unless you're shopping for camera equipment or luggage while on your trip, you'll live with your decisions and learn to work with what you've got. Besides being resourceful, as mentioned with location photography, being adaptable is equally important when doing travel photography.

Spanner Wrench

A spanner wrench is used to screw, or unscrew, threaded ring fasteners. With photography gear those fasteners are usually the rings that hold glass between something—filters, lenses, and so forth. First off, I'll get the lens disclaimer out of the way and suggest that if you have a problem with your lens that requires the lens to be disassembled, consider having the repair done by a professional. That said, let's talk about what you can do with a spanner wrench. (See Figure 3.2.)

Spanner wrenches come in several shapes and sizes, but for photography you need a flat, or slotted, tip wrench that will span at least the diameter of your filters. Take a look at your photo filters, the ones that screw onto the front of your lens, and you'll see that the glass, or plastic, is held into the outer ring by a slender internal ring, most likely with a slot on either side. You can use a spanner wrench to unscrew this internal ring that locks the glass into the filter. (See Figure 3.3.)

If you need a spanner wrench, it's generally because of an emergency such as a bent filter housing. If you drop your camera—which I hope you never do—you might be lucky enough to have your protective filter absorb the impact. Some camera lenses get damaged while you're walking with a camera slung around your shoulder. If you turn around suddenly without noticing that lamppost next to you, the camera's impact point is generally the area around the tip of the lens. Once the filter housing is bent, you can no

Figure 3.2 A spanner wrench can unscrew the rings spanning filters or certain pieces of photo equipment. *Copyright © Steve Weinrebe*

Figure 3.3 Size the spanner wrench to the ring of the filter or photo accessory you want to disassemble, and rotate counterclockwise. *Copyright © Steve Weinrebe*

longer screw on a lens shade or securely attach a lens cap. In this case you'll need a spanner wrench to unscrew the fastener ring and take out the filter. Then you can use pliers to gently torque the outer filter ring off the lens by pushing the pliers in a way that rotates the filter counterclockwise off the lens. Once removed, you can use the spanner wrench to reset your filter into another filter's housing.

Some filters have two glass or plastic elements sandwiched together in the filter housing. A polarizer filter is one example of this, but I have an infrared filter that also has two elements. If moisture or dust gets trapped in between the two elements, you'll need a spanner wrench to take the filter apart by unscrewing the fastener ring. (See Figure 3.4.)

Spanner wrenches can also be used to take lenses apart, but as I mentioned, that chore is only for the professional. If you have moisture or dust in your lens, you'd best get your camera to the nearest authorized repair center, where they will use spanner wrenches as well but be able to put back together what they've taken apart.

That said, if you are using some more traditional camera equipment, such as a digital view camera back, or if you're using a hybrid workflow, you might very well need a spanner wrench to attach lenses to lens boards, or have very old manual lenses that are made to be taken apart by the photographer to dust off the glass or blow air on the shutter. For these reasons, if you're traveling with a view camera for landscape or nature photography, you'll want to pack a spanner wrench in your bag as well.

Figure 3.4 Photography filters are held together by fastener rings. Unscrew the ring with a spanner wrench to separate the filter from the housing.
Copyright © Steve Weinrebe

True Story

Some years ago when I was traveling in Nepal, I discovered that the bottom of one of my cameras was cracked right around the tripod mounting threads. I needed to tighten a part surrounding the mounting threads, but the part was a fastener ring that required a spanner wrench. I didn't have one at the time, and was sitting in a café with my poor broken camera in my hands trying to figure out what to do. There was a fork on the table in front of me and it was just about the width of the fastener ring, but the center tines of the fork got in the way. For a good cause I broke the center tines of the fork, after much bending back and forth, and used the outer tines as a spanner wrench to successfully repair the camera. I haven't traveled without a spanner wrench since then. (See Figure 3.5.)

Figure 3.5
A spanner wrench made from a fork helped repair the camera that captured this photograph.
Copyright © Steve Weinrebe, Getty Images

Rubber Gripper

Rubber grippers, or jar openers, are designed to help people open the lids of jars. Their nonslip material makes these tools perfect for removing filters or threaded lens shades that are screwed on to a lens too tightly. Sometimes the shade or filter might be difficult to remove if it has expanded from heat at a different rate than what it's attached to. Worse case, you may have a grain of sand or bit of dirt in the screw threads that has jammed the filter or shade onto your lens. Pack a rubber gripper in your camera bag so that you can use it readily. Like many of the tools in this section, a rubber gripper is small and lightweight, and can help you work quickly and effortlessly. (See Figure 3.6.)

If you have a tripod on your trip, you may have a problem loosening the legs to extend them. My own French-made tripods are wonderful to use, but if I overtighten one of the sections, the tripod binds horribly. It takes all the force I can twist with to loosen the knurled retaining ring around the tripod leg. That's hard work for a bare human hand. Place a rubber gripper in your hand, though, and your hand turns into a super-tool to grab and loosen stuck parts like tripod extensions. (See Figure 3.7.)

Figure 3.6 Jar openers made out of rubber can be very helpful when you have a filter or threaded lens shade that is screwed on too tight.
Copyright © 2009 Steve Weinrebe

Figure 3.7 Use a rubber gripper to loosen tripod extensions that are screwed down too tightly.
Copyright © Steve Weinrebe

Tip

I mentioned rubber carpet padding earlier in the book as a way to prevent objects from sliding around. A rubber gripper can work well for the same use as long as what you want to stabilize is small enough. If you are changing lenses or need to put down your cell phone or glasses for a moment while you dig around in your camera bag, put the item on a rubber gripper so that it won't slip off the ledge or table.

Power Inverter

I once heard a photographer talk about his experiences photographing a swimsuit pictorial for a national sports magazine, and he emphasized the usefulness of the portable generators he brought with him. A portable generator sounds like a great idea until you have to listen to one chug away incessantly and at a high decibel level. But if you are traveling with a car, you already have a portable generator, and all you need are the right tools to draw power from it. The most obvious tools, some of which you likely already own, are DC-to-AC adapters for cigarette lighter sockets to charge or power your phone, GPS, laptop, and so forth. But you can get better results and more flexibility by plugging a power, or line, inverter into the lighter socket, or directly to your car's battery when stopped. (See Figure 3.8.)

Figure 3.8

Use a power inverter attached to your car's battery to power a battery charger or other device.

Copyright © Steve Weinrebe

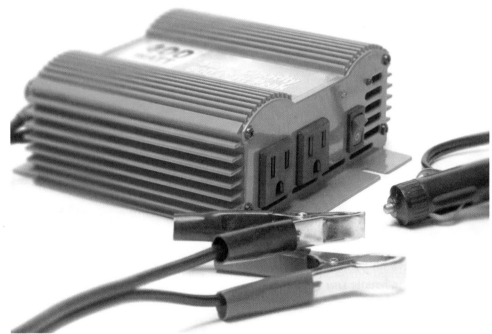

The power inverter converts DC (the direct current coming from cigarette lighter sockets), to AC, the alternating current that household outlets provide, and has standard three-prong sockets. You don't have to worry about not having a cigarette lighter plug for your camera's battery charger; the power inverter will take care of the problem and power your laptop at the same time.

If you're traveling en route to your destination, or out and about on your trip, you can use a power inverter to charge your camera batteries. But it's usually when you're stopped and shooting that great sunset scene that you need to recharge batteries, or you want to view your images on a larger screen. If you're shooting for large prints, and like packing heavy, you might even have a 22-inch screen to preview images on. If you're really ambitious, and a location photographer at heart, you might want to add a larger light to your scene other than a small portable flash. In those cases you'll be well served to pop open your car's hood and use the converter's optional battery hookups that came in the package. Follow the directions that come with your inverter to attach it to your car's battery and you'll be able to power more than just a battery charger. How much you can power depends on your line inverter's power rating, but likely enough to power a flash, a laptop, and a battery charger. (See Figure 3.9.)

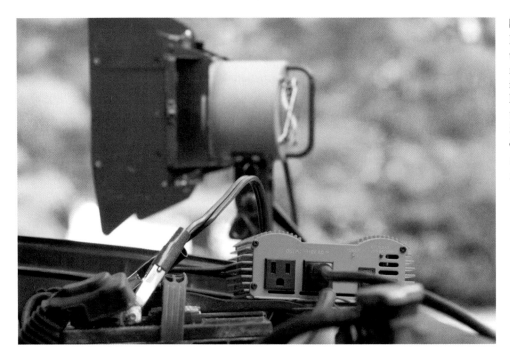

Figure 3.9

For photo tools that draw too much power for cigarette lighter adapter use, attach the inverter to your car's battery.

*Copyright ©
Steve Weinrebe*

True Story

If you need to power a light on location or while traveling, consider this: a flash will attract fewer insects, but more attention than a continuous light source. Once I was photographing in remote hills of Jamaica when I was invited to a local discotheque. The dance hall was packed and very dark, but the band was superb. There was not enough light to take an available-light photo, even with a very high ISO. But I was inspired and wanted to capture the scene, so I placed a flash unit on my camera and snapped one shot—and was nearly trampled. As it turns out, it is very bad policy to take a flash photograph in remote areas of certain countries. Some people just don't want to be seen in pictures and the subjects might assume the photographer is gathering information, not making art, a consideration that has served me well in many photo journeys since. Luckily my guide explained I was all right and the dance party went on without further incident, or picture taking.

Zippered Plastic Bags

If you've roughed it while traveling, you probably wondered when I was going to get to plastic bags. Long a staple for travelers, zippered plastic bags can be used for all sorts of packing: keeping wet things from getting other things wet, and keeping dry things dry. Let's talk about both attributes because zippered plastic bags have many beneficial uses as a photo tool. (See Figure 3.10.)

I described some handy storage containers in Chapter 2, "Irreverent Location Tools," but other than a film can, those containers are not designed to hold out moisture. Zippered plastic bags do hold out moisture, and they are inexpensive and work great. You likely have some sitting somewhere in your kitchen, and next time you're going on a trip, stuff a handful in your camera bag. Good sizes to carry are the quart size and the gallon size. The freezer bags are sturdier than the sandwich variety.

Condensation can be a major problem for cameras when traveling. When you carry your camera out of an air-conditioned hotel into a steamy tropical street, you risk serious condensation on your camera and lens. Wiping your lens dry may do little good until the lens warms up. The colder glass, metal, and plastic create a dew point around which water droplets form and the camera needs to come up to the temperature of the new environment. Even then, if you are in a humid environment, any moisture on the camera will need to be wiped off. Because digital cameras are loaded with electronics, photographers need to be especially careful not to let their cameras get too damp from condensation.

Figure 3.10 Zippered plastic bags are very useful photo tools for keeping things dry, or keeping wet things wet without dampening anything else.
Copyright © Steve Weinrebe

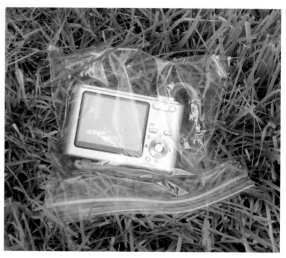

Figure 3.11 To prevent condensation, place your cameras into zippered plastic bags before taking them outside into warm humid air.
Copyright © Steve Weinrebe

Tip

The dilemma of condensation applies to memory cards as well. If you run back to your hotel room to get an extra flash memory card and bring it outside, be certain it's dry as a bone with no condensation before you open your camera's memory compartment and swap cards. You don't want the gold-plated contacts on the card to be inserted into the camera when damp.

Solving this condensation problem may be your best use of zippered plastic bags. Place your camera and any lenses into zippered plastic bags before leaving your hotel, airplane, restaurant, or anywhere your camera may have acclimated to a cooler temperature. Before you start taking pictures, let your photo gear warm up to the warmer outside temperature. Then, when you take them out of the bag, you won't have the condensation problem. (See Figures 3.11 and 3.12.)

The flip side of the zippered bag use is to keep wet or damp items from getting other things wet (a common trick for storing wet bathing suits when traveling). Use zippered plastic bags to store damp paper towels for cleaning hands or equipment. You can also dampen paper towels with a glass or all-purpose cleaner and lock them tightly in a zippered plastic bag after squeezing the air out. Ideally you'll have both, and some dry paper towels for drying out your gear after cleanup. Keep the dry paper towels in a plastic bag as well so they remain free of dust and dirt. Now you'll have an informal and somewhat irreverent cleaning kit for your gear made from a few common household items.

Figure 3.12
When travel-ing, devote some time and thought to keeping your photo gear clean and dry.

Copyright ©
Steve Weinrebe,
Getty Images

True Story

When photographing an assignment in Hong Kong one August, I had spent the late afternoon in my hotel. The hotel had windows overlooking Honk Kong harbor and, as evening approached, I saw a beautiful sunset developing behind a dramatic cloud struc-ture. It was a beautiful scene, and I rushed out with my camera bag, pulled out my cam-era, and the lens clouded up with such severe humidity I lost the shot. It took longer for the camera to dry out than it would have for the camera to acclimate to the warmer air outside while in a zippered plastic bag.

Socks

I suppose I couldn't write a book with an irreverent theme without eventually reaching the subject of undergarments, specifically the lowly yet necessary sock. Quite simply, when you are traveling for photography, there are two things you'll always need: pro-tection for your photo gear and protection for your feet. Put the two together and you have an independent traveler's dream of utilitarian packing. (See Figure 3.13.)

I'm referring to clean socks of course, and you can use socks as soft, padded cases for whatever you like. Lenses, portable flash units, small cameras, portable hard drives, and media devices can all be protected easily by slipping them into a sock and then dou-bling the sock back onto itself for extra padding and to hold the item in.

Figure 3.13 Even if you're traveling to a warm climate and wearing sandals, you'll likely pack a few pair of socks, which you can use to protect photo gear.
Copyright © Steve Weinrebe, Getty Images

Figure 3.14 Protect lenses and other sensitive equipment in socks when traveling.
Copyright © Steve Weinrebe

If you loathe checking baggage on airplanes (I do), you'll want to maximize the use of your allotted carry-on baggage. You can do this by rolling fragile and expensive items into anything soft that you're carrying with you. Socks are the perfect storage for travel, because they are shaped like a pouch and designed to be soft. The best socks for photo gear are athletic socks, which by nature have good padding. If you're concerned about lint from the sock's material getting onto your equipment, you can put the lens or camera in a zippered plastic bag first. (See Figure 3.14.)

Tip

Airplanes vibrate in a steady and incessant way that can harm anything that is put together with screws and other fasteners. There have been professional cameras that were known for failing this way. You may be tempted, for safety reasons, to put your camera bag at your feet in the pocket under the seat in front of you. Unfortunately, the floor of an airplane has the greatest amount of vibration in the cabin of the aircraft, and a camera bag may not provide enough cushion. It's better to keep your camera bag in the overhead compartment or, if that's not practical, in your lap or an empty seat next to you.

Personal Organizer

If you don't want to use cloths to help pack and protect photo gear on your travels, then you can use a spare toiletries kit. Maybe you bought a new one for your trip, or you have an extra lying around. Like camera bags, toiletries kits have several compartments and zippered sections, and are somewhat water-resistant. One of the best of the breed that I'm personally partial to is the L.L.Bean Personal Organizer. (See Figure 3.15.)

This organizer, or one like it, will help photographers travel with all the photo tools and sundry items that you don't want to keep in your camera bag. Battery chargers, memory card readers, extra power cords, power adapters, USB and Firewire cables, Ethernet or phone modem wires, large bulb blower, cleaning supplies, specialty cameras, and lenses—all can be stored in an organizer for quick and efficient retrieval. Storing in a compact way is also key, and this particular organizer's ability to hold an amazing array of items and yet fold up into a compact shape is truly exceptional. (See Figure 3.16.)

Figure 3.15 The L.L.Bean Personal Organizer comes in a variety of sizes and colors, and has many zippered compartments and sections for storing photo gear.
Copyright © Steve Weinrebe

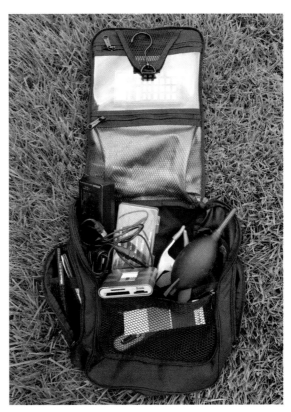

Figure 3.16 This L.L.Bean organizer can hold lots of extraneous photo accessories ready for easy retrieval.
Copyright © Steve Weinrebe

Before I found this organizer I used a less-well-designed organizer that was a promotional giveaway. Even that organizer spent years in my camera bags and travel bags and did exceptional service holding sundry items. This freebie organizer is still in service for me, holding a portable printer, paper, and cords. Hold on to organizers like this, whether you purchased them or found them as throwaway items in a yard sale. (See Figure 3.17.)

Army & Navy Store

Before a major trip, I always like to make a pilgrimage to an Army & Navy store. Before some chain-store entities and Internet shopping websites took over the look and feel of traditional Army & Navy stores, these stores were retail staples in most U.S. cities. Frequented not only by armed forces personnel, these stores are also popular with college students and young people. Customers seek military surplus clothing and accessories, camping and hiking gear, and good-quality clothing at a great price. (See Figure 3.18.)

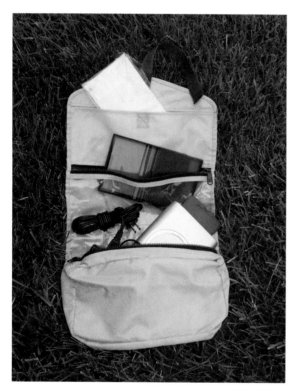

Figure 3.17 Any old toiletry organizer can be useful for packing photo gear when traveling. This organizer, with different sized compartments, was a free giveaway and easily holds a mini-printer.

Copyright © Steve Weinrebe

Figure 3.18 Army & Navy stores, like the great I.Goldberg Army & Navy in Philadelphia, are usually centrally located in cities or on major thoroughfares. Browse one of these stores for useful items before you travel.

Copyright © Steve Weinrebe

Army & Navy stores are a terrific source for irreverent photo tools. Go to one to find ugly bags (see Chapter 2), vests with pockets, organizers, protective all-weather gear, backpacks, water purification tablets (see Chapter 4)—the list goes on. Shopping an Army & Navy store is often a process of discovery and an education in resourceful travel. Military surplus items are usually well made, durable, and inexpensive.

I have jackets with multiple pockets that I purchased in Army & Navy stores that I use when I need to carry photo gear in precarious spots, like in helicopters or high up in the basket of a cherry picker. I travel with a compass in the side pocket of my camera bag in case my GPS unit runs out of power, binoculars for spotting photo opportunities, compact rain ponchos, and more, all purchased at Army & Navy stores. (See Figures 3.19, 3.20, and 3.21.)

Figure 3.19 The travel section of I.Goldberg Army & Navy in Philadelphia, PA.

Copyright © Steve Weinrebe

Figure 3.20 I.Goldberg Army & Navy's check-out counter is loaded with small and innovative items like a tiny hand-crank flashlight.

Copyright © Steve Weinrebe

Tip

This tip for carrying a tripod comes courtesy of one of the salespeople at I.Goldberg Army & Navy, a photo enthusiast. Look for a backpack with two sets of buckling straps on the side, one high and one low. Buckle each set of straps into a loop. Slip one leg of the tripod over the outside of the top strap to secure it from falling out, with the other two legs inside the loop of the top strap. Then wrap a loop around all three legs with the bottom strap.

Figure 3.21
While photo-
graphing this
scene from a
helicopter, I
wore a military
surplus jacket
with multiple
pockets to help
keep photogra-
phy gear close
and accessible.

*Copyright ©
Steve Weinrebe,
Getty Images*

Journal

Do keep a journal. Everyone thinks it might be a nice idea, but too few people do it. I'm not referring to a text-sharing website where you might keep friends up to date, and a journal isn't going to be replaced by metadata (information captured in the picture file like date and camera type) either. A journal can provide essential reference infor-mation for your travel photography when you return home. (See Figure 3.22.)

When you travel, your photography provides both art and a visual record of your sub-ject matter. You can even enhance that record by snapping some extra images of the sur-roundings of wherever you're taking pictures—street signs or building numbers for example. And while a picture is worth a thousand words, those words are indispensable.

Travel journals should be small enough to carry at all times and in convenient spots like the back pocket of a camera bag or in your jacket pocket. If you're using a paper jour-nal, keep a pen attached to it or the journal is useless. If you have a portable electronic device that you can enter reams of text into, you don't need a pen, but you will need batteries or a charger with you.

The nice thing about paper and pen when traveling is you'll always be able to take the notes, no power involved, and you won't have to resort to scribbling on a napkin to tran-scribe onto a laptop or texting device later. The journal becomes a single repository of

Figure 3.22 Use a journal to write down important information about your photos that you'll want to reference when you return.
Copyright © Steve Weinrebe

a tremendous amount of useful and incidental information. Use the journal to write down foreign-language words and phrases that you'll need in your travels, like the name of your hotel in the script of the country that you're in. You can always show it to a cab driver if the driver doesn't understand you—a common problem with foreign travel. (See Figure 3.23.)

Figure 3.23
People you meet can write into your journal as well, writing phrases in their language that you can learn to help you get by in your travel adventure.
Copyright © Steve Weinrebe

If someone helps you during your travel adventure, you can jot down his or her name, and maybe an address to send back a photo that you took back to them. I've always believed that every traveler is an ambassador for his or her country, and if you're traveling within your country, then you're an ambassador for your state, city, or town. In teaching photo workshops, I always stress to students to send back photos of people they take pictures of or shops they were allowed to take photos in. You'll do yourself a service and the next photographer who comes after you. Your journal is a place to put all that information: data that is more than just a name or address, and sometimes information that will make someone else's day better by allowing you to reach back to them with your photographs.

CD and DVD Backups

Let's get retro, not with film, but with a current technology that is quickly being replaced by newer and better methods of data storage—the compact disc or CD. Whether you are photographing for work or pleasure while you are traveling, the possibility of data loss is very real. The data that can get lost is of course your photographs and we don't want that to happen, ever. There are a number of measures you can take to prevent the possibility of losing your images, including backing up to a portable hard drive or USB drive (a.k.a. jump drive, or thumb drive).

Heeding Murphy's Law when traveling is a reasonable precaution to help you think ahead. If it can go wrong, it likely will go wrong, and anyone who has traveled a lot knows what I mean. Lost baggage, theft, water damage, and temperature damage are a few possible causes of losing images. You can probably think of a few more, and ultimately if you are photographing in your travels, your images may be more important to you than your camera should anything happen to it. Cameras can be replaced, but that perfect scene that you photographed where all the visual tumblers fell into place, perhaps the best photograph you've ever taken, might never be able to be reproduced. One simple method to be sure you never lose your work is to back up your images to inert media like a CD, or DVD, and mail the disc or discs home. (See Figure 3.24.)

Sending home a CD or DVD requires that you have or can locate a computer that you can write the disc with. If you don't have a laptop with you, the hotel you are staying at may have a business service in the lobby with a computer that you can use to write the disc. These business lounges are very common and often free to use for paid guests. An Internet café is another option. If you're not using your own laptop, simply back up your work to a USB drive or portable hard drive and bring that to whatever computer you can write the disc on. You can also use a media card reader to copy data from your camera's memory card onto the computer you'll use to write the disc.

One of the cardinal rules of data backup is to store the backup off-site. Whatever method you used to write the disc, once the images are written to it, place the disc into

Figure 3.24
Bring some compact discs and mailing envelopes with you on your trip. Back up your images to the CD and mail the disc home.
Copyright © Steve Weinrebe

a CD mailing sleeve and send it home. If you're photographing in RAW format and you are a prolific shooter, DVD might be your media of choice so that you can fit more data onto a disc. If you have a compressed RAW format as a setting in your camera's menu, use it. Compressed RAW is a *lossless* compression scheme (meaning no data is permanently thrown out and so there will be no visible difference in the quality of the image when processed in a RAW converter).

Why not just mail home a backup memory card? Like a memory card, a CD has no moving parts, but it's not an electronic device. Unlike a memory card, a CD is not susceptible to moisture, magnetic fields, or even to a certain extent a crushing blow. Blank CDs are very inexpensive and can be easily purchased in most metropolitan areas. They are lightweight, sturdy, and pack easily in a laptop case or other piece of luggage. The same goes for CD mailing sleeves.

If your laptop has a DVD writer, you can bring DVDs on your trip instead. But if you are relying on hotel lobby, or Internet café, computers to write your backup discs, you may be out of luck finding DVD writers. CD writers are much more common. You can fit multiple CDs in a mailing sleeve. Whether CD or DVD, the discs are resistant to moisture, temperature, and shock while in transit to your mailbox. If you arrive home with all your images safely with you, you have the disc backups all ready to store and no harm done. If you did lose some baggage, or accidentally erased some images, or any of the other disasters that Murphy's Law can inflict on traveling photographers, your effort was well worthwhile, and you can use the discs you sent home to retrieve your images. (See Figure 3.25.)

Figure 3.25 If you lose your memory cards or image backups while traveling, you may never be able to reproduce the lost photographs.
Copyright © Steve Weinrebe, Getty Images

Tip

If you don't have a laptop, or you have a netbook or other computer without a CD or DVD writer, and there is no other option for a computer to write backups to disc, there are a couple of other options to get your photography safely to a different location for off-site backup. For one, you may be able to find a computer with email. You won't want to try to email gigabytes of images, but JPEG images are relatively easy to email. Shoot both RAW and JPEG, a choice many cameras have in the settings menu (if you have a camera that can shoot RAW format), and only send the JPEG images to your email address. If you don't have easy access to your Internet service provider's webmail, get a Yahoo! Mail Or Gmail account for just this purpose. You can access your email from any computer with Internet access and mail your images to yourself for backup. If you've edited your images and have some favorites, by all means send the RAW versions of those to yourself in email. Zip compress them first (this works on both Windows and Mac operating systems). This may still take some time depending on the speed of the Internet connection, but having the backup will let you sleep at night.

Bulb Blower

The traveling photographer needs to be as self-contained as possible. What I mean is that you need to anticipate problems and be prepared for them with what you have on your person or in your carry bags. One of the greatest difficulties digital photographers face when traveling is keeping their equipment clean. There are a few items that every photographer should keep in their camera bag to help keep equipment clean, but I've found very few of my students actually carry cleaning tools, or the right cleaning tools. (See Figure 3.26.)

Dust on lenses is a problem. Dust on camera sensors is a bigger problem. Dusty lenses are more of an annoyance than a deal breaker for an image. If you wear glasses like I do, you know that there's always a speck of dust or two on the lenses, but with the lenses so close to the eyes the dust is generally not noticeable. The same goes for camera lenses: a speck of dust will be so out of focus and compose such a small amount of the total image that it's unlikely to be noticed. Still, the pixels that are resolving the fractional portion of the frame that is covered by a dust speck will capture less detail in that spot than if the lens were properly cleaned.

Tip

Unfortunately, sensor dust is difficult to see in the little previews on camera backs. If you have changed lenses on a digital SLR and are in a dusty environment, use the zoom feature on your camera's preview to check for dust. Look specifically at flat even areas of tone where dust will be most visible. One trick is to simply take one photo of a flat wall or the ceiling so that you have one reference image to check for sensor dust. If you see dust specks that you can't live with, get to the most dust-free place you can and clean your sensor.

Figure 3.26 The simplest of cleaning tools—a bulb blower. This small one made by Grobet USA cost only a few dollars.
Copyright © Steve Weinrebe

Dust on the camera's sensor causes more aggravation for a photographer than dust on the lens. Sensor dust is so close to the focal point of the lens, where the light coming into the lens resolves as an image onto the camera's sensor, that it is visible in photographs. Sensor dust is especially noticeable in even-toned areas and repeats as dark spots, in the same place in the frame, from capture to capture. (See Figure 3.27.)

Figure 3.27
When photographing areas of even tone, such as the wall in this photo, make certain the internal elements of your camera's sensor are clean, as I did before taking this photo.
Copyright © Steve Weinrebe

First, here's what not to do. If you have dust on your lens, you might consider blowing gently, with a short puff of breath from your mouth. The danger is getting some saliva on the lens, but that can be cleaned off relatively easily. If you have sensor dust, don't take the lens off, flip up the mirror, and blow into your camera. Any moisture inside the camera needs to be from a cleaning solution that evaporates quickly.

In my experience, most dust is removed very simply by blowing on it with a bulb blower. Bulb blowers are an ancient photo tool and maybe for that reason are overlooked by too many photographers in favor of compressed air or fancy cleaning kits. But old technology doesn't mean bulb blowers are any less useful than they always were.

Bulb blowers come in small and large sizes. I suggest you carry both on a trip, a small one in your camera bag and a large blower in your luggage for more difficult jobs. (See Figure 3.28.)

Figure 3.28 This large bulb blower, Giotto's Rocket-Air, has a longer snout to more easily get into the interior of a digital SLR and blow out the dust. The built-in valve prevents dust from being drawn back into the blower.

Copyright © Steve Weinrebe

Tip

The obvious advantage of a bulb blower over blowing with your own breath is that the burst of air is dry. The interior of the bulb, when new, is clean as well. But after squeezing the blower to push air out, air rushes back in when you let loose of the bulb. If you're in a very dusty environment, you'll suck dust back into the blower, which will blow out the next time you squeeze it. If you're in a dusty area, try pressing the blower against your shirt when releasing the bulb so that your shirt acts like a filter when air is being sucked back into the bulb. To keep dust out of the blower when not in use, store the bulb blower in a plastic bag. Some blowers, like Giotto's Rocket-Air, have a valve to prevent dust from entering the blower.

True Story

Not long after I moved to New Jersey, a friend asked me to meet him at a New Jersey racetrack to see a dirt-track-racing event. This sounded like a terrific photo opportunity, and sitting in the bleachers watching the event was a thrilling experience. Being an intrepid photographer, I ventured down as close as I could for what I believed to be an excellent position to photograph the race cars as they swung around the end of the track toward me. I snapped off some great photos of the low-riding race cars hurtling toward my camera as they rounded the bend. Then I looked up and saw a mountain of dust from the cars' wake heading my way, as the cars receded into the distance. I had just enough time to huddle over my camera before the dust cloud covered me. This was one of many experiences I've had photographing around dust and water that taught me to anticipate where the dust or water will be, and prepare for it.

Retractable Lens Brush

A retractable lens brush, or lens pen, goes hand in hand with a blower bulb. A lens brush was the first cleaning tool I ever bought, and I probably purchased it with my first camera long ago. I've replaced it since and always keep one in the side pocket of each of my camera bags so that I'll never be caught without one. (See Figure 3.29.)

In case you were considering it, never use your finger to dislodge dust from your lens, your camera's mirror, or the sensor inside your digital camera. Grease from your finger can damage the coating on your lens over time if not properly cleaned off, and once you get finger grease on your lens, it is much more difficult to remove than dust. Absolutely never touch your camera's mirror with your finger. The mirror in a digital SLR is a front-surface mirror, as opposed to household mirrors where the mirrored silver is behind the glass. That mirrored surface is thin and delicate, and needs to be treated with great care. The same can be said for the sensor, so if you have dirt in your camera, don't go poking around in there with your finger, or blowing into your camera either.

No cleaning system is perfect, and there can be problems with both the bulb blower and a lens brush. Dust that's attached to the surface of a lens or an internal part of a camera may not just blow off. That's why the lens brush needs to be used first. The lens brush won't necessarily get rid of the dust; it may just shove it around. But that's okay. Use the lens brush to dislodge the dust and then blow it out with the bulb blower.

When you are using a lens brush, bristles might fall out of the brush, so be watchful, and be sure to remove them from inside your camera. Hold the camera upside down, over your head if necessary, when you use the brush and when you blow into your

camera with the bulb blower. Don't discount the assistance gravity will give you in getting those little bits of dust, or a stray hair from a lens brush, out of your camera body. (See Figure 3.30.)

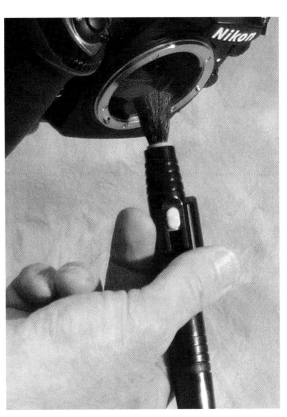

Figure 3.29 Use a lens brush to dislodge dust from your lens, and then blow it out with a bulb blower.
Copyright © Steve Weinrebe

Figure 3.30 Hold a camera upside down when brushing dust with a lens brush, or when blowing into it with a bulb blower. Gravity will help get the dust out.
Copyright © Steve Weinrebe

Tip

"STOP—Look but don't touch!" should be a warning label on all lens brushes. When you buy a lens brush and first remove the brush from the holder, you may be very tempted to touch the brush to see how soft it is. But as compelling as it may be, don't touch the brush. Trust me, it's soft. If you touch it to feel the softness, you'll also get finger grease on the brush—not something you want to transfer onto a lens.

Sensor Wipes

I'm somewhat aghast at how many options there are to clean the inside of cameras. Gone are the days when a photographer breathed into the camera body or onto the lens, stuck a finger into the corner of a T-shirt to make a cloth poker, and wiped away. Now photographers have an assortment of excellent photo tools to choose from. I hesitate to call the wipes I'm recommending here irreverent, but I like them and I'm an irreverent guy, so I'll share these sensor wipes-on-sticks with you nevertheless. (See Figure 3.31.)

I especially want to include these sensor wipes because one of the most common questions I get asked by budding photographers and photo enthusiasts is, "What is the best way to clean my camera?" I can only speak from experience, but I'd like to share that experience here.

One problem with most sensor wipes is that they are made from a fibrous material. Those fibers can catch on sharp corners or where small parts of the camera assembly meet. You might not even see a stray fiber or two from the wipe catch in your camera, but when you blow an image up to 20 by 30, you will see anything that strays close to the sensor and into the path of light through the lens. And like dust on a sensor, a fiber hovering over the sensor will repeat from image capture to image capture. Many times I've had to use a magnifier and tweezers to see and remove fibers from professional cleaning materials that are listed as safe for sensors.

To back up a bit, that fiber problem is why I so emphatically recommend the irreverently archaic bulb blower and brush to clean your camera with. Unfortunately the reality is that those alone are sometimes not enough to really get your sensor or lens clean and you need to resort to something moist to dissolve grease, grime, or stubborn dirt. That's where these stick wipes, called Sensor Swab Plus, come in. (See Figure 3.32.)

I'm not a fan of two-step solutions to anything. The simpler, the better, and these sensor swabs are pre-moistened with a sensor-cleaning solution called Eclipse, and attached to stick handles so you don't need to get your fingers inside the camera when wiping the sensor.

When traveling, photographers really have to be wary of taking a cleaning cloth to their camera's innards. As I've mentioned, dust in the air can be a problem, and the longer you have to negotiate a cleaning cloth and a separate bottle of solution, and then figure out how to apply it to your camera, the more chance dust and dirt will get onto the cleaning cloth or into your camera. These Sensor Swab Plus cleaners are self-contained in sealed packets. You only need to rip the package open just before using it, and then throw it out when done. The sealed packages are compact and travel well.

Figure 3.31 Sensor Swab Plus is a camera sensor cleaner, pre-moistened with Eclipse cleaning solution, already attached to a stick holder. The individual packets are perfect for traveling.
Copyright © Steve Weinrebe

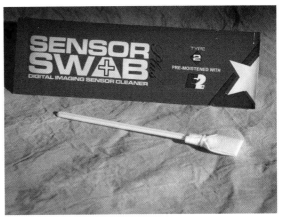

Figure 3.32 The Sensor Swab Plus does a good job of cleaning tough-to-remove dirt using the pre-moistened applicator.
Copyright © Steve Weinrebe

> **Tip**
>
> Cleaning camera sensors isn't a chore a photographer wants to do very often. Honestly I loathe cleaning my camera, and I find most photographers are very shy of touching the inside of a camera with anything. Practice good policies to help prevent the need to do any cleaning. For example, when I change lenses, I do so with the camera facing downward so that dust won't be tempted to drop into it, and I change lenses as fast as possible, again to minimize the possibility of invading dust. Follow simple and basic routines for changing lenses, storing cameras, and generally protecting your equipment, and you'll rarely have to actually clean your sensor.

Upstrap Camera Strap

While up in Maine teaching a photography workshop, I was sitting at a picnic table chatting with one of the world's greatest photographers, whose work I admire very much. He was sitting with a digital SLR with a telephoto lens on his shoulder, and no matter how he turned, reached, sat up, or sat down, he never had to hunch his shoulder to keep the camera strap from sliding off. I commented that it was an unusual strap, and he handed over his camera for me to try the strap out. I was sold as soon as the strap, laden with the heavy camera rig, rested on my shoulder. I later exchanged emails to find out where I could get one of those straps and was referred to Upstrap. (See Figures 3.33 and 3.34.)

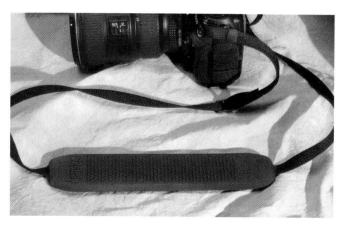

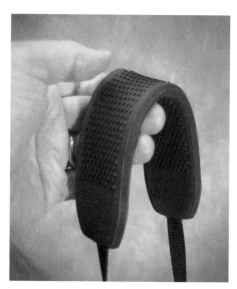

Figure 3.33 The Upstrap camera strap holds cameras securely on your shoulder without your having to hunch or otherwise worry about the strap sliding off.
Copyright © Steve Weinrebe

Figure 3.34 The Upstrap bends in either direction so you don't have to fiddle with it to orient the camera strap to your shoulder. Just slip it on and the Upstrap stays put.
Copyright © Steve Weinrebe

Upstrap's camera straps are made from a nonslip rubber with a patterned texture molded into it. The rubber shoulder portion is molded over sturdy webbing that provides excellent security and flexibility for the photographer. If you've ever had to catch your camera in the crook of your elbow as it was falling off your shoulder, you'll understand the appeal of the Upstrap.

The Upstrap shoulder strap comes with instructions on how to attach the strap to the camera, and comes with plenty of webbing. Follow the instructions and do this part properly to secure the camera to the strap.

Tip

When traveling for photography, I've found it's a good idea not to advertise that you're a photographer, or to walk around camera in hand, game-hunter-style. I like my camera hanging from my right shoulder, down to my hip, just below belt level. I walk with the camera behind my forearm, which keeps the camera from wagging back and forth. In this way, the camera almost disappears from view, and yet can be quickly grabbed for picture taking. If the camera is in a camera bag, I keep the bag in the same position.

U.S. Post Office Shoulder Pad

Domke, now owned by Tiffen, makes my favorite shoulder pad for heavy camera bags. The U.S. Post Office Shoulder pad, by Domke, is inexpensive and a great shoulder saver when toting camera bags on your travels. (See Figure 3.35.)

This pad comes with Velcro straps that overlap your existing camera bag's strap. You don't need to buy a whole new strap for your camera bag. Just slip off whatever pad came stock with the strap and replace it with the Domke shoulder pad. The pad, and Velcro fastening straps, are wide enough to fit just about any camera bag's shoulder strap. Because the shoulder pad fits on with Velcro fasteners, you can easily move it from one bag to another, depending on which one you're taking on your trip.

The outstanding feature of this postal shoulder pad is that the rubber padding has a beveled contour to mold to the natural slope of the shoulder. Even though shoulders slope downward, the U.S. Post Office shoulder pad stays straight because the rubber is thicker on the outside than on the side that lies closest to the photographer's neck. The rubber is solid too, not overly cushioned. In fact, the density of the pad put me off at first. But after hundreds of hours using this pad on trips and lugging it around on location, I found that it performed wonderfully. The non-skid rubber holds well, and the solid feel, combined with the contour of the rubber, make the pad a great choice for bags loaded with a body or two and a few lenses. It's not a dainty shoulder pad, and it's not necessary for small camera bags, but when you're hiking up some foothills or walking the length of a major metropolis with a decent-sized camera bag, you'll be glad your shoulder is protected with this shoulder pad. (See Figure 3.36.)

Figure 3.35 The Domke U.S. Post Office shoulder pad, made by Tiffen, is a substantial pad that protects the shoulder when carrying heavy camera bags.
Copyright © The Tiffen Company, All Rights Reserved

Figure 3.36 The Domke postal shoulder pad conforms to the natural slope of the shoulder, making camera bags more stable and comfortable, and less prone to slipping off.
Copyright © The Tiffen Company, All Rights Reserved

Attitude

It would be hard to understate how important a photographer's attitude is when traveling. As a tool, attitude will often get you better pictures than a thousand-dollar camera upgrade. By attitude, I mean confidence and hutzpah, kindness and understanding, reason and sensibility, thoughtfulness and readiness. Bundle it all together, and you hopefully reach the zone and rhythm that helps traveling photographers make the best images they can. Attitude will help you get around, get in doors, get smiles, get a subject's eyes focused on your lens, and vice versa. (See Figure 3.37.)

Figure 3.37 Being comfortable with my camera and the surroundings helped me capture this image of a street vendor in Delhi, India.
Copyright © Steve Weinrebe, Getty Images

If you like photographing people, or having people in your travel pictures, attitude becomes especially important. People generally like to be photographed by someone who exudes confidence and who clearly enjoys taking pictures. If you're shooting candid images of people unaware of your camera, you need to be efficient and thoughtful, not intrusive. And you especially don't want to photograph people at their worst. Attitude lets people know you'll make them look good in a photograph even if they'll never see it.

Attitude also includes kindness, or *ubuntu*. When teaching photo workshops, I always encourage the students to be thoughtful when they photograph people or business establishments. Get a subject's email address, or if that's out of the question, ask for a physical address to send a print. Then, really do send a print! You may never know that your photo reached that beach-hut restaurant where the owner posed at sunset, but it's worth the international postage to try to get it there.

Your attitude will affect the next photographer that comes along as well. If you sway someone to take a picture that might have otherwise been forbidden, be thoughtful about the surroundings and leave as if you hadn't been there. Capturing the photograph is all you want and, for the travel photographer, is a tremendous reward.

True Story

When visiting Bangkok, Thailand, and being a fan of the sport of boxing, I attended a Thai boxing match. The arena was noisy and smoky, full of shouting, betting, and throngs of spectators waving arms and jumping up and down. The area around the boxing ring was obstructed by barricades and a wire screen to prevent the boxers from being injured by hurled objects, and there was no easy angle from which to get photographs. I saw some photographers from the Thai press taking pictures, but I had no press pass with me. But I summoned all the attitude I could muster and spoke to the guards, holding out some professional association membership cards, my business card, and my passport. The guards understood no English, but I persisted and did my best to make them understand I was a competent and impassioned photographer for which the only option was to be allowed to get ringside to take pictures. After much discussion, the guards did let me in to the ringside press area so that I could take pictures. Through the smoke and the noise and the lack of a common language, attitude got me the pictures I wanted. (See Figure 3.38.)

Figure 3.38
The right attitude, and some professional association cards, got me ringside to take pictures of Thai boxing.

Copyright © Steve Weinrebe, Getty Images

4

Irreverent Tools for Nature and Landscape Photography

The next time you wake up in the middle of the night, try this—step outside. Just take a moment in the wee hours of the morning, before you go back to sleep, to step into your back yard, up to your roof deck or patio, or wherever you might have a little outdoors space. Take a deep breath; I don't care what time of year it is. No matter what, whether you are in a rural or urban spot, you'll get a special feeling that, in that moment, you are part of nature, part of the greater world. That's the feeling photographers live for when photographing nature and landscape images. (See Figure 4.1.)

There are distinctions that set apart nature and landscape photography from other genres of photography. Birds, insects, and other living things don't stay still when you want them to, or they move when you don't want them to. Landscapes change with the light and with the seasons. But the challenges these types of photography hold for photographers are similar. Nature or landscape photographers are working outdoors, sometimes traveling tough terrain, usually working with available light and sometimes dealing with inclement weather. Tripods may be a necessity, and creature comforts may be few.

As with both location and travel photography, preparation is important because once you arrive at your destination, you'll want to be free to work. It is said that being familiar with your subject matter yields the best photography. I'm not so certain of that. A lot of great photography comes from photographers who found newness in their subject matter, photographing scenes that they never encountered before. I believe that

Figure 4.1
A landscape of New Jersey sand dunes photographed at sunset. I used sleeves made from plastic bags and rubber bands, discussed later in this chapter, to protect my tripod legs from saltwater.

Copyright © Steve Weinrebe, Getty Images

change breeds progress, and that turning the lens on new subjects helps a photographer grow and mature. When a photographer repeatedly photographs the same subject, the results are a test of whether the photographer can drink from that same fountain of excitement that yielded an initial batch of excellent photos, or ends up with retreads of earlier work. With either an old or new subject, or a tired or invigorating subject, having a good set of tools to work with will hopefully free the photographer to be spontaneous and creative.

Some of the tools mentioned here may be useful for only one type of photography, but most of these tools will be useful to both nature and landscape photographers. And as mentioned previously, there is crossover between many of the themes in this book. Nature and landscape photographers will benefit from tools in the previous chapters, and other photographers may find useful tools here as well.

Backward Lens Macro

Call this a tool or a technique, but either way it works. Take the lens off a digital SLR, reverse it, and hold it up against the lens mount opening. Look through the viewfinder and move the camera back and forth to focus. You will get startlingly close-up macro focus this way. Using a lens backward is a good economical solution for photographing natural subjects very close up. (See Figures 4.2 and 4.3.)

Figure 4.2
Reverse the lens on your camera for macro photography without a macro lens. The exposure was *f*/1.4, 1/750 second, at ISO 800.

Copyright © Steve Weinrebe

Figure 4.3
Holding an old 50mm manual lens backward to the camera body, I photographed this leaf close up. The exposure was *f/1.4*, 1/350 second, at ISO 800.

Copyright © Steve Weinrebe

I generally use an old manual focus 50mm lens for this technique. The glass of the front lens element needs to be smaller than the lens mount opening of the camera, and *make certain that no protrusions from the camera's lens mount assembly touch the glass of the front element of the lens.* The lens, held this way, will let you focus very close. Move the camera toward the subject until you find your focal plane, and then snap the shutter. If there is a danger of the glass touching metal, use a different lens where the glass doesn't protrude so far or touch anything when held to the camera body.

This method is a little awkward because both your hands will be tied up unless you are able to get a tripod up very close to your subject. Shooting items in nature usually requires spontaneity and flexibility for camera position, so if you are able, you may want to shoot with a high enough ISO and a fast enough shutter speed to hand-hold the camera for the shot. (See Figure 4.4.)

What about light coming into the lens? That's certainly a consideration, especially if the sun might strike the side of the camera directly. But in practice I've found that, with the lens held tightly against the camera, the lip around the recessed front of the lens is enough to act as a baffle to prevent most stray light from entering the camera body. However, you wouldn't want to test this with a lengthy time exposure such as a night shot.

With macro photography there is a very limited depth of field so it is helpful to stop the lens down to a small aperture to bring more of the image into focus. The problem

Figure 4.4
Unless you can position a tripod close to your subject, you'll need two hands—one to hold the lens and one to hold the camera.

Copyright ©
Steve Weinrebe

is that because the lens is off the camera, the aperture stays at whatever it is set at, and if the lens aperture is stopped down, the brightness in the viewfinder will be diminished. The benefits of stopping down may be limited to only a few extra millimeters of depth of field, although that can be a lot with macro images. (See Figure 4.5.)

I often leave the lens wide open so that I can use the fastest shutter speed possible. If you need an auto exposure, try Aperture Priority mode so that the shutter speed will vary for the correct exposure. You may still need to vary the aperture on the lens manually to fine tune the exposure.

Look for a flat plane in the subject so that the subject is parallel to the lens and mostly in focus. Any defocused areas can add interest to the image and lead the eye to the focused areas. For that reason, frame the composition not just for content, line and form, but for the focused area. (See Figure 4.6.)

If you are holding the lens to the camera, you won't have a free hand to manually focus the lens. But even with the lens focused at infinity, you will still be able to get very close macro photos. There are limits, but remember this is a very simple and cost-free approach to macro photography. The best subjects will be small—an insect, part of a flower, and so forth—but photographing the visual richness of the texture of anything in nature can be very rewarding.

Figure 4.5
An old manual 50mm lens, turned backward to the camera body, yielded this macro photograph. The exposure was $f/1.4$, 1/320 second, at ISO 400.

Copyright © Steve Weinrebe

Figure 4.6
The flat plane of these flowers helped with the focus, even though the lens aperture was wide open. The exposure was $f/1.4$, 1/800 second, at ISO 800.

Copyright © Steve Weinrebe

Hemostat

While we're on the subject of close-up nature photography, you may need a tool to hold an object in place while you are doing the close-up photography. A hemostat, a locking type of forceps or surgical clamp, works great for clamping an object and holding it for photography. Ideally, get one with a curved tip to better position objects for photography. (See Figure 4.7.)

These clamps are used by surgeons to hold stop bleeding, and are made to be used one-handed. They can be clamped, or unclamped, by squeezing the handles together. Working like scissors, the tips close when the handle is closed. The inside of each handle has a protrusion with a hooked shape that overlaps and locks when the handles are squeezed together. To open the clamp, push out with one finger while stretching your fingers out, and the hooks come undone, unlocking the clamp.

Surgical clamps are made from surgical stainless steel and will not rust. When laid on the flat side, the clamp won't wobble because it's made to sit neatly on a tray waiting for the surgeon to use. This flat side works to the photographer's advantage because you can lay the clamp on any flat surface and the curved tip will hold the object to be photographed up into the frame. (See Figures 4.8 and 4.9.)

The inside tip of a surgical clamp is serrated, making for a solid grip when the hemostat is closed. The clamp is very lightweight and sturdy. Other than the curved tip, the flat profile makes the hemostat easily packed and carried to whatever location you are going to. Although this is a handy tool for many types of photography, it is especially close-up nature photography that I find this useful for. These clamps are inexpensive and can be easily purchased over the Internet or at medical-supply stores.

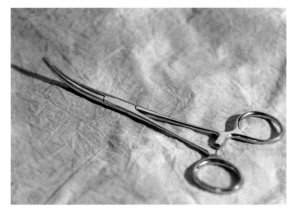

Figure 4.7 A hemostat, or surgical clamp, is a handy tool to hold small objects in place for photography.
Copyright © Steve Weinrebe

Figure 4.8 The hemostat is holding a pinecone in its pincers. The hemostat conveniently lays flat and steady, holding the small item for a close-up photo.
Copyright © Steve Weinrebe

Figure 4.9
The pinecone in this close-up was held in place by a hemostat.

Copyright ©
Steve Weinrebe

Palm Reading

When you're outdoors shooting landscapes, very often judging a perfect exposure can be difficult. A cloudy sky over a mottled landscape of trees, grass, mountains, dwellings, or any combination of these and other subjects, composes a scene with a wide variety of tones. If you are photographing a landscape and carrying an incident light meter (a light meter you can hold up toward the light for an exposure reading), you can judge a proper exposure pretty easily. But digital cameras are directional, and they take an average or spot light reading from the subject area. Sometimes an average reading works or will get the photographer close to a perfect exposure, but sometimes it doesn't work and the exposure is thrown way off.

An 18% gray card can help because it is consistently the same tone and a tone that is easy to take a reading from. The card is designed to be middle gray, so if you aim your digital camera at a gray card large enough to fill the frame, and the card is reflecting the light that is falling onto the scene, you can take a good exposure reading.

You may find yourself without a gray card though, or not own one, or not have one large enough to fill the viewfinder for a proper light reading. What you do have with you is a surface with a consistent tone that you can hold up to the lens in the direction of the light to help arrive at an exposure reading—your hand, and more specifically, the palm of your hand. (See Figure 4.10.)

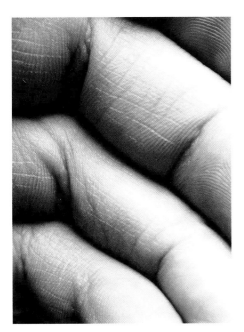

Figure 4.10 Your hand has a consistent tone and can make an impromptu gray card, after adjusting for the tonal difference.
Copyright © Steve Weinrebe

Figure 4.11 My wife takes a reference light reading from her palm. After taking an exposure reading from a gray card, take one from your palm and calculate the difference.
Copyright © Steve Weinrebe

You'll want to use your palm as an impromptu gray card because it is hidden from the sun and has a more consistent tone. Also, the palm is flatter, making for a more even surface for an exposure reading. Benchmark the exposure reading from your palm against a gray card, and you'll always have a gray card equivalent with you. (See Figure 4.11.)

Start by taking a reading from a gray card, and yes, you should own a gray card. There are many brands and manufacturers, sizes and materials. You can even borrow one or, push come to shove, stand in a camera store and do the benchmarking. Also, set your metering mode to spot-reading mode, or center-weighted mode.

The steps are simple. First, hold an 18% gray card so that it is facing the dominant light source. Hold your camera so that the gray card fills the frame. It's fine if the gray card is out of focus; in fact, it's better for the gray card to be out of focus so that the gray tone is even in the viewfinder of the camera. Depress your shutter halfway and make note of the exposure reading, both the shutter speed and *f*-stop.

Second, repeat these steps using the palm of your hand instead of the gray card. Make note of the exposure. Whatever the difference between the exposure reading of the gray card and the exposure reading of your hand, that's the factor that you will always need to compensate by to arrive at a proper exposure when taking the reading from your hand.

> **Tip**
>
> Set the exposure mode of your camera to Aperture Priority. This way, you'll have only one variable instead of two. If you have your camera set to an auto exposure mode that varies both the aperture and the shutter speed, you'll have a little more calculating to do because one, the other, or both may shift from the exposure reading of the gray card to the exposure reading of your hand.

I know from the test I described here that my own palm is consistently one stop lighter than middle gray. For example, a reading with my palm filling the viewfinder may give a reading of $f/8$ at 1/60 second when the reading from an 18% gray card will be $f/8$ at 1/30 second. In other words, when I use my palm for a spot exposure reading, the camera will always give an exposure reading one exposure value (EV) too dark (half the amount of light entering the camera) because the camera's meter is trying to make the tone of my palm one stop darker to adjust it to middle gray. So, from whatever reading the camera gives to my palm, I open up one stop, for example from 1/500 to 1/250 second, or from 1/30 to 1/15 second, or from $f/11$ to $f/8$. (See Figure 4.12.)

Benchmark your own palm to find out how the tone deviates from middle gray, and then, when using your palm for an exposure reading, just make the necessary adjustment to compensate for the difference. You can make the exposure adjustment either with the shutter speed or aperture in manual exposure mode, or with the exposure compensation feature, if you have one, so that you can shoot in auto exposure mode with the correct exposure.

Figure 4.12 The same scene exposed for the reading from my palm (left, at $f/5.6$ and 1/500 second), and then with the exposure compensated for the difference between my palm and middle gray (right, at $f/5.6$ and 1/250 second). I inset the histograms to help illustrate the difference in exposures.
Copyright © Steve Weinrebe

Green Grass Reading

While on the subject of exposure readings, here is my other favorite tool for exposure readings when photographing the great outdoors—green grass. Check out the tip in the previous section on the Zone system. On a scale of Zone 0 to Zone X, with 0 being black and X being white, and Zone V being middle gray, I generally like green grass to place at a Zone IV. Zone IV is one zone darker than middle gray. (See Figure 4.13.)

Figure 4.13

Green grass can help check or establish your exposure in a nature or landscape scene.

*Copyright ©
Steve Weinrebe*

It doesn't matter whether you are shooting for eventual output in color or black-and-white: green grass should generally correspond to a shade darker than the middle tone in your landscape or nature scene (unless your interpretation of the scene leads you in a different direction). So to arrive at a proper exposure, or to check that your camera is averaging the exposure correctly, set your camera's metering mode to spot reading mode if the grass you are reading from is at a distance, or center-weighted metering mode if the grass you are taking the reading from is close to you. Then take the light reading from the grass, and darken your exposure down one stop, or EV, to arrive at the proper exposure for the scene; for example from 1/500 second to 1/1000 second, or from $f/8$ to $f/11$. Reducing the exposure sends the tone of the grass from middle gray to one Zone darker than middle gray. (See Figure 4.14.)

Tip

If you are taking your reading from green grass close to you, set your meter on center-weighted metering mode. Then fill the viewfinder with the grass and defocus the grass so that it is very blurry. This way, the tone of the grass will be more smoothly and evenly distributed in the viewfinder.

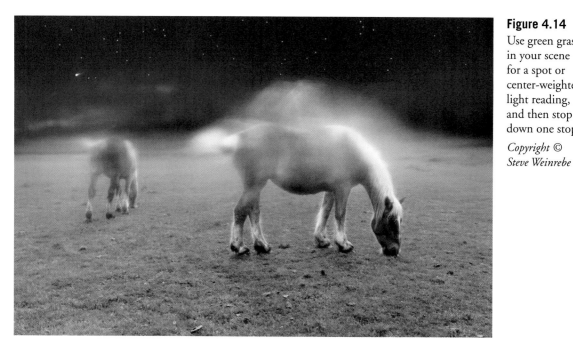

Figure 4.14

Use green grass in your scene for a spot or center-weighted light reading, and then stop down one stop.

Copyright © Steve Weinrebe

The rest of the tones in the scene should fall into place, but for unevenly lit scenes, such as a landscape where part of the scene is in shadow and part is in sunlight, try to take two readings from the grass and then split the difference down the middle to average the exposure. Then darken that averaged exposure by one stop to arrive at the correct exposure.

Sunrise Sunset Charts

The sunrise, or sunset, can be a magical part of a photo composition. The trick is knowing where and when.

Let's start with knowing where the sun will rise. Imagine yourself at four in the morning on a summer day, waiting patiently for dawn to break. You have scouted out a wonderful setting overlooking a beautiful landscape of farms and wheat fields. You are anticipating the sun to rise over the perfect spot in your composition, but no, the sun rises behind a farmhouse and the actual sunrise is blocked from view. If you knew, you might have positioned your tripod 50 yards to the right so that the sun would be caught at it rose above the wheat fields. That's where a sun path chart comes in. (See Figure 4.15.)

I learned about sun path charts during a brief stint in architecture school, and then photographing buildings for architects, many years ago. Knowing where the sun would rise or set, or how high the sun would be at midday, was a great help in preparing for a

Figure 4.15

A sun path chart can tell you where the sun will rise.

Copyright ©
Steve Weinrebe

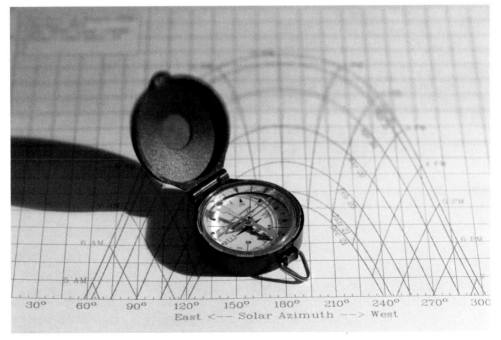

photograph. I've done many sunrise photo shoots for both work and pleasure, and knowing where the sun will rise is a great help.

You'll easily find a sun path chart by turning to an Internet search. I found a good one this way at the University of Oregon's website. Once you've found the chart by entering in your location, you'll want to print the chart and bring it with you for your nature or landscape photo shoot. Laminate the chart, or fold it up and stuff it into the back pocket of your camera bag. The chart shows, in degrees East or West, where on the horizon the sun will rise and set throughout the year. The chart also will show how high the sun will get, which can be invaluable in calculating where shadows will fall. (See Figures 4.16 and 4.17.)

This chart shows degrees in five-degree increments. It's easy to see that as I write this, in June, within a day or two of the summer solstice, that the sun will rise at 58 degrees East. All I need do is to set a compass to North and look where 58 degrees East lies on the compass to know where the sun will rise.

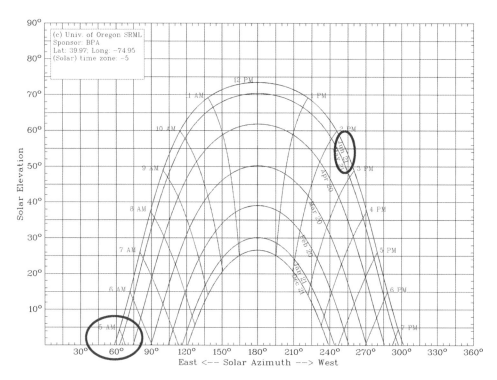

Figure 4.16

Just line up the path line for the time of year with the degrees on the horizon at the bottom of the chart, to get a very good idea where the sun will rise.

Sun chart courtesy of the University of Oregon, Solar Radiation Monitoring Laboratory. http://solardat. uoregon.edu/ SunChart Program.html

Figure 4.17
Knowing where the sun would rise helped me position myself for this photograph before a balloon flight.

Copyright © Steve Weinrebe, Getty Images

True Story

I spent several years photographing exclusively on location for corporate and editorial clients. Photographing at sunrise became part of the routine. I recall for a fact at least a couple of ad agency art directors who loved to tell their clients that we were going to do a sunrise photo shoot for them or their product. That, of course, cemented the ad agency's reputation as hard working and go-getting, even if I was the one producing the photo shoot and all the art director was going to do was nod, half awake in his car, with a cup of coffee in hand.

One of those shoots was for a bank that was sponsoring a hot air balloon. We set out to do a sunrise shoot of the balloon floating over some beautiful landscape, photographing from another balloon so that we could be at the same height capturing the customer's hot air balloon in flight. After two failed attempts, the sun, the balloons, and the wind cooperated and we got the shot. Then it was time for our balloon to land, which we did in a suburban back yard. Bear in mind this was about 6:00 AM on a June morning, and there were eight of us in the large and colorful balloon's basket. As if on cue, the matron of the household came running out of her back yard slider doors in her night robe, hands to her cheeks, screaming with excitement. After a minute or two of introductions, the kind lady ran into her house and returned to serve us all coffee and pastries. (See Figure 4.17.)

A sun path chart will show you where the sun will rise or set, and will help you to position yourself for your landscape photography, but these charts aren't as helpful in telling you exactly when the sun will come up. Again, you could turn to the Internet, but digital tools will come later in the book, and since you may not have access to the Internet while in the field taking pictures, you'll want to refer to an almanac for sunrise and sunset tables. My favorite resource for astronomical tables is *The Old Farmer's Almanac.*

If you grew up with *The Old Farmer's Almanac,* as I did, you know that it is an excellent reference for astronomical tables, tide charts, growing charts, and a boat load of essential, and often entertaining, information. I confess I give my wife, an avid gardener, one every year as sort of a ritual gift. And when I am in need of a reference to help me plan the time of a sunrise or sunset photo shoot, I turn to *The Old Farmer's Almanac* as a reference—either the print version, or online at www.almanac.com.

The *Old Farmer's Almanac's* astronomical tables, with the sunrise and sunset times, have two essential parts: the pages that compose each month's information day by day, and the time-correction pages that tell you how many minutes to adjust the times for your specific location. Thorough instructions are included, and all you need do is add or subtract minutes from the sunrise or sunset time for the day of year you're planning to do your photography.

Tip

The Old Farmer's Almanac has one other essential astronomical table, the length of twilight. Referred to by photographers as the magic hour, there is a time after sunset, or before sunrise, when the sky takes on a glorious blue color, and the brightness of the sky matches exposure values with the brightness of any lights in the scene, such as lights in homes, on buildings, street lights, bridges, and cityscapes. Photographing at that time of day can yield an evocative mood of predawn, or early evening. Because *The Old Farmer's Almanac* has a twilight chart and sunrise and sunset charts, you can easily determine the time of dawn break or nightfall by subtracting or adding the length of twilight to the time the sun rises or sets. Then you have the time of the magic hour for outdoors photography.

I was teaching a photo workshop not long ago when the students and I were planning the next day's photo excursions. Rather than a sunset shoot, which we had already done, I suggested we do a sunrise shoot. I was amazed at how excited the class became. Their eyes lit up with excitement at the thought. That got me thinking about the difference, not just with lighting, but with how people think about a sunrise emotionally. We see sunsets every day, but depending on the time of year, we may rarely see the sun rise. Early morning has a different character than late afternoon, and even our mindset may be different. And there is the adventure of catching a glimpse of the world, and being

at the top of your game, when most people are asleep or just waking up. Standing on a hillside or by the water's edge in the predawn hours, cup of coffee in hand, waiting for just the right light, can be a mesmerizing and memorable experience.

Of course whether you photograph the sunrise or sunset will depend on your vantage point and your aesthetics. If you are photographing in color, sunset and evening twilight tends to have warmer colors because of the way the light filters through the fossil fuels that have risen up during the day into the atmosphere. Predawn the air is often cleaner and so the pre-sunrise, and the sunrise itself, is often less colorful. Also, shortly after the sun comes up, it is too bright to have in the field of view, so most of the good light is predawn and your photo shoot is over a minute after sunrise. On the other hand, after sunset the light may linger beautifully and give you varying qualities for different moods in your photographs, and you can take your time deciding when it is too dark, and the exposures are getting too long, to take more pictures.

Cropping Ls

The director of an old silent movie tries to imagine how a scene will look on the silver screen, so he stands in front of the camera, holds both hands flat with thumbs out, left hand facing palm out and thumb down, right hand facing palm in and thumb up. He brings the two hands together to create a variable picture frame and moves his hands to find the perfect composition. In doing so he had used his hands as cropping Ls. (See Figure 4.18.)

Figure 4.18
Hands make simple, but available, cropping Ls to help determine the best crop for a scene you're going to photograph.

Copyright ©
Steve Weinrebe

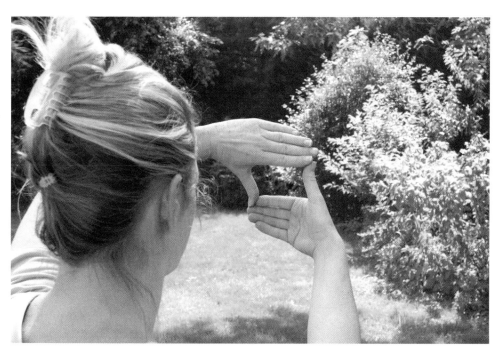

Cropping Ls are any two objects or cutouts shaped like an L that, when placed together, one 180 degrees turned to the other, form a frame. By moving the Ls closer together or farther apart, the frame can be made larger or smaller. By moving the Ls closer to your eyes or farther from your eyes, you create the effect of zooming in or out. And of course by moving the frame from side to side, you create the effect of panning. In this way, by using cropping Ls, an artist can quickly view an unlimited number of possible compositions from any scene, to help decide on the perfect one.

Photographers shouldn't discount the advantages of using cropping Ls, especially in landscape photography. There is a degree of freedom when looking through cropping Ls that you don't have when viewing a scene through a camera's lens. For one thing the possibilities from framing a subject with cropping Ls aren't limited to the viewpoint or zoom range of the lens on the camera. A particular crop that you find with the Ls might inspire you to change lenses, or to move to a different vantage point.

If you don't like to use your hands as cropping Ls, cut some out of black paper or black matte board. If you use paper, the sturdier, the better because flimsy paper will tend to tear at the elbow of the L. Carry the Ls in a flattened part of your camera bag. Avoid folding the Ls because bends in the frame will throw your eye off. (See Figure 4.19.)

Once you determine a good crop by using your hand, or with paper or cardboard Ls, position your camera to capture the composition. You can make several captures to vary the composition with your camera, but by the time you are framing the scene with your lens, you already have a good idea of the composition you want from the cropping Ls.

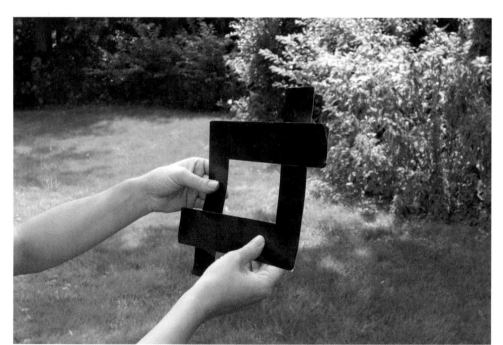

Figure 4.19
Black paper, or black matte board, makes excellent cropping Ls. Hold them at a distance from your eyes and adjust the Ls to find a suitable framing for your subject.

Copyright © Steve Weinrebe

Tip

You can better frame a panorama by using cropping Ls. Several popular software programs will stitch together panoramic images from individual, overlapped photos. But it's not so easy envisioning what an 8-inches-high by 40-inches-wide panorama will look like before you stitch the images together. Cropping Ls, positioned to create the long narrow frame and held close to your face, will give you an excellent idea of what the resulting panorama will look like before you actually shoot it. (See Figure 4.20.)

Figure 4.20 Cropping Ls are a useful tool to help pre-visualize a panoramic image, such as this panorama of seaside rocks in Maine, which I later stitched together in Photoshop.
Copyright © Steve Weinrebe

Potable Aqua

Whether you are trekking in the Himalayas or hiking in the Appalachians, having potable drinking water will be a grave concern. I used Potable Aqua tablets over 30 years ago on an expedition, to turn river water into safe drinking water. It worked then, and I'm pleased to see that it is still available as a solution to help out a thirsty nature or landscape photographer who is far in the field without a water bottle. (See Figure 4.21.)

Potable Aqua consists essentially of iodine tablets that dissolve in water, killing bacteria present in the water. You only need a quart or liter bottle to fill from an available water source. A canteen works well for that part. Then dissolve two tablets of Potable Aqua into the water, shake to dissolve, and wait 30 minutes. When dissolved, iodine and an acid are released to disinfect the water. The iodine may impart a slight odor and yellow color to the water, and if that bothers you there is a companion product called P.A. Plus, made from ascorbic acid, to dissolve in the water after the 30 minutes to remove any taste or color. In my experience the slight taste didn't bother me but everyone has different tolerances, so if you want to take the extra step after the iodine tablets have done their job, use the neutralizing tablets.

Figure 4.21
Even this clear mountain stream in Vermont likely contained bacteria that could have make me ill if I drank it—a good candidate for Potable Aqua to make the water safe to drink.

Copyright ©
Steve Weinrebe,
Getty Images

As the literature states, Potable Aqua works against bacteria, viruses, and giardia lamblia. If you use Potable Aqua, be sure to follow the directions, and not to ruin the tablets by letting them get wet. The bottle they come in is very small and easy to carry on your nature hike. (See Figure 4.22.)

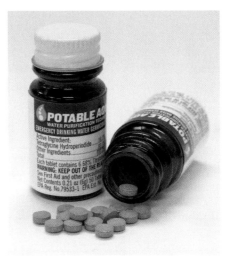

Figure 4.22
When you're photographing far from a potable water source, Potable Aqua tablets can help purify an available fresh water source for you to drink.

Copyright ©
Wisconsin
Pharmacal Co.,
LLC

Viewing Tube

Modern digital cameras have amazing LCD displays (the liquid crystal display that previews captures on the back of a camera). Even older digital cameras have very nice displays on the back of the camera. These displays have become sharper and brighter as digital camera technology, and display technology, develops. If you are indoors taking pictures, you can flip through your recent captures to evaluate the compositions, focus, and exposures. However, if you step outside into sunlight, or you are outside taking pictures for nature and landscape photography, it is very difficult to evaluate photos on the camera's display. In fact, in direct sunlight it is virtually impossible to see the images on the LCD display. That's where a viewing tube can help, by masking out the ambient light and letting you see the viewfinder's image clearly. (See Figure 4.23.)

A viewing tube can be made virtually for free, or at the least very inexpensively, if you have a mailing tube laying around the house or can find one in a mail room. I like a three-inch tube for size and ease of viewing. Two inches may be enough if you have a small LCD and are willing to squint, but a three-inch, or 3.5-inch, tube makes for spacious viewing of the LCD with both eyes open, and in very bright light. Just hold one end of the tube against the camera and look through the other end. (See Figure 4.24.)

Figure 4.23 Viewing tubes can help see the camera's display, even in bright light. The shorter ones are easier to carry, but the longer one provides a better view of the camera's preview screen.

Copyright © Steve Weinrebe

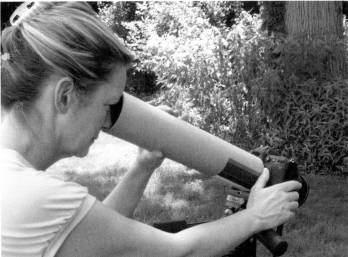

Figure 4.24 A long viewing tube reduces reflections from face or clothing. Hold it to the camera's LCD viewing screen to scroll through your captures without squinting, even when outdoors in bright light.

Copyright © Steve Weinrebe

I have viewing tubes of varying sizes, but my favorite is a 16-inch tube, which allows for very relaxed viewing of the LCD display, with both eyes open and no squinting. When you hold a viewing tube to the camera's display, the LCD display will look bright, and you can scroll through the images with your other hand. If you are using a tripod, you will have both hands free, one for the tube and one for scrolling the images. Otherwise, you'll need to hold the camera with one hand and use that hand's thumb to press the scroll button.

If you start out with a 36-inch, or 42-inch, mailing tube, you can cut several different sized viewing tubes from it. To make viewing tubes, I use a utility knife and push it in again and again as I turn the tube to make single cuts. I have used a hack saw to cut mailing tubes as well. You'll want a fairly clean cut though without a lot of frayed edges, and the utility knife is best for cleaner cuts if you have one.

Once they're cut to size, I apply 2-inch matte-black gaffer's tape to the inside edges. If you want to trump my own viewing tube, spray paint the inside with matte-black paint, or coat the inside with matte-black paper. If you do use paper, don't use a glossy adhesive tape to tape the paper down or the tape's reflections will cause problems. For black paper, double-stick tape on the backside or white glue might be sufficient to hold the paper tightly inside the tube. (See Figure 4.25.)

In my experience, the inside top and bottom edges are the most important to black out. The rest of the inside of the tube will be dark enough for viewing the LCD image. With short tubes, and with many other solutions for blocking light from the LCD, the greatest interference with a clear view of the image comes from reflections from the viewer's face or clothing. A longer tube will have fewer reflections extending into the tube and

Figure 4.25 Apply black tape to the inside of the tube at both ends to cut down on glare.

Copyright © Steve Weinrebe

Tip

Some alternatives for seeing your camera's LCD screen in bright light include using a car for a viewing room, using a medium format *loupe* (viewing magnifier), or large loupes manufactured expressly for viewing camera LCD screens. However, I'm not a fan of cars as viewing rooms because I don't like to run into any form or shelter every time I take some images, just to see if my exposure is correct. As for medium format and larger loupes, they work but can be expensive. Also, loupes require squinting while the viewing tube allows for very relaxed viewing of the camera's screen.

all the way to the LCD screen. What reflections there are will be minimized by the distance from the opening to the camera end of the tube.

A viewing tube doesn't require attaching anything to the camera's digital display, as some commercial viewing solutions do, or modifying your camera in any way. It's not a small item, though, and likely won't fit into your camera bag unless you are satisfied with a shorter tube. But if you are carrying a tripod, you may be able to slip the tripod, or one of the tripod's legs, through the tube to help carry it. A shoulder strap could be easily fashioned for the tube as well by knotting a long string at each end. Whether you want to go to that trouble depends on how you are carrying your photo gear.

Plastic Bag Rain Shield

I was shown this trick for protecting a camera from rain while teaching a workshop in Maine. My excellent teaching assistant, Andy, helped my students as some rain set on us during an outdoor photo shoot. Prepared for the worst, he pulled plastic shopping bags from his rucksack, cut holes the size of the student cameras' lens shades, and placed the bags over each camera, securing the bags to the shades with rubber bands. (See Figures 4.26 and 4.27.)

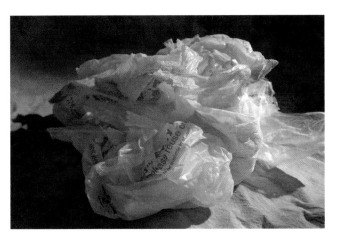

Figure 4.26 Plastic shopping bags make useful rain protectors.
Copyright © Steve Weinrebe

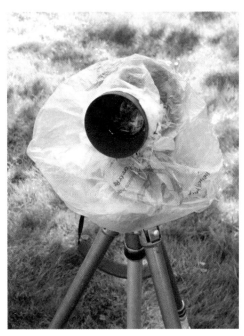

Figure 4.27 Cut a hole in a clear plastic bag to cover your camera while leaving the lens opening unobstructed. Use a rubber band to fasten the opening around your lens shade.
Copyright © Steve Weinrebe

This isn't a new trick but you might like to experiment with variations on the theme. You can try using a large zippered plastic bag. Those bags tend to be sturdy, especially the freezer variety of zippered bags, but they can be murky to look through because of the dense milky plastic they're made from. The clearer, the better, and so another type of bag that works well is a produce bag, the type that come in self dispensing rolls by the produce aisles in grocery stores. The thin clear plastic makes it easier to see the digital LCD preview, as well as the menu options on the display if you need them. Those produce bags are surprisingly strong.

Garbage bags may be large enough to cover the camera and your head while you look through the viewfinder or at the LCD screen in the rain. Personally, I don't like being so covered and shielded from my immediate surroundings when outdoors, and so I don't advocate using a garbage bag to cover your head and camera with while shooting. If you need that much protection, position an umbrella over the camera, or have a companion hold the umbrella. If you are shooting with someone else, take turns holding the umbrella. Better to have half as many good images than a wet camera.

Poncho

I've been a fan of ponchos since my college days, but became an avid fan of the poncho as a great outdoors photo tool when trekking in the foothills of the Himalayas and packing as lightly, and for as many weather conditions, as possible. In the small pack I carried on that long journey, I made sure to have room for a poncho. (See Figure 4.28.)

Besides that a poncho can be used as a padding material to keep equipment from getting scratched, the poncho is by nature designed to serve multiple purposes as a rain cover, or as a ground cloth, or even as a small tent. I've had my own poncho for so long (I keep it in the back of my car these days unless it's in use) that I forget exactly where I purchased it, but an Army & Navy store would be a good place to look for one.

The poncho pictured folds up to a compact 5 by 8 by 2 inches, yet spreads out on the ground to an amazing 50 inches by 80 inches. It's washable too. The poncho has snaps along the sides so that when worn over your head, it snaps closed along the seam below the arms. That makes the poncho great rain gear. (See Figure 4.29.)

The corners of the poncho have sturdy nylon loops that can be used to secure it from blowing away by sticking stakes through the loop and into the ground. Draped over a low-hanging tree branch and secured from the corners, the poncho becomes a small tent or a lean-to to protect you from rain or sun.

When laid flat on the ground, the poncho becomes a ground cloth. It would be hard to overstate how important a ground cloth can be to a nature or landscape photographer. Whether the ground is wet or dry, when laid out flat, the poncho covers enough turf to let you kneel and work with your camera bag, lenses, and filters, and leaves you room to eat a picnic lunch as well.

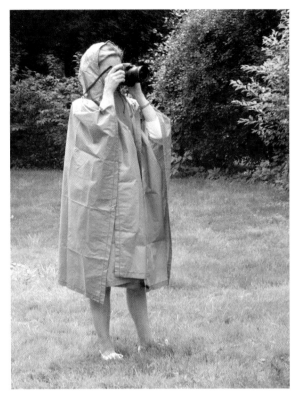

Figure 4.28 A poncho is an excellent tool for nature and landscape photographers, helping to keep you, or your equipment, clean and dry. Folded, a poncho is very compact for packing.
Copyright © Steve Weinrebe

Figure 4.29 This poncho can be left to hang loose, or snapped on the sides for a tighter fit.
Copyright © Steve Weinrebe

Tip

Cut three holes in a lawn-and-leaf-sized garbage bag for an impromptu poncho. A jumbo-sized garbage bag can be used as a ground cloth as well. Cut the bag down its side to double the size when laid flat. Static electricity may be an issue, though, because dirt or sand might stick to the underside, so you'll want to use a garbage bag this way only once. A tarp, or tarpaulin, can make a good ground cloth as well. But a new tarp never folds back down to the small package it came in from the factory, so tarps take up much more room in a camera bag than ponchos.

Tripod Leg Covers

When you are in the field for nature and landscape photography, you often need to protect your tripod from moisture. You might be photographing near water and have to place the tripod in wet sand or moist earth. Or to capture a rare flower or bird, you might need to put on muck boots and get ankle deep in a stream or swamp. If there is a chance of exposing your tripod to water, especially saltwater, protect the tripod's legs with plastic bags, held on with rubber bands. (See Figures 4.30 and 4.31.)

I have spent some time around saltwater and been amazed at how metal items will rust or corrode from exposure to ocean air—even items advertised as "outdoors rated" or "weather resistant." Direct contact with saltwater can be even more destructive to metal. Ideally, anything metal, such as tripod legs, should be washed with clean fresh water and thoroughly dried as quickly as possible after exposure to saltwater. The best practice, though, is to keep your tripod legs dry by protecting them with slip-on waterproof covers. (See Figure 4.31.)

Figure 4.30 Plastic bags and rubber bands can be applied to tripod legs or light stands to keep the metal from exposure to moisture.
Copyright © Steve Weinrebe

Figure 4.31 Protect your tripod legs from moisture by attaching plastic bags to the legs with rubber bands. Slip the leg into the bag first, wrap it around the leg, and then use rubber bands to fasten the bag tightly.
Copyright © Steve Weinrebe

When I am photographing in or near water, like on a beach, I slip gallon freezer bags over the tripod legs, roll them tightly around each leg, and fasten them with lots of rubber bands. Loop the rubber bands over and over to make them snug. The rubber bands can always be cut off afterwards with scissors. Afterward, I moisten paper towels with tap water and wipe down the rest of the tripod to remove any salt from spray and sea air. Pay special attention to joints and areas where little crevices make cleaning difficult. If you've really gotten sprayed by salty air, then use a wet cotton-tipped applicator to clean tough spots. (See Figure 4.32.)

Figure 4.32 Saltwater, and even salt from sea air, can leave residue that needs to be cleaned from your tripod and other equipment when shooting near the ocean.
Copyright © Steve Weinrebe, Getty Images

Tip

Don't collapse your tripod before you clean it, when you've exposed your tripod to moisture. If you do, you'll risk getting the moisture inside the leg tubes and the metal might begin rusting from the inside out. Wipe the tripod down thoroughly before collapsing it. Dry it with a cloth or a hair dryer if you've returned indoors with the tripod to clean.

Beach Wind Screen

While on the subject of saltwater, a beach windscreen makes a great all-purpose wind protector when photographing outdoors. One of the challenges with outdoors photography is that high winds shake cameras and tripods, causing motion blur. That's where a beach wind screen can help protect your camera from movement, and protect the photographer as well, with a calm buffer zone. (See Figure 4.33.)

Figure 4.33
Beach wind screens can help protect the camera and tripod from wind. Less wind striking the camera means less chance of motion blur in the image.

Copyright © Steve Weinrebe, Getty Images

Even imperceptible movement, from wind striking the camera body, can cause visible blurring in the image. Time exposures suffer the most. With landscape or cityscape photography, typically, you'll want to photograph at a small aperture and low ISO, which may require a slow shutter speed. Evening or night photography will require even slower exposures. Camera shake from wind causes motion blur, which can reduce overall sharpness in an image, and will be most pronounced in specular highlights—the highlights will become a line or oblong shape instead of a point. (See Figure 4.34.)

Beach wind screens have stakes at intervals. Grab a nearby rock, or pack a hammer in the car, to bang the stakes into the ground. The wind screen can be stretched out on end if the wind is steady from one direction, or wrapped in a horseshoe shape around the camera if the wind is coming from several directions. The stakes are simply dowels with points cut into the tip, and if one breaks, it is easily replaced. The windscreen is not terribly high, protecting mostly a few feet off the ground, but because it is the torque, or twisting, motion of the tripod that causes motion blur in images, even the few feet of protection will help tremendously to prevent camera shake. If you are shooting a landscape, it may not matter if the camera is 3 feet or 6 feet off the ground since the horizon line is likely far away. The lower the tripod is planted behind the screen, the more protection you'll get. (See Figure 4.35.)

Figure 4.34
Camera shake from wind striking the camera and tripod can cause specular highlights to stretch out as lines or oblong shapes, as in this time exposure of the Hong Kong harbor.

Copyright © Steve Weinrebe, Getty Images

Figure 4.35
Pound the windscreen's stakes into the ground to protect the camera from shaking. The windscreen is large enough to leave plenty of room for a photographer to work.

Copyright © Steve Weinrebe

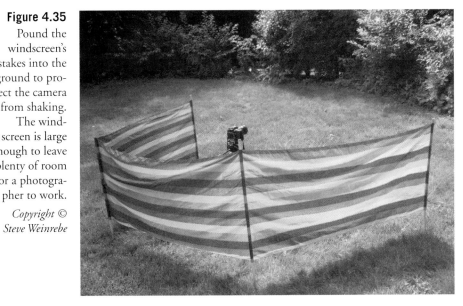

Tip

Pounding the windscreen's stakes into sand or turf can be done without much difficulty, but solid surfaces pose a problem. If you have to use a wind screen on a hard surface and have arrived at your photo shoot with a vehicle, whether it be a car, truck, or golf cart, position the vehicle upwind as close as possible to you, to shelter your camera and tripod from the wind.

Quiver

Without making puns about shooting, a quiver is a standard tool in archery that can also be a handy tool for nature photographers traveling light and carrying a small tripod. A quiver is essentially a sleeve made to hold arrows. That means it is long and designed to hang over a shoulder or from a belt. But the shape of a quiver is perfect to carry a small tripod. (See Figure 4.36.)

Quivers can be purchased very inexpensively and are made from either strong cloth or faux leather. They can be floppy, made to fold away when empty, or rigid so that they retain their tubular shape even when empty. Look for one that has a reasonably large diameter at the opening. The bottom will be more slender than the top, but tripods are shaped that way as well. Also, when shopping for a quiver, pay attention to the strap. The best quiver for a tripod will have the top end of the strap anchored at the very top of the quiver. That will help balance the quiver when using it as a small tripod case and prevent it from being top-heavy. (See Figure 4.37.)

The quiver pictured in Figure 4.37, the Allen Company's Sidekick Quiver, is made of flexible cloth and can be folded up when not in use. I modified it slightly with a safety pin to hook the loop closer to the top of the quiver for better balance. I also have a Trophy Ridge Mohican Hip Arrow Holster, which is a small, 3-inch-diameter, rigid tube that holds a mini travel tripod securely, even with the legs extended. These quivers cost about $10 at the time of this writing. Try to buy the quiver in person, not online, so that you can be certain it will fit your own small tripod.

Polarized Sunglass Lens

A simple polarizer filter can be made from a spare polarized sunglass lens. The lens I carry in my little family point-and-shoot bag is from a pair of sunglasses from which I swapped lenses for prescription lenses. If you ever turn store-bought sunglasses into prescription sunglasses, make sure to ask for the original lenses back so you can use them as a photo polarizer. This tool is best for nature photographers who use a small point-and-shoot camera with a small lens at the front. But if you can find a pair of very large polarized sunglasses, you may be in luck using this simple polarizer with a larger lens like a digital SLR lens. (See Figure 4.38.)

Figure 4.36 A quiver is a long slender sleeve made to hold arrows, but it can just as easily hold a small tripod.

Copyright © Steve Weinrebe

Figure 4.37 Find a quiver that has the strap attached at the top end, or modify it so that it isn't top heavy. This quiver fits like a holster, with a clip that positions the tripod for easy retrieval.

Copyright © Steve Weinrebe

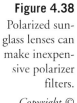

Figure 4.38 Polarized sunglass lenses can make inexpensive polarizer filters.

Copyright © Steve Weinrebe

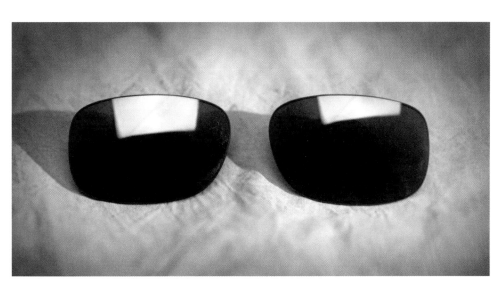

If you don't have spare polarized sunglass lenses, you can purchase an inexpensive pair of polarized sunglasses and pop the lenses out of the frames. You can even use the sunglasses you are wearing, although you may have a little difficulty rotating the frames around the front of the camera for the optimum effect. (See Figure 4.39.)

Figure 4.39
A polarizer can darken a blue sky so that clouds are more pronounced. For these images I rotated the lens from a pair of neutral-colored sunglasses in front of the camera's lens until I could see the sky darken around the clouds, and then snapped the shutter. The bottom image is without the polarized sunglasses, and the top image is with the sunglasses in front of the lens.

*Copyright ©
Steve Weinrebe*

Polarizer filters reduce glare coming through the filter to eyes, for glasses, and to a camera's chip with photography. Polarizer filters can make a blue sky look like a darker blue, or a pond surface look transparent. The angle of your view relative to the source of the glare will determine how much of the reflection you can get rid of with the polarizer.

Polarizer filters screwed onto a lens have two rings, one fixed and one that freely rotates. By rotating the polarizer and looking at the live image, the photographer can see at what point of rotation the reflections are mostly reduced. The little hand-held polarized eyeglass lens can work the same way. Just hold it up against the lens, concave side inward so that the sunglass lens wraps around the lens barrel of the point-and-shoot, and rotate the sunglass lens while looking at the live image on the LCD screen. When you find the best angle of rotation for your scene, snap the shutter.

Tip

The polarizer lens from sunglasses might have a tint. Try to find the most neutral-colored pair of polarized sunglasses for photographic use. One of the advantages of shooting digitally is that images can be white-balanced, also known as gray-balancing, to correct the colors in the image. If your polarizer is off-color, green or brown or yellow, be sure to use an auto-white-balancing setting on your camera or white-balance the image in software after you download it to your computer. Chances are, if you are using an auto exposure setting on your camera, your camera will color-correct for any tint to the lens, but you may need to adjust the image further if the tint is not altogether removed.

Moisture-Absorbing Packets

If you rummage through your medicine cabinet, or open a package of just about anything new, chances are you'll find small moisture-absorbing packets (also known as desiccant). These packets help keep pills and other medicines dry, as well as suck moisture out of the air within product and clothing packaging. These packets can help keep your photo equipment dry when shooting outdoors, especially in extended humid or damp conditions. (See Figure 4.40.)

Moisture-absorbing packets or nodules are also called a desiccant, for the moisture-absorbing substance they contain. There are many substances that can absorb moisture, but what we want is a simple way to keep equipment dry. Save the packets and use them when they are new, not when they've been shelved for many months. Eventually, depending on the level of surrounding humidity, these packets will lose their moisture-absorbing quality and be useless to you.

For that reason, try to use packets from dated products, like vitamins or pharmacy items, so you have an idea of the expected useful life of the desiccant. If the packets have been

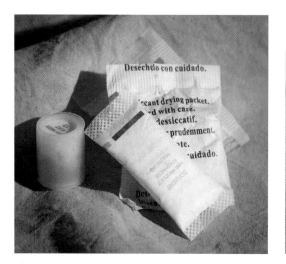

Figure 4.40 Moisture-absorbing packets can be found in medicine and pill bottles, as well as in the packaging of newly purchased items. These packets can help keep your photo gear dry.
Copyright © Steve Weinrebe

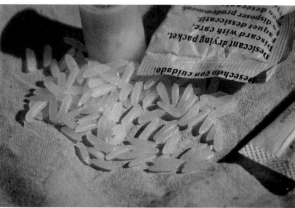

Figure 4.41 Rice has excellent moisture-absorbing qualities. Use a packet of cotton cloth filled with rice to help keep the interior of equipment bags dry.
Copyright © Steve Weinrebe

directly exposed to moisture though, or feel caked up inside, discard them. Some desiccants include a chemical that will allow them to change color when the moisture-absorbing quality is expended. So if the desiccant has a color, like blue or pink, it's also a good idea to discard it.

I have explained how useful plastic bags can be when heading outdoors with delicate camera equipment. Those plastic bags make excellent small environments to keep out humidity. Plastic is porous, though, and moisture-absorbing packets can help keep that small environment even dryer. If you are packing memory chips, lenses, small point-and-shoot cameras, flash units, and so forth, and have to use them in humid air or with sweaty hands, you'll help keep them dry by placing them back into plastic bags with moisture-absorbing packets in them.

Rice can work well as a desiccant too, although you'll have to create your own packet of rice. You may already keep rice in a salt shaker to keep the salt dry. The reason it's so hard to keep salt dry in a humid environment is because salt is also an excellent desiccant. But salt has corrosive qualities as well, so you wouldn't want to use salt as a desiccant around metal camera equipment. (See Figure 4.41.)

Camera bags, however, can take on an odor when exposed to very humid conditions so when you've returned home from a nature or landscape shoot, your bags may have become slightly damp. Letting them sit closed without anything to absorb moisture or odor inside is a bad idea. Open baking soda boxes, the type used in refrigerators, can help prevent odors from developing inside camera bags and gear cases after you're back home from those wetlands, or that beach, you've been photographing.

Headlight

An LED headlight is a great tool for illuminating scenes without using your hands. These lights are made to fit over your head with an attached strap. That's what makes them excellent companions on a nature or landscape photo shoot, because if you are passionate about your outdoors photography, you may well find yourself outdoors after dark, or before dawn break. (See Figure 4.42.)

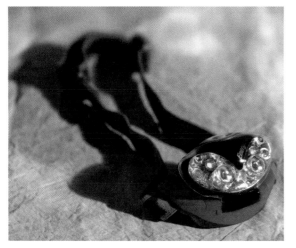

Tip

I use an LED headlight in still-life sets as a small light source because the light is very bright and easily positioned. The cool color of the LED light is closer to daylight than tungsten light. If your final product is black-and-white, the color of the LED is irrelevant. I often mix the LED light's illumination with tungsten lights and let the LED's blue color add some color ambience to a small still-life set.

Figure 4.42 Headlights are small, but powerful, LED flashlights attached to a strap to fit around heads. They are great tools to carry on outdoors photo shoots for illumination. This Energizer 6 LED Headlight has red LEDs for use in night-vision mode.
Copyright © Eveready Battery Company, Inc. Reproduced with permission. Photo Copyright © Steve Weinrebe.

A headlight can be used to fill some light into macro shots as well. It won't add much in sunlight, but if you're shooting in shadow, under a dense forest canopy for example, you can hold the light up close to a subject to help fill in the shadows. (See Figure 4.43.)

The headlight pictured has six LEDs. One of the best features of this Energizer headlight is that it has, besides spot- and floodlight abilities, a night light. Two bright-red LED lights can give you enough light to work with, without being so bright that it will scare away wildlife or reduce your ability to see in the dark once you turn the light off. If you drop something or just need to find something in your camera bag, the red LED will likely be enough. If you need more light, the spotlight is extremely bright. Because the headlight straps onto your head and pivots downward on an adjustable hinge, your hands are free to change lenses or, at the end of a long day, pack up to go home.

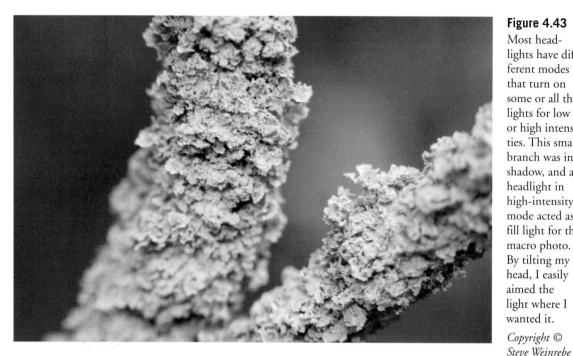

Figure 4.43
Most headlights have different modes that turn on some or all the lights for low or high intensities. This small branch was in shadow, and a headlight in high-intensity mode acted as a fill light for this macro photo. By tilting my head, I easily aimed the light where I wanted it.

Copyright ©
Steve Weinrebe

True Story

Years ago I had an assignment to photograph Hong Kong for a corporate client. Hong Kong is a beautiful city and is especially photogenic at night because of all the neon signage and lighted buildings. I had learned from experience that some of the best cityscapes are photographed from rooftops. To photograph from vantage points that are unusual and novel, it's best to gain access to rooftops that most people don't have access to. I obtained permission to photograph from the rooftop of one of Hong Kong's finest hotels along the Kowloon side of Hong Kong harbor. From there I had a magnificent view of Hong Kong island and its cityscape, seen in the final photograph (composited with a starry sky), in Figure 3.12 from Chapter 3. After dark I found myself without any light in my immediate area to work with. I could have used an LED headlight to help find and change lenses and generally see my immediate surroundings. However, at the time LED headlights hadn't been invented yet, and I used an old-fashioned flashlight. Unfortunately, "hands-free" in that situation meant laying the flashlight on the ground and hoping some of the illumination spread to where I needed it. With an LED headlight I could have aimed the light wherever I turned my head, and my hands would have been free to work.

5

Irreverent Portrait Tools

If photographing nature and landscape or still-life imagery is calming and meditative, making images of people is part of life itself. From ancient civilizations to modern day, making art from the likenesses of people has been a part of our culture. Whether you photograph portraits with high-end digital equipment or use point-and-shoot or mobile phone cameras, you are a part of that tradition. (See Figure 5.1.)

I personally believe portrait photography is one of the highest forms of artistic photography, although I use the term "portrait" loosely. Not all portraits are formal, and portraits can be made indoors or outdoors. Most people, upon first acquiring a camera, photograph themselves—in mirrors, with the self timer, or just hand-holding the cameras in front of their faces. Self-portraits are an important part of the art of portrait photography.

Besides that self-portraits can be fun to make, they're part of the process of discovery for how we work with people in front of the camera. There is no more powerful tool in portrait photography than the photographer's "attitude" (see Chapter 3). If you are tentative and shy when taking pictures of yourself, you may have that demeanor when taking pictures of others. People respond to the photographer, not the camera. If you want to capture someone, or a group of people, at their best, project your best when taking pictures. Be gregarious, even if you are not a gregarious person. Be entertaining, funny, direct, uninhibited, even if you might not act that way without the camera in your hand. Portrait subjects want you to be that way; they want to be loosened up because most people understand that they will be remembered for how they are captured in one fraction of a second, and few people want to be remembered as stiff and withdrawn.

Figure 5.1 Making portrait images of people has been a part of our culture since ancient times.
Copyright © Steve Weinrebe, Getty Images

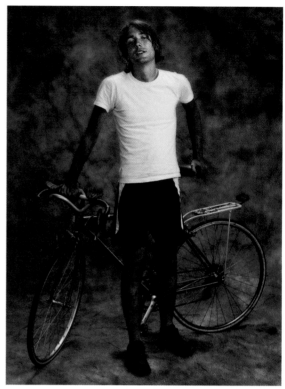

Figure 5.2 Being open to spontaneity can help capture impromptu portraits. My wife's nephew had just arrived after a four-day bicycle ride from Ohio to New Jersey. Before he cleaned up, I placed him in front of a background with his bike, positioned some lights, and shot this portrait.
Copyright © Steve Weinrebe, Getty Images

When you do have a portrait subject in front of the camera, you may need to act and react quickly. As with other types of photography, planning ahead can help you a lot, because the fewer decisions you have to make while taking the pictures, the more your mind will be on your subject. If you have a scheduled portrait, don't wait for someone to show up before you think about what you want to do. Always give yourself options: choice of backgrounds, lighting, clothing, and props, even if you end up using few of these. Photography is full of happy accidents, and the best portraits can be the result of such "accidents." Are they really accidents, though? Not if you are well prepared. Then those spontaneous moments were guided to, and given time to evolve, because of the preparation, environment, and atmosphere you created for the shoot. (See Figure 5.2.)

Portrait tools are marketed in abundance in stores and catalogs, at trade shows and in online videos. You could mortgage your home to set up a first-class portrait studio. But

in the era of six-dollar portraits at mass retailers, paying for that equipment won't be easy. Whether you are shooting portraits professionally, as a hobby or avocation, or as a favor to someone you know, having some easily found tools and handy lighting solutions can help you with your portrait photography, and leave you with some money left over for a lens or new camera to make portraits with.

Plain Cloth Backgrounds

Unless you plan to only photograph portraits outdoors or in room settings, backgrounds are an essential part of a portrait set. Painted backgrounds can be purchased or made, but because they have a character to them from the colors used and the patterns of the paint, they may be right only for certain portraits. Plain backdrops are more flexible, and neutral-colored backdrops are the most flexible for the same reason neutral colors are good for clothing or cars or anything else. Neutral colors don't stand out or scream for attention, and don't distract from the surroundings. In the case of portraits, neutral colors won't distract from the people posing in the picture. Clothes are less likely to clash with the background as well. (See Figure 5.3.)

One simple choice for background material is black velvet. Buy it by the yard at any retailer that sells fabric. Black velvet is very inexpensive, and if you sew it together, the seams will not likely show in photos. Black velvet chews up light. By that I mean that the material has almost zero reflectivity and so you can concentrate on lighting your subjects and not worry too much about the light falling on the background. Contrast that with using a paper or painted background, which will show pronounced shadows if too close to your subject. (See Figure 5.4.)

For home-based portrait setups, space is usually a problem. You may be photographing portraits out of your basement or living room, or you may be photographing someone in their own living room. Either way, you'll be dealing with low ceilings and lots of problematic reflections, especially f you're using a light with an umbrella, or a soft box. Black velvet can give you freedom to light the portrait subject from a light positioned just to the side of the camera. Because the background will be jet black, make sure to fill in the shadow side of faces to separate those tonal areas from the background.

Tip

If there is anything reflective in the framing of your portrait photograph, such as a glass-covered picture on the wall behind the person, you can use black velvet to make the reflection go away. Position a sheet of black velvet, whether taped or pinned to the wall, or hanging from a pole, so that it is reflecting into the glass instead of other parts of the room.

Figure 5.3 Plain-colored cloth can make simple background material for portraits.
Copyright © Steve Weinrebe

Figure 5.4 Black velvet provides an even, dark backdrop without texture or sense of distance to the subject. Make sure the black extends to the edges of the image area for the best effect.
Copyright © Steve Weinrebe

Muslin, like black velvet, provides a neutral background color that can be used again and again. The shade of the muslin, how bright it is, can be controlled by how far or near the light source is. You can use it outside for daylight studio portraits, or in your own studio setup. Muslin can be purchased in 10-foot widths. In fact, a muslin painter's dropcloth can work very well for the same purpose. (See Figure 5.5.)

Don't bother to fold your muslin backdrop; just stuff it in a bag. That's not out of laziness. It's because random wrinkles look more natural and less distracting in a backdrop than evenly spaced folds do. A thinly milled 10-foot-by-10-foot sheet of muslin will stuff into a plastic shopping bag easily. Thicker fabric can be stuffed into plastic storage containers that can be purchased at most discount retailers. (See Figure 5.6.)

Painting muslin backdrops can be fun, although a bit tedious to make. If you want to paint your own backdrop, just be prepared to use a lot of paint. Muslin really soaks the paint up, and to achieve a random pattern with different colors or tones will take a lot of time and patience, as well as a large area of floor to lay the muslin out on for

Figure 5.5 Muslin has a neutral color that's suitable as a backdrop to match a wide variety of outfits. In this portrait, the muslin is out of focus, to make any wrinkles smooth, and lit from beneath, to create a slightly textured look similar to a painted backdrop.
Copyright © Steve Weinrebe

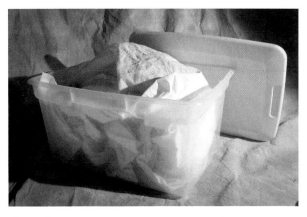

Figure 5.6 Containers like this can be purchased at discount retailers and big-box hardware stores, and can hold a 10-foot-by-20-foot bundle of muslin.
Copyright © Steve Weinrebe

painting. If you want an art project, though, making a painted muslin backdrop can be fun and rewarding. (See Figure 5.2.)

The farther you can get a muslin backdrop behind your subject, the more out of focus the wrinkles in the muslin will be. A wide aperture will help send any wrinkles out of focus because the wide aperture gives the photo a very narrow depth of focus. Those out-of-focus wrinkles will become a random texture behind your subject, making your portrait subject stand out from the backdrop. If you are shooting your portrait subject full figure, it may be hard to send the background out of focus. Don't worry, though, because at that distance the wrinkles in a muslin backdrop will be very small and still take on the feeling of a random texture set apart from your subject. And you can always make any wrinkles look out of focus with some blurring in post-production.

For pure simplicity, use a white bedspread for a neutral high-key backdrop. Don't fold it, though, and if you have just purchased a white sheet for photography, wash it, throw it in the dryer, and then stuff it in a bag just like with muslin so that the sheet will have

random wrinkles. On the other hand, if you have a way to stretch the fabric out to be a very flat white background, like pinning it to a wall tightly from corner to corner, iron the wrinkles out first. (See Figure 5.7.)

When shopping for a white sheet for a background, look at the white color of the sheet. The color white can vary widely from product to product. Just look at white paper around your home or office and you'll see several different whites. Look for a warmer white, or a white that has a slightly cream color, for portraits. Stay away from white sheets that have a cool, or blue, bias to the white because that will be less attractive against skin tones.

Tip

A colored bedspread can make a nice backdrop for photography as well. Bedspreads can be expensive, but you may find a plain-colored sheet on sale for a real bargain cloth backdrop. Because the bedspread will be used for a photo background, it doesn't matter what the fabric is; a polyester backdrop photographs just as well as cotton.

Figure 5.7 Like muslin, a white bedsheet makes a good white background for portrait photography. In this portrait, I positioned the sheet several feet behind the subject and kept the light intensity low so that the sheet wouldn't become a blown-out white in the photograph. The neutral color gives a different mood to the portrait compared with the warm-toned muslin background in Figure 5.5.

Electrical Pipe

Whatever you end up using for your photo background for portraits, you'll need a way to hold the background up. Pipe does a great job holding up both rolled backgrounds and cloth backdrops. Galvanized electrical pipe makes an excellent background holder for a number of reasons. The pipe is neutral in color, comes in 10-foot lengths (long enough to hold a 9-foot roll of background paper or a large cloth backdrop), and has a narrow enough diameter to easily accommodate spring clamps. (See Figure 5.8.)

For supporting photo backgrounds, avoid narrow-diameter PVC pipes. They are too flexible and will tend to bend in the middle under the weight of the background. Half-inch copper plumbing pipe (you may have a piece lying around) is also good for suspending shorter backgrounds like a 4-foot background. A 10-foot length of copper pipe can suspend a large background, but if the background has any weight to it, like with a 10-foot roll of background paper or a heavy muslin backdrop, the copper pipe will tend to sag in the middle. (See Figure 5.9.)

That's where galvanized electrical conduit comes in. Also known as electrical metallic tubing, both the half-inch and the three-quarter-inch size work very well as a background support. The metal is less flexible than copper, and the extra diameter provided with the three-quarter-inch electrical conduit provides a much sturdier support that won't sag under the weight of most backgrounds. Electrical conduit is lightweight and, like most small-gauge pipe, can be easily cut with a pipe cutter. (See Figure 5.10.)

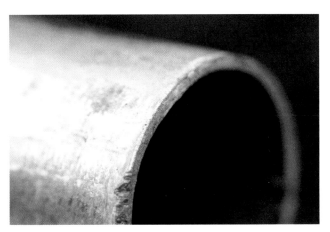

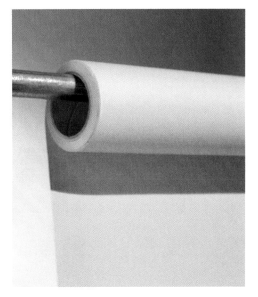

Figure 5.8 Galvanized electrical conduit makes a lightweight, sturdy, and inexpensive support pole to suspend backgrounds from.
Copyright © Steve Weinrebe

Figure 5.9 Electrical conduit is a sturdy and inexpensive solution for supporting even heavy portrait backgrounds.
Copyright © Steve Weinrebe

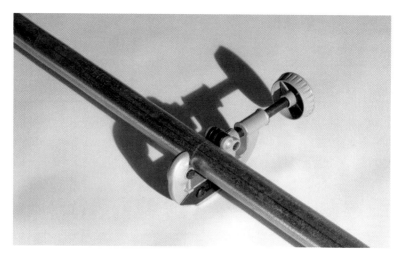

Storage Hooks

Pipes make great supports for backgrounds, but now you need something to hold up the backdrop support for the portrait shoot. That can be accomplished a number of ways. Of course there are traditional supports for background poles including light stands and clamps, and if you're a professional photographer, you may have several of these already. But if you are dabbling in portrait photography or setting up a home studio, you may want an economical solution to hold up your portrait backgrounds. As long as you are willing to drill a couple of holes in your wall or ceiling, storage hooks make a great solution for holding up the pole, or pipe, that supports your background. (See Figures 5.11 and 5.12.)

Figure 5.11 Storage hooks are strong enough to hold up heavy rolls of background paper or cloth backgrounds.

Copyright © Steve Weinrebe

Figure 5.12 Sling the pole, or pipe that holds the background, over the storage hooks.

Copyright © Steve Weinrebe

Storage hooks come in many different shapes and sizes. They are coated with a non-skid rubber, so the pipe that your background is attached to won't easily slide on them. Storage hooks come in a variety of colors as well. You should ideally look for black ones only so that they won't reflect into anything you may ever have in a photo set that has a mirrored surface. But for portraits, the color doesn't matter, so feel free to buy red, yellow, or any other color hooks as it pleases you. In fact, if they will be anywhere they may be bumped in to when not supporting a background, a bright color may be a good idea.

Always pre-drill a hole when you are going to screw in one of these hooks. Use a drill bit slightly smaller than the threads of the screw-in part of the hook. Once screwed in, these hooks will stay put and hold up background poles quite easily. Most storage hooks have a depth to them so you can fit more than one pole onto them, but that's not practical when using paper rolls. However, if you are hanging different colors of cloth for backgrounds, you can hang a few backdrops, each attached to its own length of pipe, and just rotate the one you want to be in front by lifting it off and repositioning it in the order they sit on the hooks. (See Figure 5.13.)

Figure 5.13
Storage hooks can hold up a background roll anywhere you want to position the portrait set, as long as you have a wall or ceiling to screw them into.

Copyright © Steve Weinrebe, Getty Images

Tip

If you have a drop ceiling, you can use the brackets that support the ceiling panels to hold up your background. Use picture-hanging wire to make about a 6-inch loop around the brackets that support the ceiling panels. The loop will go up around the bracket, and hang down. Try threading the wire up around the bracket and back down, and then tying the ends securely together. You need two of these spaced apart a little less wide than your support pipe. Then just slip each end of the pipe through each loop to hang the background support pipe from your ceiling. If your background has substantial weight to it, hang the loops on the drop ceiling brackets near where the brackets are supported by the ceiling joists. Test them and use good judgment as to how much weight you can hang from them, but the drop ceiling brackets, if installed properly, should be strong enough to hold a cloth background clamped to a lightweight pipe.

A-Clamps

If you've ever used a 9-foot roll of background paper and unrolled it from high up while on a ladder, you may know that as soon as the weight of the paper that's been dropped down gets heavy enough, it will keep pulling the paper down of its own accord, and you have to quickly stop the paper from unwinding or the entire roll will end up in a heap on the floor. If that happens, you need to immediately clamp your background paper down to the pipe that's holding it. A-clamps, a.k.a. spring clamps, are what you'll need, and you should have a couple in your pocket, or clamped to the ladder, background support pipe, or your clothing, before you begin unrolling any background paper. (See Figure 5.14.)

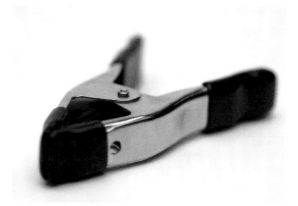

Figure 5.14 A-clamps, a.k.a. spring clamps, are an essential photo tool for holding in place the pipes that support your portrait backgrounds.
Copyright © Steve Weinrebe

True Story

We learn by our mistakes, and that's why I never get caught without an A-clamp or two when unrolling background paper. I have had entire rolls of background paper unroll in seconds while I stood high in the air on a ladder. A 10-foot roll of paper lying on the floor like ribbon candy isn't a pretty sight. Unfortunately, once background paper unrolls, and unlike a cloth background, it will never retrieve the seamless background look it was bought for, no matter how carefully it's rolled back up.

A-clamps can be bought very inexpensively at any big box hardware retailer. They are called A-clamps because they are shaped like the letter A, but your retailer may know them as spring clamps. I like the ones the hardware stores sell because they usually have black rubber handles and clamp tips, and cost about a dollar. There are A-clamps that are marketed specifically to photographers and videographers, film gaffers and the like, that cost three times as much or more. I own several of those more expensive clamps as well, and I find little difference between the two. The rubber at the tips of the clamps may last longer with the more expensive variety, but I've never had a real problem, and the A-clamps from the big box hardware stores are so inexpensive it's a lot easier to purchase a dozen or more without feeling like you've just put a dent in your savings.

Two ways to use A-clamps to hold backgrounds are at the side of a roll of paper to keep it from unraveling, and along a pipe that holds a cloth background. For rolls of background paper, you need at least two clamps, one to hold the paper to the pipe and one to hold the pipe to whatever is holding the pipe up. You may want a couple of clamps at the bottom of the paper, as well, to hold the paper from curling back up. For cloth backgrounds like velvet or muslin, clamp the top end of the cloth to a pipe at intervals, and then let the cloth hang down for the portrait background. (See Figures 5.15 and 5.16.)

For a more direct use of A-clamps in portrait photography, you can clamp a subject's clothes tightly against their body. I learned this trick years ago when shooting portraits of local news anchors. When they sat on a stool for a head-and-shoulders portrait, their jackets or dresses would often look rumpled in the front. An A-clamp at the subject's back side does a great job keeping clothes from looking rumpled in the front. (See Figure 5.17.)

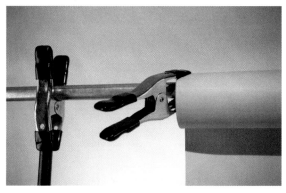

Figure 5.15 Use inexpensive A-clamps from big box hardware stores to prevent a roll of background paper from falling or unraveling. A-clamps are used here to hold the paper's support pole to a light stand, as well, by letting the pole rest in the open end of the clamp.
Copyright © Steve Weinrebe

Figure 5.16 Use A-clamps at intervals to secure a cloth background to a pipe.
Copyright © Steve Weinrebe

Figure 5.17 An A-clamp, at a subject's back and hidden from the camera, can hold a jacket or dress tightly to someone's body so it doesn't look rumpled in a portrait. *Copyright © Steve Weinrebe*

Tip

Search dollar stores for very inexpensive A-clamps. The cheaper, the better, and the weaker the better. Weak A-clamps, clamps that have a spring without a tremendous amount of tension, serve a purpose in portrait sets: holding a reflector to a light stand without punching a dent into the reflector, for instance. Having both strong and weak A-clamps gives you the option to use a clamp with more or less tension when clamping things together.

Stools

When I'm teaching, I like to have a stool to sit on when I'm not standing or jumping around making a point, and I'm always amazed at the blank looks I get when I ask for one. You may not need one for me, but for portrait photography you should always have two or three stools, preferably of different heights, waiting to be used. (See Figure 5.18.)

You should have at least one short stool and one taller stool. A 24-inch stool and a 30-inch stool will do nicely. The stool that your subject will sit on isn't a prop and will likely be out of the picture. It's just a way for the subject to relax but still sit at a good height for your camera. You can buy nice stools, but for portrait photography the stability of the stool is more important than its looks. The stools I use for portraits are very generic but very stable, and have enough weight that they won't easily tip over.

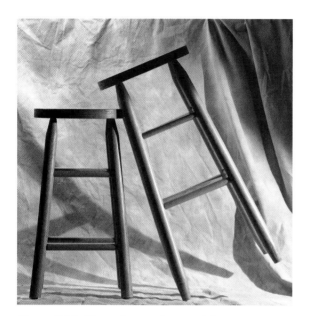

Figure 5.18 Keep a few stools around for portrait photography. Choosing sturdy stools is more important than choosing pretty stools, since the stools will likely be out of the photo.
Copyright © Steve Weinrebe

Figure 5.19 Different height stools help accommodate different sized people.
Copyright © Steve Weinrebe

When sitting on a stool, your subjects can vary their posture without chair arms or back getting in the way, or the slope of a chair's seat setting their body off at a funny angle. A stool can be easily positioned or taken out of a set with one hand. If you're photographing a group portrait, you can use stools to help even out the subjects' height for the photo composition. You can put a shorter person in a taller stool, for instance. (See Figure 5.19.)

I'm not a fan of cushioned stools unless I'm sitting on them for something other than photography. Your portrait subjects aren't going to be sitting on the stools for a long time, and a hard-topped stool will keep them more still. I find that subjects tend to wobble on cushioned stools, so I stay away from them for a portrait set.

If you need to shoot a larger area and the area of the stool is going to end up in the frame, use a cloth backdrop if possible. If it is large enough, like 20 feet by 30 feet, for example, you can drape some extra cloth from the foreground of the cloth over a stool so that the stool is hidden.

Breath on a Lens

Soft focus portraits have a sentimental and timeless look. Although soft focus isn't for everyone's taste, it's a look that can add a dreamy quality to portraits and be attractive for a subject. There are many types of soft focus filters for cameras and many of them are excellent. I own several myself and have my favorites. But one of the problems with soft focus filters is that they have a fixed diameter, and if you own several lenses with varying filter sizes, you would have to own a soft focus filter for each of them to cover yourself. If you usually use one lens for portraits—an 85mm or 105mm, for example— you could buy a soft focus for only that lens, but you'll always be limited if you want to try out a different lens, with a different filter size, for a portrait. For the simplest and most flexible of soft focus techniques, simply breathe on your camera lens just prior to taking the portrait. (See Figure 5.20.)

The moisture from breathing on a lens doesn't last long, only a few seconds in a dry environment, so you'll have to work quickly. Every time you breathe on a lens, the diffusion quality of the soft focus may be different, but that adds to the spontaneity of your portrait session. If the moisture on the lens doesn't evaporate quickly enough, or you accidentally get too much moisture on it, wipe the lens gently with a lens cleaning cloth or other suitable material. Always shoot some portrait exposures with and without a soft focus effect because you may decide afterward that you don't like it.

> **Tip**
>
> Don't try this outdoors in below freezing temperatures, or you may end up with ice crystals on your lens. Also, put the lens cap back on only after the moisture from your breath evaporates.

You can try adding the soft focus effect in digital post-production as well. There are some excellent techniques for doing so. In my experience, there is a difference between shooting through something diffuse, like a soft focus filter or a hazy lens, and creating soft focus in the computer. The effect of light coming through a fog filter, or a foggy lens, is a magical look that is difficult to replicate faithfully in digital post-production. (See Figure 5.21.)

Figure 5.20 For a simple soft focus technique, breathe on your camera lens just prior to taking the picture. *Copyright © Steve Weinrebe*

Figure 5.21 For this portrait, I breathed on the lens just prior to snapping the shutter. Each try results in a different effect. I applied a contrast curve to the final image, to optimize the brightness values. *Copyright © Steve Weinrebe*

To control the intensity of the soft focus effect, you can try varying the aperture in the camera's lens. But while this works with traditional glass filters, aperture control for softness is less meaningful here because the density of your breath on the lens will vary, and the evaporation on the glass will be different each time you press the shutter.

An advantage to shooting with a soft focus effect is that you can instantly please the portrait subject. People want to look good immediately, not be told they'll look better after you've had your way with the digital file. You can use this technique, breathing on a lens for soft focus, for just a capture or two and show the subject the previews, knowing that the rest of the pictures will be photographed without any soft focus effect until you add it digitally. That way, the portrait subject knows what to expect, and you have the flexibility of adding the soft focus effect later.

Old TV

Now that the digital transition for TV broadcast has taken place, you might find yourself with an old analog TV sitting around unused. If your camera has an analog (NTSC or PAL) video-out port, you can put that old television to good use as a portrait preview device. (See Figure 5.22.)

When taking someone's picture for a portrait, you can provide yourself and your subject instant feedback when using an external display, and a small TV makes a simple and convenient preview device. It's a great way to recycle an old television as well. Many digital cameras have analog video-out ports. You may even have one and not know it, so check your camera's manual if you're not sure. Use the cable provided with the camera, or go to an electronics store to buy the cable you need to connect your camera to the TV. If your camera has an analog video-out port, it will likely be a small round hole protected by a rubber cap.

A 13-inch television is a good size for video previews, and relatively easy to tote around as well. A larger television won't necessarily be sharper, and a high-definition television may not be your best tool for a preview device because you'll get false expectations of color, thinking the image is so crisp it must be accurate. Also, televisions can be very unforgiving, so you really just want to get an idea of what the photo looks like, the lighting and framing, not an exact replica of what the image will look like in your production-computer setup. You'd be better off sending the previews to a computer display for that, but that's a problem if you have a desktop computer elsewhere that's inconveniently located for your portrait set, and may require additional hardware for an optimal setup.

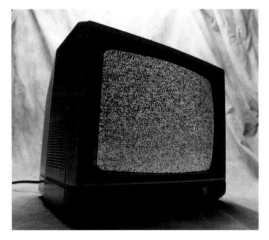

Figure 5.22 Use an old TV as a video preview device for portraits.
Copyright © Steve Weinrebe

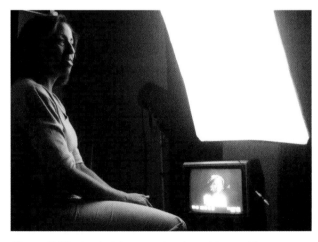

Figure 5.23 A television can give the subject guidance as to how the posture looks or just how the portrait session is turning out.
Copyright © Steve Weinrebe

Depending how old your television is, you may need an adapter/converter to attach your camera's video cable to the TV's antenna input or Video In socket. If your TV has a Video setting, choose that. Another connection option is to plug your camera into a VCR's input, and then attach the TV to the VCR. If you do this, set your VCR to Line or Video. That way, you can make good use of two old-tech devices at once. (See Figure 5.23.)

When I shoot portraits, I like to work fast. With portrait photography I don't believe shooting more is better. Subjects tire and are most fresh in the early part of a portrait session. A television preview can help the subject get comfortable with how you are photographing them, but it may be a good idea to unplug the TV from the camera after a few preview captures. You don't want your subject distracted by the TV.

If you've ever watched an interview subject on television who seems to be constantly looking away from the camera, it's because there is a reference monitor nearby and the subject keeps looking at it. So use a cheap throwaway TV for a quick preview and then take it out of the equation so that the activity, and the dynamic, is just between you and your portrait subject. (See Figure 5.24.)

Figure 5.24

A television preview can help your subject take proper position in the camera, but it's best to take the TV away while shooting so that it doesn't distract your subject.

Copyright © Steve Weinrebe, Getty Images

> **Tip**
>
> A TV for portrait previews is especially helpful when shooting group portraits. One of the difficulties of working with more than two subjects is that someone's head is always in the wrong place. As the photographer, you'll need to carefully guide your subjects to position themselves with optimum sight lines to the lens. But when you're telling your subjects how to stand or squat or shift their heads, they can be greatly aided by having a video showing them exactly what you're seeing through the lens. For positioning it doesn't matter what their eyes are looking at, so it's okay if the subject is looking at a TV preview while moving their head from behind someone's shoulder in order not to be blocked for the photo.

Translucent Powder Makeup

If you have little or no experience with makeup, you should buy this one excellent makeup item to use for portrait subjects. I wish I could remember who taught me about translucent powder makeup, long ago, so I could thank them. Skin, under photo lights and without makeup, will tend to shine from the lights' reflections. Keeping a compact of pressed translucent powder makeup in my camera bag at all times has saved countless portrait shoots by dulling the subject's skin for photography. (See Figure 5.25.)

A professional makeup artist can easily spend a half hour to an hour applying makeup to someone's face for a photo shoot. Fashion models, news anchors, and television personalities are used to sitting in a chair having their face made up to appear in front of a camera. If you ever have an opportunity to hire a professional makeup artist, your job will be easier and your portrait will be better for it. But most portrait sessions don't call for a professional to be on hand applying makeup. Usually, portrait photographers have their subjects very briefly, and you need to make the best use of your time taking pictures. The advantage of a translucent, or colorless, makeup powder is that you can quickly dull the shine from a subject's forehead, nose, cheeks, and chin so that you can light the face without reflections. (See Figure 5.26.)

You don't need to go to a department store cosmetics counter for this powder. You'll find what you need in the cosmetics aisle of any major drugstore chain. Look for an inexpensive powder that is labeled as translucent or colorless. I like powder that has corn starch, and powder made from corn silk, as ingredients. Talc will also probably be an ingredient in any face powder you buy. I don't believe a lot of chemical ingredients are necessary just to dull shine in someone's face for a portrait photo session. Natural ingredients work wonders for neutralizing oily skin, and you won't need to apply a lot of the powder. Ask your subjects first if they have any allergies to cosmetics, and especially to corn starch, for example.

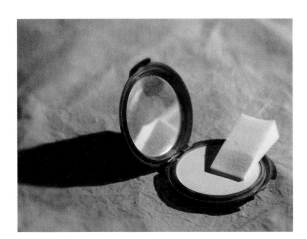

Figure 5.25 Colorless, translucent, powder makeup can dull the shine in a portrait subject's skin.
Copyright © Steve Weinrebe

Figure 5.26 When applying makeup for a portrait shoot, pay attention to the forehead, nose, cheeks, and chin of your subject.
Copyright © Steve Weinrebe

I like the pressed powder, as opposed to loose powder—it's less messy. When you buy the makeup, buy some disposable applicators, as well, so that each person gets his/her own applicator. If you want to splurge, get a new compact of powder for each portrait shoot. People like to see something new being opened just for them, especially if it's something that's going to touch their skin.

If you're like me, you might have little experience in applying makeup. That's okay. All you need to know is that less is more, and you're applying makeup to your portrait subject for photography, not a night on the town. You're not trying to soak up all the oils in someone's complexion for the rest of the day, just the duration of the portrait session. Use a disposable applicator, brush, or cotton ball and lightly brush some powder on the forehead, nose, and chin of your subject. (See Figure 5.27.)

Don't go overboard powdering someone's cheeks; just gently swab a small amount of powder onto the cheeks with strokes that feather the powder in. A portrait subject's cheeks are where you will most likely see flaws in powdering if there is a sudden transition from dull to shiny, so blend the powder in or skip the cheeks altogether if the subject isn't especially shiny there.

Figure 5.27
Go easy with the amount of powder that you apply to a subject's face. Apply it before you start shooting and add more only if needed.

Copyright © Steve Weinrebe, Getty Images

A bald person's head may need some powder as well. For obvious reasons, a hair light, or rim light, may not be a good idea if your subject is bald. But sometimes there is only one bald person in the group shot, and you may want a light from above to separate the shoulders of the subjects. While you are powdering the rest of that subject's face, ask the bald person if you can powder his head, explain why you want to, and leave it up to him. If his skin tone is pale and his head is reflecting your lights, you may need to show him a preview shot to convince him of the need to powder.

No one, man or woman, neighbor, executive, or well-known personality, has ever objected when I asked if I could dab a little powder to cut down the shine on his face for a portrait. Even if at first sight someone doesn't look like his face has a shine to it and you think you can put off applying makeup, you don't want to snap your best portrait shot and realize the subject has already started to shine from perspiration. While taking your portrait photos, you want to concentrate on your subject's expression and posture, not her complexion, so apply the powder before the shoot, and add a little during the shoot only if needed.

Tip

Try to buy an unscented face powder. Whether the powder you use has a scent or not, offer your portrait subject a place to wash it off after the photo session. If you have applied scented powder, you may need to remind your subjects to wash it off because they'll forget you applied the powder by time the shoot is over.

True Story

When photographing some news anchors, I had the good fortune to work with a makeup artist who knew the anchors and understood what they liked for makeup. Her work took considerable time, but when she was done, the anchors came onto the photo set with impeccable complexions and skin that didn't shine under my lights. It helped me to appreciate, not so much that news anchors have makeup on, but the excellent work that enables them to look the way they do on camera.

That makeup artist had "the gift of gab," and there wasn't a quiet moment when she was applying makeup to the news anchors. On another shoot I worked with the daughter of that makeup artist who also was very good, and who had "the gift of gab" even more so. That shoot was for a corporate client, and we were extremely pressed for time with the marketing manager leading us around the facility to complete our shot list. My client, an agency art director, kept tapping his watch because everyone was on the clock. This makeup artist was prepping the marketing manager to pose as a model for one of the shots and taking a great deal of time doing it. But the marketing manager was enjoying the stories she told and the attention she was giving to primp him for the shot. Behind in schedule as we were getting, the art director and I could only roll our eyes at each other because the makeup artist was clearly ruling the shoot for the time being.

Disposable Makeup Tools

As I mentioned, when applying powder makeup to a portrait subject, you want to use disposable makeup applicators. But besides foam swabs and cotton balls, there are other useful items that can be used to primp and alter someone's appearance. (See Figure 5.28.)

Powdered makeup can be easily applied with little, foam, wedge-shaped makeup applicators that you can buy at drugstores or discount retailers by the bagful. Cotton balls and cotton swabs also work well and are likewise inexpensive and easy to find. If you are shooting a portrait at the subject's location, a home or office, just pack a handful of applicators in a zippered plastic bag for the shoot.

Makeup brushes are more costly than the disposable applicators, but there's an irreverent solution to nearly everything. Head to the nearest art supply store, hobby shop, or better yet a dollar store, and look for disposable bristle brushes sold in bulk packages. These brushes may not have the fullness of a dedicated makeup brush, but a portrait subject will be pleased to see you pull a new one out of a package and dispose of it when you're finished applying makeup with it.

Combs can be bought in bulk packages as well. Use a new comb for your subject's hair and dispose of it when you're done. Hair, more than lint, is difficult to retouch in digital post-production. A few seconds tending to a portrait subject's hair with a comb can

Figure 5.28 Use disposable makeup tools when working with portrait subjects.
Copyright © Steve Weinrebe

Figure 5.29 Use disposable combs for hair and, to add to your portrait subjects' comfort level, let them notice that you are using a new one just for them. I purchased these combs in a variety pack at a dollar store for less than 10 cents each.
Copyright © Steve Weinrebe

save hours of effort with photo-editing software. Whether the combs come in a tub or plastic bag, if you go on location for the portrait, bring the container of combs with you. It's not so evident that a comb hasn't been used before, so let your subjects see you pull a new one out for their hair. It's the little things that, bundled together, give your subjects a comfort level that will make your job taking their portraits easier. (See Figure 5.29.)

Tip

In Chapter 1, I mentioned that packing tape can be rolled into a reverse loop so that the sticky part of the tape is on the outside. Put your fingers into the loop and dab the tape against someone's clothing to remove lint. This trick is especially useful for portrait photography, when you may be photographing close enough to clothing that lint will show. People like to be at their best in portraits, and they also like to feel the photographer is prepping them to look their best. Besides appreciating a little attention to makeup and hair, portrait subjects like the photographer, or photo assistant, to make sure their clothes look good. Use the tape tricks in Chapter 1, and your portrait subjects will appreciate it.

While you are applying the makeup and tidying the hair of your subject, you should consider using rubber gloves. That's more important for you, the photographer, than for your portrait subject. Unlike a barber or hair stylist, you probably don't have a sink next to your portrait set, and if you get makeup on your hand, you don't want to transfer that makeup to your camera. (See Figure 5.30.)

Figure 5.30
Use a disposable rubber glove when applying powdered makeup with a cotton ball or foam wedge. Toss it away when you're done so you don't transfer any of the makeup to your camera.
Copyright ©
Steve Weinrebe

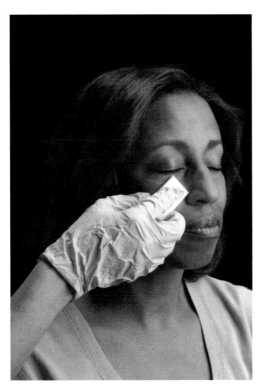

Spray Water Bottle

Speaking of hair, there is an exceptionally easy way to get rid of cowlicks and stray tendrils, or to tighten curls on someone's head. Simply spray a little water onto their hair. (See Figure 5.31.)

Hairspray is an item you definitely want to keep away from your cameras. In any case, male portrait subjects may not like hairspray used in their hair. Keep a small spray bottle filled with water, nearby for before and during a photo shoot. More than makeup, which should stay put during a shoot, hair tends to have a life of its own. If someone has a cowlick or some hair that wants to lay in a different direction than all the other hair in your shot, spray just a little water on the hair and gently press it down.

You may have to do this repeatedly during the portrait session. It will be worth it to you so you don't have to try to fix the hair later, digitally. (See Figure 5.32.)

Figure 5.31 Spray a little water in a portrait subject's hair to help keep stray hairs matted down, or keep curls in place.
Copyright © Steve Weinrebe

Figure 5.32 Use a small spray bottle to apply a little water to hair to keep it in place.
Copyright © Steve Weinrebe

Another use of a spray bottle is to smooth out a cloth background. If you have wrinkles you don't want in a cloth background, spray the background well before the photo shoot. The wetness and weight of the background will naturally make the wrinkles smooth out. Spray water only until the background is slightly damp, not soaking wet.

For larger spraying applications, like for a background, recycle a spray bottle from a window cleaner or household cleaner. Wash the bottle thoroughly before filling it with water, and label it so that anyone who might use the bottle knows that the bottle contains only water.

Pencil Box

If you decide to store more makeup than just a powder compact and some cotton balls, you should assemble a cosmetic kit for portrait photography. Cosmetic kits come in many expensive and stylish forms, but for photography you don't need something that's

pretty to look at, just something utilitarian and preferably inexpensive. For a simple cosmetic kit that will hold just about everything you need for portrait shoots, a plastic pencil box is perfect. (See Figures 5.33 and 5.34.)

Pencil boxes can be purchased at any drugstore or discount retailer and come in a variety of colors. Test the clasp of the box in the store to make sure that it won't open up easily in case you need to travel with your cosmetic kit. If you want to see the cosmetics without opening the box, which can be handy to know you have everything with you that you need, get a transparent or translucent plastic pencil box.

Figure 5.33 A pencil box makes a useful, portable, and inexpensive cosmetic kit. A bright-colored lid makes this box easy to grab in a darkened studio.
Copyright © Steve Weinrebe

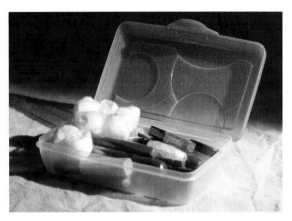

Figure 5.34 This pencil box cost only a dollar and holds more cosmetics than I usually keep on hand for portraits.
Copyright © Steve Weinrebe

Because pencil boxes are marketed to school children, you may find some wild styles, so you can go with a sedate pencil box or a day-glow pencil box depending on your taste. I prefer a bright color for a makeup kit because it's easy to lay my eyes on in my cluttered studio, although one with muted colors may look more like a piece of photo gear.

If you need something larger for your makeup kit, buy a fishing tackle box. Tackle boxes come with trays that pull out or fan apart in tiers when you open the lid. They have many different sized compartments in the trays, as well as a large compartment in the bottom of the box. You may need a lot of cosmetics to fill a tackle box, but you'll have room to grow if you add to your cosmetic repertoire for prepping portrait subjects. (See Figure 5.35.)

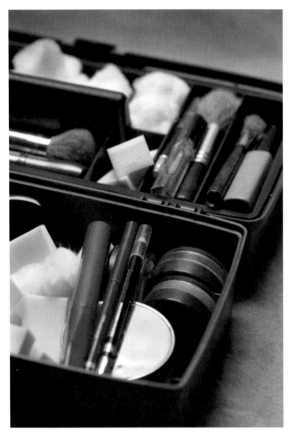

Tip

If you ever shoot pet portraits, or suspect that a pet might play a role in a portrait shoot, keep dog and cat treats in your makeup kit. That way, you'll always have them on hand. Buy sealed packets of pet treats so they don't get stale or cause an odor in your makeup kit, or buy an extra pencil box just for the treats. You may need the treats to keep a pet in the set, and you may need the treats to keep a pet out of the set if the pet wants to get into the act and you prefer the pet on the sidelines. My cat, for instance, loves to walk onto a photo set for attention, and a treat or two lures her out quickly.

Figure 5.35 A fishing tackle box has loads of room for cosmetics, brushes, and other makeup items. This one cost well under $10, and its dark, muted colors make it fit in as a piece of photo gear.
Copyright © Steve Weinrebe

Dummy Stand-In

Nail your lighting down before your portrait subject arrives for the shoot. That may take some time. I like to set aside 90 minutes to prep and take some test shots before a portrait subject arrives. Sometimes I work faster, and sometimes slower and more methodically when setting up. But it always seems to take 90 minutes no matter what, so I plan accordingly. One tool I've found invaluable for that preparation is a dummy stand-in for the lighting. (See Figure 5.36.)

Many times I've found myself staring at a portrait set with a background surrounded by lights. If you have a photo assistant, or a family member with time to spare, you may have a stand-in ready at hand. You can watch them while you adjust the lighting, take

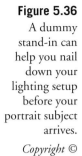

Figure 5.36
A dummy stand-in can help you nail down your lighting setup before your portrait subject arrives.

Copyright © Steve Weinrebe

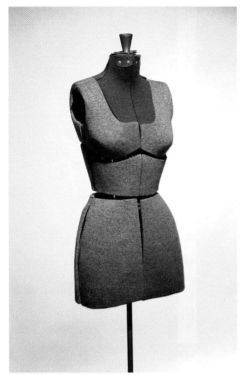

test shots, white-balance the camera, and so forth. But if you don't have an able and willing body to stand in for the portrait subject while you set up, you may be stuck. Using the self-timer on your camera can work, but it's distracting and not the easiest solution.

The easy solution is to keep something around that's roughly the height of a person and has some texture or substance to it—more than just a light stand. I have a dress form dummy that I use, as well as some other assorted props and items that I can position in place of the portrait subject. (See Figure 5.37.)

Whatever you use, find something that has an adjustable height and that you can drape clothes on so you can get an idea of how light will fall on clothing. If the subject will wear white, I can put a white shirt on the dummy, or if the subject will wear black, I use a black jacket. If the subject is blond, it's a good idea to use something at head height that is light in color. That way you can see if a hair light is too strong, or if you need one at all.

One simple solution for an adjustable-height stand-in is a light stand with a cardboard box, or boxes, held onto it to drape some clothing onto. Use an empty shipping box, make holes in one end large enough to fit over the top section of a light stand, and push the light stand through the hole and up through the box. When you're done, you'll have a simple dress-form dummy to drape clothes on. (See Figure 5.38.)

Figure 5.37

The dummy stands in for lighting tests before a portrait shoot. Here I use variations of simple portrait lighting, with two soft boxes and a reflector, to refine my setup before the portrait subject arrives.

Copyright © Steve Weinrebe

Figure 5.38

Don't laugh … by using even the simplest props, you can nail down the position of lights and the camera, as well as lens choices, before your portrait subject arrives. Here, improvising with what was at hand, I used a cardboard box, an old sport jacket, and my daughter's jack-o-lantern to do just that.

Copyright © Steve Weinrebe

Zen

I don't know enough about Zen to write extensively about both Zen and archery, but I do know a little bit about archery because it was a sport I competed in when I was younger. There is little about the mental focus used in archery that I haven't brought forward to photography, and those precepts have served me well time and again. (See Figure 5.39.)

Figure 5.39

The mental focus needed to shoot an arrow on target is similar to the mental focus needed to capture a good portrait photo.

Copyright © Steve Weinrebe

In archery, a key to shooting an arrow on target is to release the arrow at the same time that you know it will be on target, not before and not after. Photography of people works very much the same way. The Zen component comes from the mental connection that a portrait photographer creates with the subject. You want to snap the shutter at the same moment you know the portrait subject's expression and posture is right for the portrait. You also want to create a rapport with your subjects so that they know it's the right moment as well.

Good models, such as seasoned actors and fashion models, excel at knowing the right moment at the same time the photographer does. But after photographing hundreds of portrait subjects for advertising and editorial assignments, where I had only met the subject perhaps minutes before we started taking pictures, I've learned that any subject

can connect with the portrait photographer if the photographer lets them. Let the subject know you are hunting for the right moment, whether you're shooting quickly or slowly, and the subject will hunt with you by moving his/her face, expression, eyes, head, shoulders, and by using other types of body language that can be communicated to the camera. (See Figure 5.40.)

In archery, practicing the discipline of taking single shots builds the skill that allows those shots to hit their mark. Single captures in photography can help you build that discipline as well, so if you use a motor drive for portrait photography, turn it off, or set it to single capture mode, and slow down the process. The portrait subject, and you, will know the perfect moment and capture it at the same time.

Figure 5.40 Let the portrait subject hunt for the right moment along with you. Create a mental conduit that lets your subject, with or without words, find the best expression for the portrait.
Copyright © Steve Weinrebe, Getty Images

6

Irreverent Still-Life Tools

Take any photograph without people in it and, in a sense, you have taken a still-life. I don't know of any hard and steadfast rule that still-life images need to be taken of small things. But generally a still-life photograph is considered a photo of small objects on a table or background, often with dramatic lighting. (See Figure 6.1.)

When I taught evening classes in photography, I would always have a movie night. One of the films showed a segment of the great photographer Edward Steichen photographing a still-life of fruit. He sat patiently in front of a tabletop in his studio and moved some grapes one way, and then another, up onto the table, and then draped downward. While he set up his still-life, his hand controlled the composition and his eye was the camera. Nothing was happening fast. Sometimes I think that's where the term comes from, because still-life photography forces the photographer to slow down and look.

If you are taking the still-life photo, you are in control of the lighting and the composition. You decide the mood created by lens choice, and that great creative decision whether to end up with a black-and-white image or let the saturated colors of your subjects reveal themselves to the viewer. (See Figure 6.2.)

Great still-life images can come from found or created objects. Something inanimate, that's at first glance uninteresting, can take on a life of its own. It's all about how you see your subject matter. Then, in addition to a camera and maybe a tabletop and background, you'll need some tools that can help you capture your vision.

Figure 6.1
Still-life photographs are usually taken of small objects with dramatic lighting.

Copyright © Steve Weinrebe, Getty Images

Figure 6.2
As the photographer you decide the mood in a photo. This bear trap didn't need to be open, or even look particularly usable, to evoke a sense of danger.

Copyright © Steve Weinrebe, Getty Images

Tip

For a great learning experience on how to compose still-life images, go to the nearest museum and look at still-life paintings—at how the painter arranged the objects for the still-life. If you don't have a museum nearby or time to go, get on the Internet or stop into a bookstore where you can easily find reproductions of great still-life paintings. The history of art is a great well that every photographer should go drink from.

A Window

I was speaking with a magazine photographer, someone who shoots still-life images for national publications and is excellent at what he does. We got onto the topic of food photography and how difficult it is, especially photographing under studio lights. Studio lights tend to wilt food, melt anything meltable, and generally hamper a food photographer with a time limit. Also, lighting is critical in still-life images of food, because the lighting will often determine whether the food looks appealing. Surprisingly, he told me that, with the vast resources of a corporate photo studio, he uses a window to light his food photos. (See Figure 6.3.)

Figure 6.3
A window makes a great light source for still-life photography. This window has a white rice paper screen that acts as a light diffuser.
Copyright © Steve Weinrebe

When I teach photography, students always ask me about one type of photo equipment or another. My problem with answering questions like that is that I hate telling students to spend money. The greatest photographic artists I know work with very little "professional" equipment. Meanwhile, some of the most dreadful photography out there in publications has been taken with equipment beyond the budgets of most photographers. You need look no further than the great still-life images of, for example, Edward Weston, to see what can be accomplished with merely a window (or, in his case, a skylight).

If you do pick a window to shoot by, try to find a window that faces north. That's because the sun never shines from the north, and the light is called north light. Artists seek out studios that have north-facing windows or skylights. If you don't have a north-facing window, don't dismay. Go to a home accessory store and look for a white or neutral-colored rice paper curtain that you can drop down over your window when the sun is shining in. A sheer curtain liner may also take care of diffusing direct sunlight enough to use in photography, but you'll want material thick enough to soften any harsh shadows in your still-life setup. (See Figure 6.4.)

Figure 6.4 A window facing north lets in only diffuse skylight to illuminate this teapot. The narrow plane of focus, from using a wide lens aperture, was intentional.
Copyright © Steve Weinrebe

Fake Window

If you took my advice and went to a museum or bookstore to view still-life paintings, you may have come across the work of the great Dutch masters. The light they represent in their paintings has an almost unimaginably diffuse quality. You might be able to reproduce that light with a natural-light window, but here's a way to recreate that light quality for your still-life sets. (See Figure 6.5.)

Figure 6.5

Two sheets of foam core or paper, a window cut in one, and light shining on the other, makes a beautiful, soft light for photography. I used barn doors on the one light source to contain light spill, but black foil would work just as well (see Chapter 1).

Copyright © Steve Weinrebe

The term photographers sometimes use for the quality they're trying for with soft lighting is *wrap*. Wrap means that the light seems to envelop the objects in the set, not just glance off the side like direct sunlight or a spotlight might. By bouncing light off of one white surface so that the bounced light shines through a window cut into another surface next to it, photographers can simulate the effect of diffuse skylight coming through a window. That's just the type of light the 17th-century Dutch painters used, although the size of your source, the bounce side and window side, will affect the light quality.

The wrap effect is caused by the light coming through the hole, or window, coming from several directions, so if you can throw two or three lights onto the bounce surface, or light it with another diffuse light source, the light coming through the fake window will spill through evenly from multiple angles. Make sure no direct light comes through the window you've cut and only bounced light comes through. (See Figure 6.6.)

Figure 6.6

By bouncing light off one sheet of white foam board, through the window cut into a neighboring sheet, diffuse light wraps around this piece of porcelain. Note how the direction of the light, placed high and to the side, brings out the shape of the pitcher.

Copyright © Steve Weinrebe

For a small fake window, use sheets of foam core or a sturdy white board. You'll need stands for each of the two sheets, one stand or set of stands for the board that light is bouncing off of, and another for the board that has the window hole cut into it.

For a larger fake window, use white rolls of background paper. Again you'll need stands for each of the two paper surfaces: possibly two roll paper stands, although you could use light stands and A-clamps for a simple background support, as shown last chapter in Figure 5.15.

True Story

Many years ago I made the acquaintance of one of the best advertising photographers, at that time, in the region. One of his regular clients, a bread-and-butter client (so called because the client doled out regular work and could be counted on to help pay the bills), was a newspaper syndicate. The photographer routinely photographed ads, destined for billboards, featuring rolled-up newspapers. The elegantly rolled newspapers in his photos lay on a white background with a smooth drop shadow around the product. One day I was visiting and observed how he achieved the smooth lighting and the beautiful drop shadow that was reproduced on billboards throughout the city, and for which he was paid thousands. His method was to take the newspaper, and a white cardboard background, onto his rooftop late in the day when the sun was obstructed by a nearby building. The sky was his light source, and he simply stood back and snapped away.

Window Screen

On the topic of lighting, light modifiers are a key to getting just the right light for your still-life subject. If you search for lighting modifiers in a nearby camera store, or virtual photo store, you'll find loads of professional tools—translucent silks, soft boxes, umbrellas, reflectors, and so forth—to add to your lighting arsenal. However, there's one lighting tool that you likely have attached to a nearby window, or a spare one in your basement or garage, and that's a window screen. (See Figure 6.7.)

The narrow lattice of wires that make up a window screen help to diffuse light coming through them. For photography, you simply need to position the window screen between your light source and your subject. You can do this a number of ways. If you are using a window for your light source, position a window screen between the window and your still-life to soften the light.

If you are using an artificial and continuous light source like a tungsten or fluorescent light, position the screen between the source and your subject. You can double up screens, if you have two of them, to create an even softer light. If possible, have a reflector around your light source to broaden it, or a shade like a white lamp shade partially softening your light source. Then soften the light even more with the screen.

Figure 6.7 A window screen can be used to create the look of a soft box. You may have a spare one lying around that you can turn into a photo tool.

Copyright © Steve Weinrebe

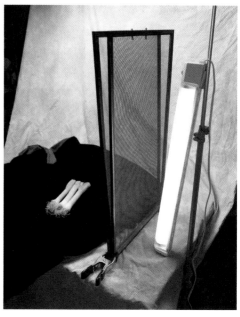

Figure 6.8 The simplest of all lighting setups—a couple of old window screens sandwiched together and held up with A-clamp legs, and a fluorescent utility light I stole from my laundry room.

Copyright © Steve Weinrebe

Fluorescent tube lights make excellent light sources for this type of still-life use. Because the tubes are long and frosted, they are ideal for a pre-diffused light. Ideally, have a fluorescent fixture that has two or four tubes in it, like a work light, or utility light, that can be purchased at a hardware store. If you can easily find daylight-balanced fluorescent lights, you'll have a better colored light source for photography. But because digital cameras are easy to white balance, and sometimes even have a fluorescent white balance setting, you can get away with the cheaper, cool white fluorescent tubes. (See Figures 6.8 and 6.9.)

Tip

If you're using a fluorescent fixture for your still-life photography, you'll want to shoot time exposures and have the camera on a tripod. Use the lowest ISO possible unless you want the grainy look from the digital noise that high ISOs cause in photos. Also, because fluorescent lights emit a great deal of light in the green part of the spectrum, you can white balance for that but not other non-fluorescent sources mixed in at the same time. Work in a darkened room so that stray daylight doesn't spill onto your set and throw off your white balance.

Figure 6.9

These leeks are lit by a fluorescent utility light shining through a couple of window screens.

Copyright © Steve Weinrebe

Mirror

If one light is good, two must be better! Well, that's not necessarily true, but there are times when you want to have two lights illuminating your subject and you just don't have the extra light, or you don't have a light small enough to position at just the right spot in a still-life set. In that case, you can simply take a piece of mirror and stick it into the set. The mirror creates a duplicate of your light as if it were coming from the direction of the mirror. (See Figure 6.10.)

Working with mirrors can be tricky. You want to first position the mirror with your hand to get the light's reflection aimed just where you want it, and then carefully prop the mirror up so that you can take your hand away. Mirror glass is inexpensive and you may even have some small mirrors lying around. If you get mirror glass from a glass or hardware store, be sure to ask the store to grind down the edges so that they aren't sharp. If you are working with mirror glass that does have sharp edges, use packing tape or white paper tape along all four sides to cover the sharp edges. (See Chapter 1.)

One trick I like, when using a mirror as a secondary light source, is to place a colored gel over the mirror to reflect a slight colored light into the set. A slight amber-colored gel works well because it won't diminish the intensity of the light so much as just give the reflected light a warm color. Colored gels, a.k.a. theatrical gels, can be purchased online or from photo and video retailers. The one pictured is a 1/8 CTO, which shifts light from 5500K daylight to a slightly warmer 4900K color temperature. One single sheet of a gel will last a lifetime and can be cut to size for multiple purposes. (See Figures 6.11 and 6.12.)

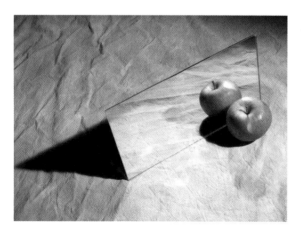

Figure 6.10 A mirror can reflect your primary light source so that you effectively have two light sources illuminating your still-life.
Copyright © Steve Weinrebe

Figure 6.11 Position a gel over a mirror to add a second colored light to a still-life set.
Copyright © Steve Weinrebe

Figure 6.12
This still-life had only one actual light source, and a mirror reflection for the secondary light. An amber theatrical gel (5500K to 4900K) adds a little color to the reflected light.

Copyright ©
Steve Weinrebe

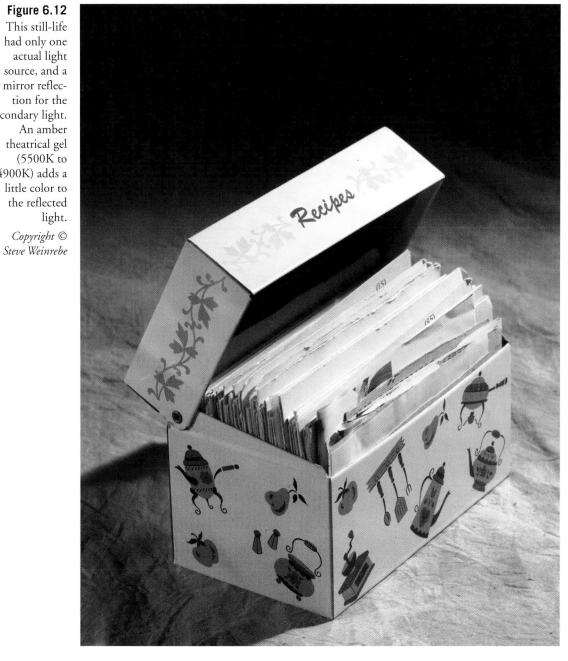

Flashlight

Another great lighting technique for still-life photography is to use a flashlight to paint with light. Painting with light came into vogue in the 1980s, but technology for flash-lights, and especially bright LED flashlights, has evolved since then. And while a flash can be used to paint with light in large scenes, for small still-life sets, a flashlight works best. (See Figure 6.13.)

All you need to do is position your camera on a tripod and use the Time or Bulb set-ting on your camera, which allows you to open the shutter and expose the chip to the scene for an extended period of time. You need to work in a completely dark room so that stray light doesn't cause an unwanted exposure. All the light that will be exposed onto your camera's chip will be from a flashlight shining over different parts of the still-life as you move it.

Figure 6.13 A flashlight makes a great lighting device to paint light onto a still-life set.
Copyright © Steve Weinrebe

> **Tip**
>
> With a camera's Bulb exposure setting, the shut-ter remains open as long as your finger is on the shutter button. With a camera's Time exposure setting, the shutter opens the first time the shutter is pressed, and then closes the next time the shutter is pressed. Not all cameras have either or both, although most digital SLR cam-eras will have one or both settings.

Like some other techniques I've discussed, each exposure will be different. To help make your shots at least somewhat consistent, and to help along the trial-and-error part of getting down your exposure, count out seconds while you are moving the light—one potato, two potato, and so forth. Try to remember how long you moved the flashlight around the still-life set before closing the shutter. If you hold the light still on an area of the still-life for any period of time, that area will be brighter, so, again, try to count the seconds. After your exposure you'll see the preview and you can decide to try again just as you did the first time or add or subtract time from your flashlight exposure. (See Figure 6.14.)

A different effect can be had using a digital camera's multiple exposure mode. First make a double exposure of a still-life with one ambient light exposure, and then an exposure from painting with light. The first exposure should be underexposed and will provide an anchor or background for the light painting. Then, paint highlights into the scene with the flashlight. Because the first, ambient light, exposure gives detail to the entire set, the flashlight is just used to "brush" light onto specific areas. Which areas you choose to highlight with the flashlight will radically change the look of the final image. You can use a diffuser over the lens, or breathe on the lens (see Chapter 5), for the second exposure, the flashlight exposure, to add a glow to those areas you paint light onto. (See Figure 6.15.)

Figure 6.14 Paint light onto your still-life set with a flashlight. Count the seconds so that you can repeat or vary the exposure with some control.
Copyright © Steve Weinrebe

Figure 6.15 Make a double exposure, with an ambient-light underexposure and a second exposure painting light onto the set to add glowing highlights to individual still-life props. For this image I added a black-and-white adjustment, with a tint, in Photoshop.
Copyright © Steve Weinrebe

Spray Can Columns for Glass

Shooting an object on a sheet of glass can serve two purposes: to have a reflection of the still-life subject as a graphic technique or to shoot something without a shadow. In order to do the latter, especially, glass has to be raised up from a tabletop. I've found no better support for a glass still-life tabletop than cans of spray paint wrapped with white or black paper. (See Figure 6.16.)

It's not so easy to dispose of spray cans, especially spray paint cans, without violating one township code or another, so why not recycle them as photo tools? Four spray cans are the perfect support for a sheet of glass in a small set. I have several sized sheets of glass for different purposes in still-life sets, and the spray cans support them all. I recommend wrapping them in white paper (or black paper, depending on your needs) so that they don't reflect colors or labels into any shiny objects in your set. If there is a reflection of one of the cans into something in your still-life, the reflection will look nondescript and the viewer won't take notice, or the reflection will be easier to retouch out because it blends somewhat with the background.

If your background is white, wrap the spray cans in white paper. If your background is black, such as with black velvet, wrap the spray cans with black. Likewise, use white or black tape depending on what color paper you wrapped the cans with. Even if you don't photograph reflective objects, wrap the spray cans. They look better in the set, and provide a just-in-case failsafe if you ever do have something reflective and forget to wrap the cans. (See Figure 6.17.)

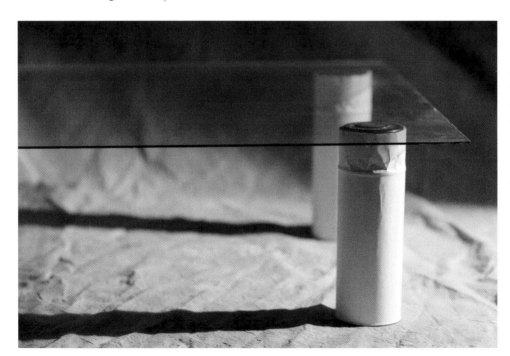

Figure 6.16
Spray paint cans wrapped with paper make excellent support columns for a sheet of glass in a still-life set.

*Copyright ©
Steve Weinrebe*

Figure 6.17
I photographed
this still-life of
an eggplant on
a sheet of glass,
for a shadow-
less effect. The
glass is held up,
over white
paper, by four
paper-wrapped
spray cans.

Copyright ©
Steve Weinrebe

Wood Blocks

It may be since your childhood that you played with wooden blocks, but you should definitely keep a lot of them, all different sizes, shapes, and weights, for propping up items in your still-life photo sets. (See Figure 6.18.)

Toy blocks work great for propping up very small items, but anything with weight to it will need a larger block behind it. Size and shape is important because you have to be very careful not to let the block show in the photograph. Make frequent trips to look through the viewfinder to make sure any blocks you have, supporting items in your still-life, don't show. Depending where they are, any visible edges may be very difficult to retouch.

If you're a pack rat like me, you probably have some wood blocks, or something that can serve as wood blocks for set supports, lying around. My favorite blocks, which I've used to support items in still-life sets thousands of times, come from two sources. One is from cut-up wood molding. The molding is simply trim board that would go along a wall at the edge of the floor. I cut it into roughly 3-inch pieces. I can stack them, and they work great when I want to raise something up off the background to be higher than items around it. They work similarly to how a stool raises a person up for a portrait. (See Figure 6.19.)

Other blocks I have are from a scrap pile outside a woodworker's studio, mixed with a few from my own woodworking days. These blocks are made of hardwood: walnut and rosewood. The hardwood blocks are heavier than blocks made from scrap wood like from a cut-up two-by-four. Children's blocks can work for still-life sets if they are made from a hardwood, typically oak. The blocks should have a good heft to them when picked up.

Figure 6.18
Wood blocks are simple and inexpensive but essential tools for propping up items in still-life sets.

Copyright © Steve Weinrebe

Figure 6.19
Wood blocks, hidden from the camera's view, helped prop up and position these old tools to keep them in place for the photograph.
Copyright © Steve Weinrebe, Getty Images

Tip

Sometimes when a prop (and by prop I mean anything in your still-life) wants to lean, it will just push the block back or aside. Try placing a piece of rubber carpet padding (see Chapter 2) beneath the block to keep the block from sliding. You can also use a piece of tape (see Chapter 1) to better hold a prop against its support block to keep the prop in place.

Rubber Kneadable Eraser

Besides the Army & Navy stores, and the hardware stores, office supply superstores are offer a bonanza of irreverent photo tools. Next time you are shopping for note pads or toner cartridges for your office, stop into the aisle that features pencil and erasers and pick up a rubber kneadable eraser to keep as a photo tool. (See Figure 6.20.)

It's the little things that can save you when you're hard at work creating a still-life photo. A kneadable eraser serves at least two important purposes: erasing small marks in a background and propping up small objects.

What makes a kneadable eraser a great eraser is its ability to come clean by squishing the eraser a few times as you fold it over onto itself—kneading, for those readers who never made bread by hand. (Do make bread by hand at least once in your lifetime; it's a great aesthetic experience, and you'll learn all about kneading.) When new, like other erasers, a kneadable eraser is clean and can be used to erase marks on background paper. Also, like other erasers, once you erase a mark, the discoloration from the mark is transferred to the eraser. Most erasers stay like that until you erase the next mark. A kneadable eraser is softer than most erasers. It is malleable and can be kneaded, folded, and pulled, like saltwater taffy. When you knead the eraser, it essentially turns inside out, revealing clean portions and hiding the dirty part. (See Figure 6.21.)

For that reason alone, keep a kneadable eraser near your still-life set. Some marks are very difficult to retouch depending on where they are. What might take you an hour in Photoshop will take only moments to eliminate with a good eraser. Rub the eraser gently and make sure not to leave any scraps from the eraser in the set.

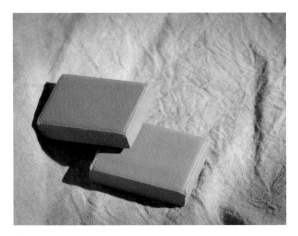

Figure 6.20 A rubber kneadable eraser is a handy multi-tool for the still-life photographer. The eraser can be used to clean marks off backgrounds, and to help position props in a still-life.
Copyright © Steve Weinrebe

Figure 6.21 A rubber kneadable eraser can be stretched and torn like saltwater taffy. You can tear pieces just the size you need to prop a small item up in your set.
Copyright © Steve Weinrebe

But that's not the only trick a kneadable eraser can perform for a still-life photographer. Small portions of the eraser work great for helping prop up small items without slipping, and keeping rounded items from tipping over. My method for keeping rounded items in place is to tear off two equal-sized chunks of the eraser and tuck them under the rounded item to create legs. The pieces need to be hidden from the camera, but you only need very small pieces tucked beneath the rounded prop, to keep it in place. (See Figure 6.22.)

What's great about a rubber kneadable eraser, for positioning small props or holding round things in place, is that you can very easily rip off pieces of the eraser and twirl or pinch the pieces to the size and shape you need. The eraser leaves no residue yet has the sticking power of rubber, so it tends to stay in place. You can work quickly and position props in a still-life, tearing off pieces of the eraser as you need them.

Tip

To get into small areas where a large piece of eraser might move a prop out of position, break off a small piece and twirl it into an eraser with a pointed tip. After using the eraser, consider blowing with a little canned air or a bulb blower to shoo the dust away. A small paintbrush works great for taking eraser dust out of your set as well.

Figure 6.22 This acorn was held in place by two small pieces of kneadable eraser tucked underneath each side.

Copyright © Steve Weinrebe

Dental Wax

There are two types of wax that are terrific tools for the still-life photographer, but dental wax has the catchier title, and I'll start with that. So continuing our shopping excursion, now that we've been through the Army & Navy store, hardware store, and office supply stores, we're on to the drugstore and the art supply store. Our first stop is at the drugstore for the dental wax, also known as wax for braces. (See Figure 6.23.)

Figure 6.23
Dental wax, a.k.a. wax for braces, is great for sticking props together or to surfaces.

Copyright © Steve Weinrebe

You may not have a lot of experience with braces, but whether you do or not, you can probably imagine why wax for braces is a staple in the dental hygiene aisle of any drugstore. After all, braces—if you have them—are complicated mechanism to have in your mouth. The various reasons someone with braces might use dental wax require something that is removable, repositionable, and nontoxic—all excellent traits for a still-life tool to hold props in place.

Dental wax is essentially colorless, except that when wadded up, it looks to be a neutral white. It comes in long strips that can easily be torn apart, and it's only slightly softer than candle wax. That means it's crushable, bendable, and can be easily torn. As a bonus, dental wax is mildly heat-resistant because it's meant to retain its shape at least at body temperature.

For small still-life props like jewelry, dental wax is ideal because you can push a pin or clasp into a ball of the wax, pressed against your background, and the jewelry will stay in place without tipping over. Position the wax on the background first, or the wax to the jewelry or small prop first, and then place it in your set. Wax, unlike a kneadable eraser, does leave a residue, so you have to be a little careful about positioning it. If you're shooting with a paper background and you get unwanted wax on the paper, you may need to cut that portion of the paper off and pull out a clean section from the roll. Other surfaces, like colored plastic sheets, glass, or metal, are easier to clean a small smudge of dental wax from. (See Figure 6.24.)

Figure 6.24
Dental wax holds these earrings in place for the still-life photo. The posts of the earrings are pressed into small balls of the wax.
Copyright © Steve Weinrebe

Tip

If you have a heavy still-life prop with a round shape and you want to hold it in place without falling over, you're better off using two balls of dental wax, one to each side of the underside of the rounded object, to keep it from moving or rolling off the set. A watermelon or wine bottle, for example, might be difficult to hold in place with just a couple of pieces of kneadable eraser. The weight of the watermelon might push the rubber eraser aside. Dental wax is stickier and will hold its place. Making sure your still-life set is level (see Chapter 1) will also help to keep round props from rolling around in your set.

The other type of wax that has saved me on countless still-life shoots, holding props in place or stuck together, is pressure-sensitive adhesive wax. This type of wax is made for an art supply tool called a hand waxer, which is used to mount photos, posters, and other pieced of flat art, while keeping it repositionable or removable. Unfortunately, hand waxers are becoming, or have recently become, obsolete. Fortunately, you don't want a hand waxer, you just want the wax refills for the waxer, and some art supply stores carry the refills for people who still use the waxers.

If you can lay your hands on a box of the pressure-sensitive adhesive wax made for hand waxers, you'll likely have enough wax to last you a long, long, time. Check out an art supply store to see if they have any on hand, and search online auctions for some of this great wax. (See Figure 6.25.)

Figure 6.25
Pressure sensitive adhesive wax, made for hand waxers, is a very sticky wax suitable for holding props together, or to a still-life set's background.

Copyright © Steve Weinrebe

The adhesive wax made for hand waxers is not nearly as heatproof as dental wax, but at room temperature it is easy to work with. In my own experience I have worked with it under hot lights, with care, but it is a tool best saved for flash, fluorescent, or window light shoots.

Because this type of adhesive wax isn't very heatproof, it is stickier and more pliable. The wax will hold a large object in place, even against gravity to a point. It's not a glue, and it will pull off, but a wad of pressure-sensitive adhesive wax works almost like hot-glue, and I have used it to hold together items that otherwise might need gluing.

Heavy Washers

On the topic of propping items up in a still-life set, besides blocks, rubber, and wax, keep a small pile of heavy round washers handy. Because the washers are flat, they are stackable. The hole in the center is useful to help balance things on the washers. Washers slide easily into place and can be added, one by one, beneath a prop to raise it up. (See Figure 6.26)

Figure 6.26

Large, heavy washers are excellent shims for lifting up small props in a still-life set. These are half-inch washers; that is, the hole is a half-inch and the outside diameter is 1⅛ inch.

Copyright ©
Steve Weinrebe

I used to use quarters for shims, but that was becoming pretty expensive. Much less expensive than quarters, and like any good shim, these large washers raise things into place. Photographing a still-life is usually a very exacting process where a very small move in the set can make a huge difference in the final image. Often something only needs to be raised up a fraction of an inch. By stacking washers beneath a prop, you can refine the position of the object for your still-life composition. (See Figure 6.27.)

I like half-inch washers for a still-life set tool. The washers have a half-inch opening in the center, and have a 1⅛-inch outside diameter. They are thicker than a coin and have a good weight to them. These washers are also useful if you have something that needs to be weighed down in the set: not a lot of weight, just enough to balance something. A food photographer may need to balance a utensil over the side of a dish, for example.

By taping some washers to an end of the utensil, outside the framing of the photograph, the utensil can be placed with precision. A hemostat, for holding items for close-up photography, could also be weighed down with heavy washers (see Chapter 4).

Figure 6.27 Washers propped up the smaller chess pieces to make the composition work better for the still-life image. *Copyright © Steve Weinrebe*

Irreverent Video Tools

Writing about video tools in a book about photography tools, in this age of transition at least, means also writing about converging media, or *convergence* for short. I began writing about convergence years ago when none of the major camera manufacturers had incorporated video at all, let alone decent-quality HD video, into professional still camera equipment. I didn't have inside industry knowledge, just the crystal ball of experience that told me the convergence of still and video was in the cards for photographers. (See Figure 7.1.)

Figure 7.1
We've come a long way from old 16mm "home movie" cameras to the video capture devices that are available today.

*Copyright ©
Steve Weinrebe*

For the past many decades the moving image and the still image prospered independently. When young people were interested in making images, usually they would have the choice of pursuing film school or photography school, and then to pursue either a career in film or video, or go in the direction of still photography. Each of those avenues had myriad career paths, and each career path took years to master.

Enter the computer, and digital imaging. When I first became professionally involved with digital imaging circa 1991, scanning transparencies into Adobe Photoshop to create photo-illustrations for magazine covers, I started attending computer user groups. I was struck by the way different professions were pulled toward the magnetic core that the computer and Photoshop had become at that time.

One user group I attended was held in a hospital's amphitheater, populated largely by doctors. Yet the discussions were all about photography and Photoshop, not how computers and imaging might change the practice of medicine. Another user group was attended by architects and graphic designers. Clearly when so many industries are using the same tools, there is going to be a convergence of industries and jobs. If I use a computer and Photoshop, and my customer uses a computer and Photoshop, at what point is my customer going to say, "Hey, I can do that, and I can make more money doing that myself …"? Integration, convergence. (See Figure 7.2.)

These days, digital imaging tools are standard in all the trades mentioned here. There have been sea changes, caused by digital imaging, in both still and motion picture

Figure 7.2
This is a frame from the award-winning children's video *Popsies*, which was shot almost entirely with equipment that would be traditionally considered still photo gear.

Copyright © Steve Weinrebe, Getty Images. Copyright © Whole Cloth Productions™

photography, as well as countless other industries, including news reporting, graphic design, medicine, law enforcement, architecture, real estate, and the list goes on.

When a young person asks me for advice on getting into a career in photography, I tell them, "Learn everything you can about video." By the time someone has asked me that question, they are usually well along the learning curve in the art of the still image. But making money from still images is another matter, and there is no use pigeonholing a start-up career in the visual arts. The devices we use to make images, the software we use to process images, the devices we use to view images all are capable, or becoming capable, of handling both still and moving images.

Online video websites and social networking have also helped push along convergence. After all, a spontaneous video shot from a point-and-shoot or camera phone is the most fun if it can be immediately shared with others. Part of what is driving convergence is portability. It's easier to carry a camera phone than a camera and a phone. A point-and-shoot camera substitutes just fine in most situations for a larger video camera. A digital SLR with HD video capabilities replaces an entire other camera bag of video gear, for the pro photographer who shoots both still and video. (See Figure 7.3.)

Figure 7.3
Another still from the children's puppet video *Popsies.* The production represents an example of convergence, because it was shot with mostly traditional photo gear.
Copyright © Steve Weinrebe, Getty Images. Copyright © Whole Cloth Productions™

Regardless of how sophisticated your end use will be, as I've said before, whenever possible, spend your money on good cameras and good lenses. I'll make some tool recommendations for use with convergent video gear, digital SLR, point-and-shoot, and camera phones, that might save a few pennies along the way.

Tip

More and more photojournalists are being asked to shoot both still and video when covering stories. To see some of the very creative work being done by some of these photographers, scour the online news websites for features that include both still and video. One excellent website showcasing the integration of still and video reportage is www.mediastorm.org.

Hay Fork Handle

Technically, this tool is a manure, hay, and bedding fork replacement handle, and I'll call it a fork handle for short. You can find one at a big box hardware store, and at a local hardware or farm tool store depending where you live. The fork handle is designed as a replacement for the broken wooden handle of a pitchfork for hay. This handle makes an excellent monopod or boom for both smaller and larger cameras. (See Figure 7.4.)

A monopod takes on great importance when shooting video. The extra sway and easy repositioning of a monopod allows the photographer to pan and pivot the video camera for more seamless and flexible motion capture. Equally important for motion capture is a boom because some shots require the dramatic angle that a boom can provide. For a tool to serve both these purposes, it needs to be heavy enough to be sturdy as a monopod, yet light and inflexible enough to hold out as a boom.

This fork handle is 48 inches long and made from a sturdy hardwood, ash, and has a steel collar covering the end of the pole. The handle is contoured in a way that makes it very comfortable to hold. However, it requires one simple modification—a three-eighths-to-one-quarter-inch adapter screw. (See Figure 7.5.)

The fork handle, on the fork end, has a pre-drilled hole just large enough to screw the three-eighths-inch end of a tripod screw adapter into. If you get one that doesn't have a hole on the end, you'll want to pre-drill it. Then you'll need a three-eighths-inch-male-to-one-quarter-inch-male screw adapter, also known as an adapter spigot or a camera stud. Either the spigot or the stud will work. These are commonly available online or at a professional photo retailer. Screw the three-eighths-inch end into the hole at the end of the fork handle, and the quarter-inch end of the adapter can be easily screwed into any camera. (See Figure 7.6.)

Once you've attached your camera to the fork handle, you're set to use it as a monopod or as a boom. A monopod gives that extra bit of stability that can make a motion capture look smooth. Plant the bottom end firmly on the ground, holding the monopod to the ground while panning the camera as need be to get a fluid motion and capture the scene fully. (See Figure 7.7.)

Figure 7.4 A hay fork replacement handle can be easily modified into a monopod or boom for a digital video camera.

Copyright © Steve Weinrebe

Figure 7.5 Here are a couple of different one-quarter-to-three-eighths-inch tripod screw adapters. The round adapter is called an adapter spigot, and the hexagonal adapter is called a camera stud. Either will work.

Copyright © Steve Weinrebe

Figure 7.6 With a tripod screw adapter attached to the fork handle, the quarter-inch end of the adapter easily screws into most cameras, small or large.

Copyright © Steve Weinrebe

Figure 7.7 The hay fork handle makes a sturdy monopod.

Copyright © Steve Weinrebe

A camera boom can get you shots you otherwise wouldn't be able to get—looking down and outward from a bridge, for example, without getting the railing in the shot, or up and over obstructions. The fork end of the handle has a slight bend to it that I've found works to the photographer's advantage, when using the fork handle as either a monopod or a boom. You can tip the bend toward you for a slight up angle, and away from you for a slight down angle. (See Figure 7.8.)

Figure 7.8 Using the fork handle as a boom, the photographer or videographer can capture shots from otherwise impossible vantage points. *Copyright © Steve Weinrebe*

Tip

Most people think of raising a camera high up when they have the camera on a boom, but one very interesting point of view is a worm's-eye view, or a view from very low to the ground. Just hold the fork handle with the camera at the bottom and start the capture. The moving image will be upside down so you'll need video-editing software capable of rotating the video 180 degrees.

Light Bulb Changer

My neighbors keep coming over to borrow my light bulb changer. I keep the large one on a painter's extension pole. Sometimes I use it to change burned-out floodlights that are installed high up on the eaves of my house. But sometimes I use it to hold a camera high up to get a bird's-eye view, high-angle shot, of a scene that would otherwise be very difficult. The light bulb changer is great for this because it is a cup-shaped device with several spring elements that naturally form around what you put into it. (See Figure 7.9.)

For video with a digital SLR, or with a point-and-shoot, the light bulb changer makes high-up shots simple. Light bulb changers come in different sizes and shapes, designed to remove and replace different sizes of light bulbs. The large changer is designed to wrap around floodlights and can accommodate a digital SLR of moderate size.

The medium-sized changers are designed for standard round, or A19-size, light bulbs. A point-and-shoot camera can fit on end, into one of these medium changers. That makes the medium changer less suitable for video because you'd be stuck with a vertical image. But if you're doing still work, consider the medium, A19-size light bulb changer as a tool to attach the point-and-shoot to a boom.

Figure 7.9 A light bulb changer has several spring elements that can clamp around a camera. The base of the changer screws onto a standard extension pole or broom handle.
Copyright © Steve Weinrebe

Figure 7.10 Use rubber grippers, the kind used to open jar lids, to protect the camera from scratches and help hold it tight in the light bulb changer.
Copyright © Steve Weinrebe

For the large bulb changer, you'll want to use a protector for the camera so the metal of the changer doesn't scrape the camera body. Rubber grippers (see Chapter 3) work great for this because they don't take up any extra space, yet protect the camera from scratches and hold the camera in the bulb changer by gripping the camera and changer tightly. (See Figure 7.10.)

Once you've placed the digital SLR into the light bulb changer, you can screw an extension pole into the changer to use the setup as a long boom for the bird's-eye high-angle shots. Some changers actually come with a pole, and that can be a money saver. If you really want to stretch your camera up high for your video shoot, consider investing in a good, solid, painter's extension pole—something substantial and easy to hold on to.

Whatever pole you use, after you screw it into the light bulb changer's base and tighten the locking thumb screw, if there is one, test your boom out safely before using it. First gently tug on the camera and make sure it isn't scraping any rough surfaces. Add padding or another rubber gripper if need be. Then, holding the pole, hover the camera just over a mattress or very padded surface and jiggle the pole gently to make sure the camera doesn't fall out. If it does, well, better first over a mattress than over pavement or water. And if it falls out, add padding or a flexible strap to make it more secure.

Even still, only use a light bulb changer to nest the camera for work up high, not to hover it laterally, parallel to the ground. Use the fork handle discussed earlier in the chapter for that. For work up high though, the bulb changer boom works very well. (See Figure 7.11.)

Figure 7.11
Use the light bulb changer on a pole to hold a camera up for a high-angle shot. Use a wired video cable to a monitor if you need an accurate preview.

Copyright © Steve Weinrebe

Now that the camera is tested and firmly held in the light bulb changer, the boom is ready for action. Start the video capture and then, holding the pole vertically, extend the pole as need be and hold the camera up high. Gently rest the pole against a firm surface if you need stability. Video shots like this are often best edited into shots taken from a standard viewpoint, so you may not need much footage from the high-angle point of view. The unusual viewpoint can add a great deal of drama, though, even if the clip is a moment in a longer scene. To better gauge what's being captured, use a video-extension cable for a preview on a separate display.

Large Hook-and-Loop Straps

We can't all afford a professional device to steady video where the videographer is moving. There is some terrific equipment out there for just that use, but it goes beyond the bounds of irreverent tools. But there are ways to make your tracking shots—that is, video where you move along with, or toward, your subject—at least a little more stable. That's where hook-and-loop fastener straps come in. (See Figure 7.12.)

Figure 7.12

Hook-and-loop fastener straps can hold a tripod or boom to your body while you shoot a video while tracking along with your subject.

Copyright ©
Steve Weinrebe

You can purchase hook-and-loop straps of varying sizes at hardware stores and online. You may even have some lying around unused. If you can, get the type of strap that's meant to wrap back onto itself, with a buckle on one end so that it can loop back onto itself like a belt. You might find straps like this in a medical supply store.

If you can't find straps like that, the two-sided straps that peel apart can work, but you don't want straps with adhesive because you're going to use the strap like a belt. A fabric store would be a good source for non-sticky hook-and-loop straps in a wide width. You'll need to sew a piece of the loop side onto the end of the hook side so that, when you wrap it around like a belt, you have something to attach the loop side to.

Either way, you'll want a strap long enough to wrap around both a tripod and your waist. Depending on what you get, you may need to double up two straps by strapping one to the other. Look for a strap two inches wide because that is pretty comfortable wrapped around your waist. You could use a belt or a stretchable cord for this tool, but neither is as comfortable, easy to tighten, and easy to take off one-handed as the hook-and-loop strap. (See Figure 7.13.)

Attach the camera to the tripod first. Then, while holding the tripod against your midsection, wrap the strap around both yourself and the tripod. If you have someone to help you, all the better, but this can easily be done by the photographer alone. The advantage of the hook-and-loop strap with an end buckle is that you can adjust it by pulling it tight before you go to work with the camera. Position the strap high enough above your hip so that the gait of walking won't sway the camera. You can use your hands to add an extra bit of stability to the tripod, but your waist is doing most of the work and holding much of the weight.

Figure 7.13 Hook-and-loop fastener straps hold a monopod, or a tripod, around a videographer's waist to hold the camera steady for a tracking shot.
Copyright © Steve Weinrebe

Figure 7.14 Use a boom or a tripod strapped to your waist to steady the camera while it is above your head for tracking shots from a higher viewpoint.
Copyright © Steve Weinrebe

You can also use this for tracking shots where the camera is higher up. Use the hay fork handle, discussed in beginning of this chapter, as a boom with the strap holding the boom tightly to your body. You can track a video segment this way with the camera at least a foot or two above your head. You would never be able to hold the camera as steady with your hands and arms. (See Figure 7.14.)

Mover's Dolly

If holding the camera on a boom via straps on your waist doesn't steady the camera enough for you, or you have trouble walking with the camera this way, you may want to attach a tripod to a dolly for a moving video shot. A mover's dolly is ready-made with four wheels on ball-bearing pivots and soft carpeting covering the wood frame. You can purchase mover's dollies at hardware stores and moving supply stores. They are pre-made and inexpensive. (See Figure 7.15.)

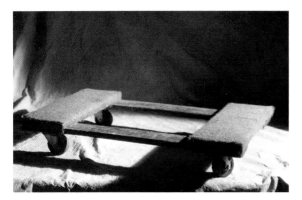

Figure 7.15 A mover's dolly has pivoting wheels and soft carpeting over the wood frame. A tripod can turn it into a moving dolly for motion video.
Copyright © Steve Weinrebe

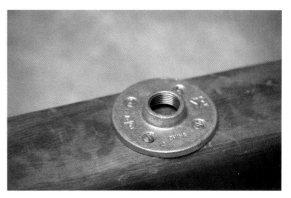

Figure 7.16 Three floor flanges, bought in the plumbing supply aisle, are mounted to the mover's dolly to secure the legs of a tripod.
Copyright © Steve Weinrebe

To use a mover's dolly as a dolly for a tripod, though, something needs to be added to hold the tripod's legs to the dolly. What I have used is an inexpensive plumbing item called a floor flange. The floor flange is a disk of metal designed to screw pipe to. You can buy these in the plumbing aisle of a hardware store or at a plumbing supply store. Floor flanges come with different-sized center holes for different-sized tripods so you can buy a set of three to fit the legs of smaller or larger tripods.

The flanges have four screw holes each, so they will be nice and secure on the dolly after you screw them in. Mount the flanges in a triangular pattern. If they're a little uneven so the tripod isn't fully spread out, the tripod will still be very steady because of the way the legs push into the flanges.

You won't need the screw threads of the flange unless you want to be even more irreverent and make your own tripod from plumbing pipe. The legs of the tripod will sit in the holes of the flange and be anchored by the lip around the holes. (See Figure 7.16.)

Now that the mover's dolly has something attached that the tripod legs can fit into, simply place the tripod onto the dolly and you have a rolling dolly for moving video shots. Your total cost for a new mover's dolly and flanges may be less than $50, or a little more depending on where you live and what dolly and flanges you buy.

This is considerably less expensive than any professional equipment made to move a video camera on wheels. But that's another advantage of convergence. The equipment that still photographers have available for video now is much more lightweight than ever before. I'm not talking about traditional broadcast-quality video gear, but for gorilla or independent, or online video, you can have a lot of fun with motion shots from a simple dolly like this. (See Figure 7.17.)

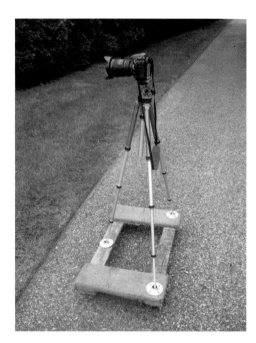

Figure 7.17
This mover's dolly has a tripod on top, ready for a rolling motion video shot.

Copyright © Steve Weinrebe

Vinyl Gutter

The kind of tracking shots I've referred to are really fake tracking shots, because without a track, it's not literally a tracking shot for video. If you want to move along with your subject, or move toward or away from your subject, with a more controlled motion than you can get with the mover's dolly alone, you need something to help the dolly move in a straight line. Heavy track is hardly irreverent for this purpose, but some inexpensive vinyl gutter works just great for lightweight gear like a digital SLR, or point-and-shoot camera, mounted via a tripod on a mover's dolly. (See Figure 7.18.)

You can purchase vinyl gutters in 10-foot lengths at hardware stores. They are amazingly inexpensive given that you get 10 feet worth. The gutter pictured cost considerably less than $10. You'll need a pair of gutters, but they are very lightweight to carry to the checkout line, and to transport home.

Figure out what you want to see in the video tracking shot. Walk the length of the shot and look with your eyes, with cropping Ls, or through the camera. Then lay the vinyl gutters on the ground parallel to each other, and apart as wide as the wheels of your dolly. You can use packing tape or sticky wax to hold the gutters in place. If the surface warrants it, use screws to hold the gutters in place. Then place the dolly onto the track, mount your tripod and camera, and take the tracking shot by moving the dolly along the gutter track while capturing the scene. (See Figure 7.19.)

The vinyl gutters are very thin and can be easily overlapped to make longer tracks. The track length can be modified by how much sections of gutter overlap. The run of track

Figure 7.18 Vinyl gutters are inexpensive and can be paired on the ground as a track for a dolly. *Copyright © Steve Weinrebe*

Figure 7.19 Tack the gutters down with wax, tape, or even screws if possible. Place the dolly in the gutters and roll the dolly along the track of the gutters to capture the motion tracking video. *Copyright © Steve Weinrebe*

is going to be straight, but that will serve most motion tracking images. If you really need to turn corners, you may be better off using a boom from out of the window of a slow-moving vehicle. For linear tracking shots, moving alongside a moving subject, or toward or away from a still subject, a straight track works very well.

Tip

To transport a 10-foot length of material like a vinyl gutter, you may need to poke it out of a car window to carry home. If you do, tie something red, like a red bandana, onto the end that's sticking out of your car. That should be standard operating procedure (SOP) anytime you have something extending out of your car window. If you don't have a red bandana, use red ribbon. Keep some in the trunk of your car at all times so that, when you do buy something like a 10-foot vinyl gutter, you'll always have the red safety ribbon with you. Of course, drivers around you will appreciate the warning flag the red bandana or ribbon provides.

Tip

A famous type of tracking shot done with a dolly moving toward or away from a subject combines the zoom on a zoom lens with the camera movement. As you move the dolly along the tracks toward your subject, zoom out from telephoto to wide angle.

Light Bulb Base Adapters

There is a dizzying array of lighting solutions available for photographers and videographers. Some of these lighting tools overlap, although you'll often see different lights, and light modifiers, if you search the photo and video catalogs. With the convergent media that dual-use cameras provide for still and video, photographers can really benefit from keeping several light bulb base adapters for adapting light bulbs to different fixtures for video. (See Figure 7.20.)

Whether your video lights are utility lights, professional studio lights, or wall and table lamps, there are too many types of bulb sockets to bother to keep light bulbs for all of them. Likewise, video may require many different wattages of light bulbs, and to keep different wattage bulbs with different sockets on hand is a burden on both the expense account and storage space.

Typically, a problem with using still photography lighting for video is that video requires a much lower light intensity than still photography does. Video lighting also needs to be a continuous light source, not flash. So you need nice light, not bright light.

Traditional photo light modifiers work just fine. Fill reflectors, soft boxes, flags, gobos, snoots, barn doors—all are useful for video lighting. Likewise, natural lighting can look great with video. Light intensity is equally an issue with natural, or available, light. A window might greatly overpower a room light, or a room light might be underpowered to fill in shadows or balance against another room light.

Bulb adapters let you use lower-wattage lights in fixtures designed for higher-wattage lights. That's safe; the other way around isn't. Don't use high-wattage lights in fixtures

Figure 7.20 Light bulb base adapters are made for most screw-in types of bulbs, usually to allow bulbs with smaller bases to fit into fixtures with larger sockets.
Copyright © Steve Weinrebe

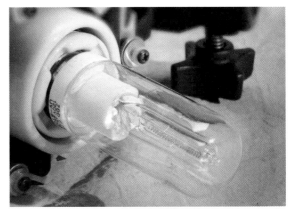

Figure 7.21 Because video requires less light intensity than still work, you can use socket adapters to modify fixtures designed for larger bulbs to accept smaller bulbs, such as with this professional photo light.
Copyright © Steve Weinrebe

rated for low-wattage lights; you'll risk a fire. Bulb adapters let you screw light bulbs with smaller sockets into fixtures designed for light bulbs with larger sockets. (See Figure 7.21.)

The types of sockets that you'll likely be dealing with in the US are the oversized Mogul base, the typical Standard base, and the smaller Candelabra base. You can easily find socket adapters for all of these. The European base is somewhere in between the Candelabra base and the Standard base, and socket adapters are made for those as well.

A light designed for a Mogul base might be rated for bulbs as high wattage as 1,000 watts. Thousand-watt bulbs and 500-watt bulbs typically have a Mogul base, and the fixtures that accept them are rated for the high temperatures those bulbs reach when lit. For video, 250 watts likely is plenty if you're using a light modifier like a soft box. A 250-watt bulb usually has a Standard base. So screw the lower-wattage Standard base bulb into a Mogul-to-Standard socket adapter and that into the fixture designed for the Mogul base, which may be a spotlight or other tungsten hot-light fixture for photography.

Likewise, if you have a lamp in a room that is a little too bright, and the only low-wattage bulbs you have on hand are 25-watt Candelabra base bulbs for a chandelier, for example, that's no problem as long as you have some Candelabra-to-Standard socket adapters handy. Screw the Candelabra-based bulb into the socket adapter and that into the lamp. The socket adapters are a lot more convenient and inexpensive than dimmers.

Tip

If you ever find yourself in a conversation with a video lighting expert or salesperson, you may hear light bulbs referred to as lamps. Traditionally, and technically, in the world of light bulbs, "lamp" is the correct terminology for what we usually call a bulb. Conventionally, though, a lamp is something with a shade sitting on the piano, and a bulb is what you screw into it.

True Story

I had my own first experience with convergence when sitting in a movie house in Boston circa 1965. I was a teenager, aspiring photographer, and serious fan of French new wave cinema. I was watching one of those new wave films when the moving images on the screen suddenly became interspersed with captivating still images—a face distressed, a look back over the shoulder, a moment of joy. The still photographs were profoundly powerful and, more importantly, fell seamlessly in step with the moving images. In these instances, and in new media that combines still and moving images, the still image flows from and gains momentum from the moving image, and vice versa.

Archery Quiver Microphone Holster

Previously, I wrote about an archery quiver as a tool to tote around a small tripod (see Chapter 4). That quiver was cloth, but some quivers have a hard shell and, like the quiver in Chapter 4, hang holster-style from a belt. A hard-shell quiver makes an excellent and accessible case for a shotgun microphone. (See Figure 7.22.)

The convergence of still and video cameras has yielded some excellent equipment that photographs very good quality HD video. But video is rarely presented without sound. Sophisticated video equipment has either much better microphones as part of the camera package, audio-out ports on the camera, or both. Fortunately, new digital SLR cameras that feature good-quality video incorporate audio-out ports as well. Audio-out ports give the photographer more options because different types of external, wired microphones are made for different purposes. Almost any external microphone—that is, a microphone that's not built into the camera—will yield better audio recording quality than a built-in microphone on the camera.

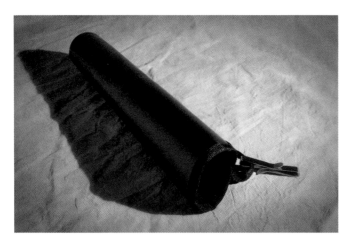

Figure 7.22 A hard-shell quiver makes an excellent and accessible case for a shotgun microphone. The quiver pictured is a Trophy Ridge Mohican Hip Arrow Holster.
Copyright © Steve Weinrebe

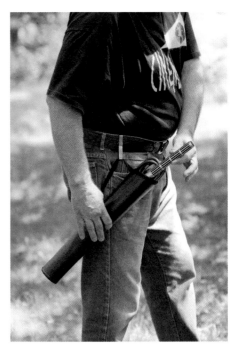

Figure 7.23 The Trophy Ridge Mohican Hip Arrow Holster holding a shotgun microphone at the photographer's side, ready to pull out and use for directional sound recording.
Copyright © Steve Weinrebe

A popular type of wired microphone for recording sound for video is called a shotgun microphone. Although some microphones are designed to record ambient noise from all around the tip of the microphone, the shotgun microphone is very directional. Its design is mostly suitable for picking up sound from one direction, such as for a person talking. This makes a shotgun microphone ideal for video shoots where you want to record an actor reciting lines, or a subject being interviewed.

Smaller shotgun microphones might fit in a camera bag, but many shotgun microphones are long and more difficult to carry easily without holding them in your hand. If you want to be ready to capture sound at a moment's notice, a holster-type archery quiver works very well. If the shotgun microphone isn't long enough to poke out of the quiver, simply stuff some padding on the bottom of the quiver to adjust the depth the microphone drops to. (See Figure 7.23.)

The quiver pictured in Figure 7.23 is a Trophy Ridge Mohican Hip Arrow Holster. Simply hang the quiver from your belt by the included clip, and drop the microphone into the quiver. Because the quiver is open ended and hanging at your side, it's easy to grab the shaft of the microphone and pull the microphone out to use for directional sound recording. When it's not in use, you can coil the cord up into the top of the quiver, or into your pocket.

Orange Safety Cone

Orange safety cones, you can't miss them. There's a reason—because they scream out to anyone driving, walking, or riding a bike that there is something up ahead to watch out for and not run into. I don't go out for a public shoot without an orange safety cone in the car, just in case. (See Figure 7.24.)

A typical risky scenario you may need a cone for: you are doing a video interview of someone on a sidewalk in front of his establishment or home. You want to pull back and get more in the frame, so you step farther and farther into the flow of pedestrians, though hopefully not into the flow of traffic. As you pull back, pedestrians in a hurry walk right between the camera and the subject.

Believe it or not, that's happened to me many times. After all, tourists are interrupted in their picture-taking all the time by people walking in front of the camera, so if there's nothing official like an orange cone, you might not be doing anything pedestrians feel they should walk around. Place an orange safety cone next to you or off to the side of your setup, and people will be much more inclined to walk around you. The orange cone brings respect.

The orange cone is a small and inexpensive device for safety. You can purchase orange safety cones at hardware stores, and they are not expensive. Add some reflective tape if you are shooting at night.

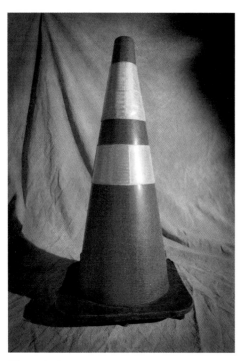

Figure 7.24 Use an orange safety cone to protect yourself from being run into while on video shoots.
Copyright © Steve Weinrebe

True Story

While photographing in a supermarket for an organic vegetable company, my assistant and I had arranged the tomatoes in the produce aisle for an ad. Just when we started shooting, a shopper stepped into the set, over the wires that ran across the floor for our lights, and started grabbing tomatoes from our carefully arranged set. I had thought the lighting equipment, the camera and tripod, camera bags, and thoughtful looks of the photographer and crew would be enough to keep shoppers from intruding. But the shopper really wanted those tomatoes. That was the last time I packed for any production on location, large or small, without an orange cone or two.

If you are shooting a large production, you need lots of them. Photographers tend to travel light, though, and I'll go on the assumption that if you are a photographer shooting some video, you don't have an army of assistants to divert traffic, nor enough of a budget to pay the parking authority to close the street for your video shoot. An orange safety cone won't protect you from idiot drivers, nor from idiot pedestrians, but at least it's a little extra signage to alert anyone around you that there's a photographer, and some potentially expensive gear, in their path.

Irreverent Photoshop Tools

If you know me, you know teaching Adobe Photoshop is a passion of mine. If you don't know me, please read my bio, and then read on with confidence. Besides my background, I confess contributing to the deluge of Photoshop books, videos, and online tutorials available to Photoshop-using photographers in recent years. Although I always try to keep my own teachings short and to the point, many of the learning aids available to Photoshop users concentrate on what's new, or what yields "cool" effects, and too often what in Photoshop can accomplish a goal after a ridiculous number of steps.

In the past, I've had students implore me to help them with tutorials they've tried to work through in vain. Usually their problem is that, in step 34 for example, they missed a word. There has to be an easier way to use Photoshop, and I like to teach Photoshop with that in mind. (See Figure 8.1.)

One of the most difficult aspects of writing about Photoshop is that new software versions sometimes make at least some of the writing obsolete. Students who have the latest version want to, understandably, learn the latest version. But I have some tools and techniques that I use when I work with Photoshop that have been around forever. The program is so deep that there isn't time to mine all those tools—even in the course of most training classes.

One of my mottos of late has been to make life simpler whenever possible. So, although there are an incredible number of tools in Photoshop, I'll include tools here that have been around for several versions, and I hope will be around in the future. If they aren't, well, one irreverent Photoshop tool is simply an older version of Photoshop. Some good tools, as well as some companion programs that used to install along with Photoshop,

Figure 8.1

The cover image from my first book, *Adobe Photoshop & the Art of Photography*, is a composite I made in Photoshop from two of my photographs. Although there is some detail work to do with this sort of technique, the actual steps are few.

Copyright © Steve Weinrebe, Getty Images

are no longer around. But if you have an older version of Photoshop kicking around on one of your computers, maybe even an old computer you don't use much anymore, sometimes it's worth firing it up just to use one of those great old tools (ImageReady from Photoshop CS2 and some earlier versions, and Extract from Photoshop CS3 and many earlier versions, are good examples).

So read on and bear in mind—things change. That means some of the screen shots may not be entirely accurate for future versions, as well as past versions, of Photoshop. I'll write this in a way so that you should be able to find your way with these tools if you have any recent version of Adobe Photoshop.

I should mention these are mostly intermediate to advanced Photoshop tools and techniques, and a solid understanding of how Photoshop works—its layers, channels, and tools—will help you make best use of this chapter. I should mention, too, I am writing here using Photoshop CS4, which is the professional Creative Suite version of Photoshop, and not Photoshop Elements, or other consumer image-editing programs (often received as trial versions on a new computer). If you own a different image editor, you may find that some of the tools I mention look similar to something you have, or you may not. But reading this chapter might give you insight into what you can do with whatever other image-editing program you use, and certainly with Photoshop.

Lens Blur at Light Speed

Lens Blur is a terrific tool, and just one of the filters in Photoshop that's very useful to photographers. But I'm not here specifically to teach you Lens Blur because that might take the entire chapter. I'm here to give you an unusual technique that will speed up your work with Lens Blur and save you potentially hours of time watching progress bars in the course of your work. There aren't a lot of steps, and the amount of time saved is dramatic. (See Figure 8.2.)

Lens Blur is a Photoshop filter that gives an image an out-of-focus effect, that simple. Of course, if that's all it did, Lens Blur might never be used, since photographers usually take great pains to get their images in focus. But you have at least a few excellent options to control what portion of your image Lens Blur affects. One option for controlling where Lens Blur is applied in an image is to create an Alpha Channel, so that you can preview the blur in only the unmasked areas in your image. Another good way to control what portion of the image is blurred is to apply the blur to a duplicate layer and then use a Layer Mask to hide portions of that layer. That's going to be the workflow here.

If you work only with web resolution images, 72 pixels per inch (PPI), for example, you won't need this technique. But if you work at print resolution, 240 or 300 PPI, you may

Figure 8.2

This photo of the Taj Mahal was entirely in focus when shot. The de-focused areas are the result of Photoshop's Lens Blur filter, which lets you create an out-of-focus look in your photographs.

Copyright © Steve Weinrebe

already know how slow the Lens Blur filter can be. The technique that saves time with Lens Blur when working in print resolution (high resolution) images is the addition of some image resizing and layer scaling. Here are the steps to get Lens Blur to work at light speed. (See Figures 8.3 through 8.7.)

Figure 8.3

Step 1: Open the image you want to apply Lens Blur to. Then, choose Image > Image Size. Make sure the Resample Image box is checked, and enter 72 into the Resolution field to make the image 72 PPI. Click OK.

Copyright © Steve Weinrebe

Tip

An Alpha Channel can be used to control which portion of the image you'll apply Lens Blur to, with the channel's white areas being the default areas that will be blurred in the image. With an Alpha Channel applied, you'll see a preview of the filter being applied only to the unmasked portions in the Lens Blur dialog box. I've written tutorials about this, and you can consult my first book, *Adobe Photoshop & the Art of Photography* (Delmar Learning), if you want to learn how to make Alpha Channels using tools like Quick Mask.

Figure 8.4

Step 2: Apply the Lens Blur filter to the image. Use the Radius slider to control the amount of blur. Set other parameters to change the shape and size of the blur, in other words to change the look of the blur as it extends beyond the boundary of previously sharp edges. You'll see the blur effect in the preview. Remember, you'll control what portion of the image is blurred with a Layer Mask afterward. Click OK to apply the blur.

Copyright © Steve Weinrebe

Figure 8.5

Step 3: First, copy the blurred layer onto the Clipboard. To do this, choose the menu items Select > Select All and then Edit > Copy. Then make your History panel visible. If you can't find it, choose History from the Window menu. Click on the History state just prior to the state called Image Size. (Be sure to click on the *name* of the history state, not on the little box next to the history state.) This will return your image to high resolution.

Copyright © Steve Weinrebe

Figure 8.6 Step 4: Choose the menu item Edit > Paste. The blurred image from the low-resolution version will paste into the middle of your document. Then choose Edit > Free Transform, and drag the corners of the bounding box (the box with corner handles) to the corners of the image window, a.k.a. the Canvas. Make sure the transform snaps the new layer exactly to the edges of the Canvas. Note that the preview may look pixilated, but it will smooth out once the transform is committed and the layer is interpolated. Click the checkmark in the Options bar, or double-click in Free Transform's bounding box, to commit the transform.
Copyright © Steve Weinrebe

Figure 8.7 Step 5: Add a Layer Mask to the blurred layer, by clicking the Layer Mask icon at the bottom of the Layers panel, and paint black with the Brush tool to hide whatever portions of the blurred layer you don't want to be blurred in the final image. Use a very large soft-edged brush to get a feathered edge to what you paint, and use a small soft-edged brush to paint on the Layer Mask in tight areas. (See Figure 8.2.)
Copyright © Steve Weinrebe

And you're done! The image now has an out-of-focus area created with Photoshop's Lens Blur filter. Depending on your computer system, the technique described here can save you several minutes, at least, each time you apply the filter.

Note how fast the blur is achieved, in a small fraction of the time it would take to apply Lens Blur to a high-resolution image. What is remarkable is that when you transform that small pasted layer from the low-resolution blurred image to be as large as the high-resolution image, the resulting interpolation doesn't really harm the blur effect because you want a blur anyway. I've done this time and again, and any variation in the results is greatly outweighed by the tremendous time saved from applying Lens Blur this way. And if you do use Lens Blur on a high-resolution image, you'll see what I mean by potential time savings.

Negative Vibrance

The Vibrance adjustment is available in Photoshop's companion RAW editor Camera Raw, Adobe Lightroom, and now Adobe Photoshop CS4. Vibrance provides a slider that will add saturation to the less saturated colors in an image first. Add the ability to ignore skin tones, and Vibrance becomes one of Photoshop's super-tools. Vibrance is used all the time by photographers to increase the saturation in images, with a greater degree of control than the Saturation slider.

But the Vibrance slider moves both ways, and negative Vibrance can be a powerful effect to mute the colors in an image. Unlike subtracting the Saturation of an image, which just moves an image directly toward being grayscale, what I have found is that certain images can be altered in very appealing ways by subtracting Vibrance. (See Figures 8.1 and 8.8.)

By subtracting Vibrance, in this case using Photoshop CS4's Vibrance adjustment, I created more of a dreamscape, an image that comprises line and form but doesn't hit you over the head with saturated colors. It doesn't replace the original; it is simply another take on the image for a different mood and purpose.

Tip

You have to choose wisely—only certain images will benefit from this technique. By previewing negative Vibrance in Camera Raw or Lightroom, or as an adjustment layer in Photoshop, you can always change your mind because of the nondestructive nature of these tools.

The photograph of a saxophone is all about the brass color in the fully saturated version. Notice how the mother-of-pearl keys take on prominence as the brass color is faded back by negative Vibrance. (See Figure 8.9.)

The photograph of the little girl on a beach has a lot of color in the water and skin tones, but the photo is too saturated for the desired mood. By using negative Vibrance, the water turns almost grayscale, whereas the skin tones retain some of their color. This is largely because Vibrance, besides first affecting the less saturated colors, also has built-in skin-tone protection. The result, whether it's the look of an old faded photo or a beach scene on a hazy day, has the feeling of a nostalgic day at the seashore. (See Figure 8.10.)

Figure 8.9
The original photo of the saxophone, top, has very saturated colors. The version with negative Vibrance, bottom, has a softer feel, allowing the shapes to take center stage in the composition.

*Copyright ©
Steve Weinrebe,
Getty Images*

Figure 8.10
The photo at top has some very saturated colors—too saturated for the mood. By pulling the Vibrance slider to the left, you remove color from everything but the skin tones, because of the Vibrance feature's skin-tone protection. This gives the bottom version a more nostalgic mood.

Copyright © Steve Weinrebe, Getty Images

Precise Cursors

Getting a paint stroke to be precisely on the desired pixels in an image can be extremely difficult. Very often photos have straight edges where something that needs to be cloned, healed, or painted lies along the edge. That edge might be a person's shoulder or the curb of a street, a hem in a garment, or the side of a building. (See Figure 8.11.)

Figure 8.11
The horizon line, along the dunes in this photo, needs to be cleaned up with the Clone Stamp or the Healing Brush to remove some visual distractions from the little girl's face. Precise Cursors will help do this accurately.

Copyright © Steve Weinrebe

The default preference for tool cursors in Photoshop, as found in Photoshop's Preferences, is for Painting Cursors to have what's called a Normal Brush Tip, and for Other Cursors (the Eyedropper, Lasso, Crop tool, and so forth) to have Standard Cursors. For the Normal Brush Tip of the painting tools, Photoshop displays a circle that gives an idea of brush size (although the circle doesn't show how feathered the edge of the brush is). The Other Cursors' Standard Cursors show icons for the cursors, like the little lasso for the Lasso tool, and an eyedropper for the Eyedropper tool. (See Figure 8.12.)

Figure 8.12 Photoshop's Preferences dialog box, with the Cursors preference options. The default settings are Normal Brush Tip for the painting tools, and Standard Cursors for the other tools. You have the option of leaving these preferences alone, and using Caps Lock on your keyboard to view tools as crosshairs, a.k.a. Precise Cursors.
Copyright © Steve Weinrebe, Getty Images

Hold up on making any changes to the default preference for the Painting Cursors. However, I recommend you always switch your Preferences setting for Other Cursors to the Precise Cursors setting.

For painting tools, though, use the Caps Lock key on your keyboard to turn any tool cursor into Precise Cursor mode—which gives you crosshairs. After all, you won't always want Precise Cursors for the painting tools, and the default circle indicating brush size works well. But the great advantage of using Precise Cursors for the painting tools is the crosshairs. With those crosshairs you can target edges in your image precisely, living up to the cursor's name. (See Figure 8.13.)

Figure 8.13
The crosshairs of Precise Cursors allow pinpoint accuracy when painting, cloning, or healing.

*Copyright ©
Steve Weinrebe*

Quick Mask Gradients

Whether you are using Photoshop's Lens Blur filter or trying to use a Curve on an area of a photo where the tone graduates, gradient masks are a key to success. Whenever you want to make a gradient in a mask in Photoshop, turn to Quick Mask for the solution. Quick Mask has been around forever in Photoshop. I'm always amazed at how few of my students use it. All you need to do to use Quick Mask is click the Quick Mask icon at the bottom of Tools, or tap the Q key on your keyboard. Then, with the Gradient tool at its default gradient of Foreground to Background (with Linear Gradient selected from the Options bar, and the default Foreground/Background colors of black and white), you click-and-drag the Gradient tool in your image to paint a gradient into Quick Mask. (See Figure 8.14.)

On exiting Quick Mask, the gradient you painted becomes a selection, which can be turned into an Alpha Channel for the Lens Blur filter. You could also leave the selection (a.k.a. marching ants) and add an Adjustment Layer, which would automatically turn your gradient selection into a Layer Mask. The possibilities are endless for gradient masks in Photoshop, and Quick Mask, with the Gradient tool, is the fastest way to get there. (See Figure 8.15.)

Figure 8.14 In Quick Mask mode, painting with black paints red mask, and painting with white paints clear. Upon exiting Quick Mask, the clear area becomes selected, and the red area is outside of the selection, or masked. Here I use the Gradient tool to paint with the default colors of black and white, to paint clear and red into Quick Mask.

Copyright © Steve Weinrebe

Figure 8.15
I used a gradient mask, created with Quick Mask and the Gradient tool, for an Alpha Channel. I used the Alpha Channel, from the Depth Map Source menu, to apply Lens Blur in a graduated way to this image.

Copyright © Steve Weinrebe

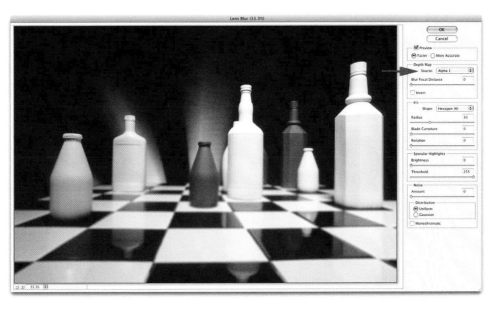

Midtone Selection

There are several methods to select midtones in your images. Midtone selection is a popular subject because it can be the key to broad-based tonal fixes or subtle fixes to skin blemishes or architectural images. There is a midtone-selection tool built right into Photoshop, and it is part of the Color Range feature. (See Figure 8.16.)

Figure 8.16
This image could use brightening in the midtones. Making adjustments to the midtones of an image can often yield better results than adjusting the highlights and shadows. Use Color Range for its midtone-selection capability.

Copyright © Steve Weinrebe

Color Range can be accessed from the Select menu at the top of the Photoshop workspace. As its name suggests, Color Range makes a selection (an unmasked area surrounded by a masked area) in Photoshop. You may not have known it was there, but the Midtones selection has actually been part of Photoshop's Color Range dialog box for quite some time. (See Figure 8.17.)

Figure 8.17
Within the Color Range dialog box, click on the Select menu to find the Midtones option.
Copyright © Steve Weinrebe

At the top of the Color Range panel is a drop-down menu to choose what to select. The default is Sampled Colors, meaning what colors in the image you click the sample eyedropper on, as well as the Add to Sample and Subtract from Sample eyedroppers. Click on that menu, and you'll get a list of primary colors and something more. The something more is at the bottom of that menu: Highlights, Midtones, and Shadows. Choose Midtones, and then click OK in the Color Range dialog box. Voila, the midtones in your image will have a selection, and the rest of the tones in your picture will be masked off from whatever you do next. (See Figure 8.18.)

Color Range looks on the midtones in images as roughly the middle 30% of the range of tones in your image from black to white, with a slight fade of about 15% in the tones just to the darker and lighter sides of the selected tones. That fade amount is key because you'll get smoother results when making adjustments to those midtones.

Once the midtones are selected, apply a Curve adjustment layer to adjust the midtones to be lighter or darker, or apply an S-shaped curve to add contrast. For the pineapple, with a Curve applied to lighten only the midtones via Color Range, the middle tones

Figure 8.18 Once the Midtones are selected in Color Range, click OK to see the marching ants selection in your image. Then apply a Curve adjustment layer, or other tonal adjustment, to only the midtones of the pineapple to lighten only those tones, leaving the highlights and shadows alone.
Copyright © Steve Weinrebe

are lighter, but the shadow and highlight tones remain unaffected. The overall result is much more pleasing because the image retains the contrast in the nooks and crannies of the pineapple that give the image depth.

Print Border

I've found in teaching photo workshops using Adobe Lightroom that a popular feature in that software's Print module is Stroke Border. In order to print a black line around a photo in Lightroom, check Stroke Border and drag the slider to the right to see the thickness of the black border previewed around the photo. It's a nice effect and one that, at first blush, seems missing from Photoshop's Print dialog box. But that tool is right there in Photoshop's Print dialog box, hidden under the Output options. (See Figure 8.19.)

Adding a black border to a photo in Photoshop is easy, once you know where to look. Choose Print from the File menu, or use the keyboard shortcut Cmd/Ctl+P, to bring

Figure 8.19

Look in Photoshop's Print dialog box, in the Output options, for the Border button. Choose your border size in the Border dialog box, and click OK. The black border that will print around your photograph will preview in the Print dialog box.

*Copyright ©
Steve Weinrebe*

up Photoshop's Print dialog box. At the top right of the dialog box, you'll see a menu item called Color Management, with lots of important color-management options beneath it. Click on that menu item and, from the drop-down menu, choose Output. Choosing Output changes the right side of the Print dialog box to feature some advanced printer functions, some of which you'll likely not need. But toward the bottom of the Output options are three buttons, one of which is Border.

Click on the Border button to get the Border dialog box. It's a small dialog box with one numeric field for entering the thickness you want for the border. Enter an amount within the limits of the tool, and you'll get an alert if you try to exceed the allowable border. You won't see the border preview until you click OK, but before you do, choose whether you want your amount in points, millimeters, or inches. Once you do click OK, the black border previews around the image in the Print dialog box preview.

Lens Correction to Add Vignette

Vignette can be a good thing or a bad thing. Bad vignette generally results when a lens causes the corners of an image to get darker, when that's not the photographer's intention. Wide-angle lenses are especially susceptible to unwanted vignette, and the poorer the lens, the more likely images will have this unwanted unevenness. Good vignette is usually added by a photographer, where the intention is to draw the eye toward the interior of an image's borders, and away from the edges. (See Figure 8.20.)

Figure 8.20
Here I use a vignette created in Lens Correction to help draw the viewer's eye into the photo and away from the edges of the frame. A Black-and-White adjustment layer, with a tint, adds to the vintage look of the photo.

Copyright © Steve Weinrebe

Vignette has been used throughout the history of photography and is mimicked some-what with antique oval-shaped frames. There are two ways I like to add vignette in Photoshop, the long way and the short way. The short way is with the Lens Correction filter. (See Figure 8.21.)

Figure 8.21 Access the Lens Correction Filter from the menu Filter > Distort; the Lens Correction dialog box will open. If need be, turn off the Grid view.
Copyright © Steve Weinrebe

You can access Photoshop's Lens Correction filter from Filter > Distort. Choose Lens Correction, and the Lens Correction dialog box will display as a large window on your computer screen with a sizable preview so you can see the effect of your changes. If you want to make the Lens Correction dialog box larger or smaller, drag from the bottom-right corner. If the grid is showing, you may want to turn it off by unchecking the Show Grid checkbox at the bottom of the dialog box. If you are new to the Lens Correction filter, you may want to explore some of the other options available in the Lens Correction dialog box.

To add vignette, all you need to do is drag the Vignette slider to the left. Below the Vignette slider is a Midpoint slider. It allows you to control how far into the middle of the image the vignette extends. When you're done, click OK to apply the vignette to your image. (See Figure 8.22.)

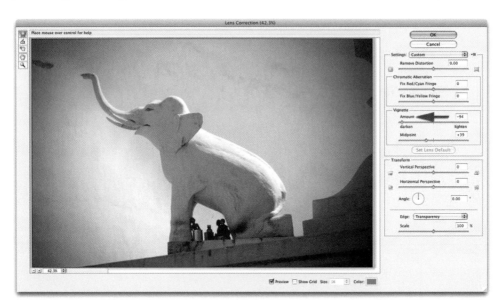

Figure 8.22
In the Lens Correction filter, drag the Vignette slider to the left to darken the corners of the image. Here I also dragged the Midpoint slider to the left to enlarge the vignette toward the center of the photo.

Copyright © Steve Weinrebe

Tip

Camera Raw and Lightroom have excellent vignette tools and are worth exploring if you are shooting RAW images, or want to open your JPEG or single-layer TIFF files in those RAW editing programs. Like Photoshop's Lens Correction vignette, the tools were designed for flawed images with uneven brightness toward the edges, but they can be used just as easily to add vignette. But if you have a recent version of Photoshop CS3 or beyond, you can add Lens Correction to a Smart Object as a Smart Filter and retain the nondestructive nature that adding vignette in Camera Raw, or Lightroom, provides.

Tweening Versions

Creating different versions of an image as you work can be very helpful, especially when you have to show the work to someone else for approval. Customers like choices, and if you are doing an adjustment or applying a filter to your image, you may want the flexibility of offering different versions to your customer. Or you may want to see an effect at different intensities without creating multiple layers and reapplying the effect each time. Ultimately, you, or your customer, want just the right variation to pick from all the possible options. (See Figure 8.23.)

The technique I'm going to show with Photoshop's Tween feature is available to Photoshop users with version CS2 and beyond. As with the Lens Blur technique earlier in this chapter, this technique is not in the rule book. But I like making my own rules, so let's use the Photoshop Animation panel's Tween ability to give us some flexibility with versions of a photo edit. I'll start with the unedited version of the image in Figure 8.23. (See Figure 8.24.)

Like many image changes in Photoshop, the effect I'm giving this photograph, a vignette and a selective blur, can be done in many different ways. But since I have already written about Photoshop tools and techniques to speed up both Lens Blur and vignette, I'll use those tools here so you'll know how I got to the next step.

After opening this image in Photoshop, I duplicated the Background layer by right-mouse-clicking on the Background layer and choosing Duplicate Layer so that there

Figure 8.23 Use Photoshop's Tween feature to see different versions of an adjustment, before settling on the best version.

Copyright © Steve Weinrebe

Figure 8.24 This photograph could benefit from a vignette to darken the corners, and the Lens Blur filter for effect. I used Tween to create versions to choose from.

Copyright © Steve Weinrebe

were two identical layers. Then I applied a vignette to the duplicate layer to darken the corners of the image, using Lens Correction as described in the previous section. After applying the vignette, I applied Lens Blur to the layer. I then used a Layer Mask to hide the center portions of the blurred layer by painting black onto the Layer Mask in the areas I wanted to hide. The black portions of the Layer Mask allow you to see through to the layer below. (See Figure 8.25.)

Figure 8.25

This is what the Layers panel looks like. After duplicating the Background layer and applying a vignette with Lens Correction, I blurred the layer with Lens Blur. I added a Layer Mask to hide the center portions of the blurred layer.

Copyright © Steve Weinrebe

At this point, the Animation panel needs to be visible. The easiest way to access it is from the Window menu. (Again, the Animation panel is in Photoshop CS2 or newer.) By default, the Animation panel will open at the bottom of your screen. If you have one of the recent Extended versions of Photoshop, you'll need to click the bottom-right corner of the panel to switch from the Timeline view to the Frames view. If you don't have Photoshop Extended, you'll automatically be in Frames view. The panel will have one single frame in it, numbered with a 1. (See Figure 8.26.)

The Animation Frames work with layer visibility. Each frame only shows the layers in the Layers panel that are visible for that frame. For frame 1, I'll hide the visibility of the new layer so that only the Background layer is visible. Layer visibility can be toggled on and off by clicking the eyeball icon to the left of the layer in the Layers panel. (See Figures 8.26 and 8.28.)

Next, I add a new animation frame, frame 2, by clicking the New Frame button at the bottom of the Animation panel. That icon is pretty universal in Photoshop for a new "something" of whatever panel the button is on. For this new frame, frame 2, I have turned the visibility on for the new vignette and blur layer so that the photo shows the full effect of the Lens Correction vignette, and the blur from Lens Blur. (See Figure 8.27.)

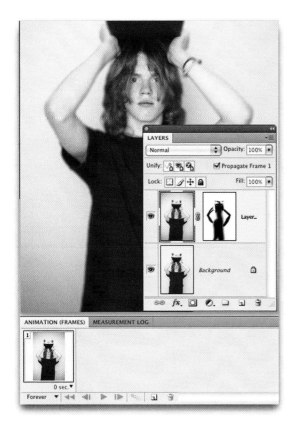

Figure 8.26 When you first open the Animation Frames panel, only one frame will be in the panel. That frame shows whatever layers are visible in the Layers panel.
Copyright © Steve Weinrebe

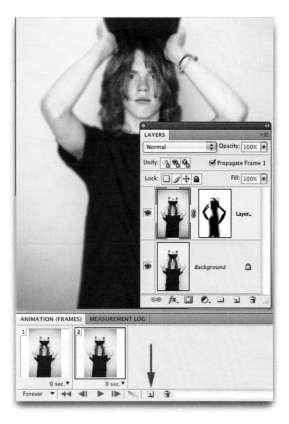

Figure 8.27 Use layer visibility to control which layers are visible at each frame in the Animation panel. For this exercise, I have only the Background visible for frame 1, and both layers visible for frame 2. That means with frame 2 highlighted, both layers will be visible. A new frame can be added by clicking the New Frame button at the bottom of the Animation Frames menu.
Copyright © Steve Weinrebe

Now for the Tween. Tween is an animation feature that adds new frames as graduated blends of already existing frames. In traditional animation, tweening can speed up the process of creating motion animation. However, you can bend Tween to your will, so to speak, and use it to create multiple versions of an image.

Remember, frame 1 shows the image with only the Background layer and the other layers, with vignette and blur, turned off. Frame 2 shows the edited result because both layers are visible. First I'll highlight frame 1 by clicking on it. Then I'll access the Tween dialog box by either clicking the Tween icon at the bottom of the Animation panel or by choosing Tween from the panel's fly-out contextual menu. (See Figure 8.28.)

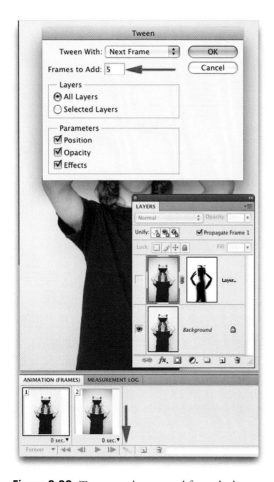

Figure 8.28 Tween can be accessed from the button at the bottom of the Animation Frames menu, or from the Animation panel contextual menu.
Copyright © Steve Weinrebe

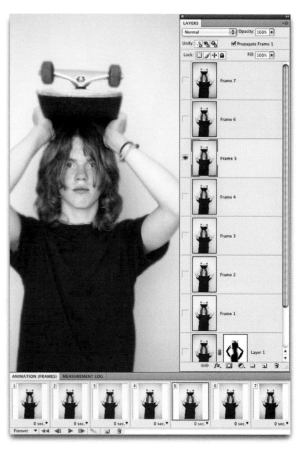

Figure 8.29 Use Flatten Frames Into Layers, from the Animation panel's menu, to create a new layer for each version of the image—unedited, edited, and the tweened versions in between.
Copyright © Steve Weinrebe

The Tween dialog box has some useful options for our purposes. For example, if you have multiple frames, you can choose which frame to tween with, how many new frames will be created when tweening, and whether to tween with all layers or only selected layers. Here, I create five new frames from all layers. The five frames will graduate between frame 1 and frame 2, and the result will be seven total frames showing varying degrees of vignette and blur, from no vignette and blur, to the full effect.

You could click on the frames to see the result, but in order to use the different versions, you'll need the versions as layers. That's no problem in Photoshop because the Animation panel's fly-out contextual menu includes a menu item called Flatten Frames

Into Layers. Choose that menu item and the effect from each frame, including the tweened frames, is turned into a layer in the Layers panel. After doing this, you can click on individual frames to see which level of the effect you like—none, all, or something in between. You can also use the shortcut key, Opt/Alt+] or [, (that's Option/Alt with the right or left bracket key), to move up and down between layers. (See Figure 8.29.)

If you want to share these versions, you can use a script that's accessible from File > Scripts, called Export Layers to Files. You can use the resulting dialog box to save JPEG or other types of files from each layer, or only from visible layers in the Layers panel.

Tip

Another terrific way to create versions in Photoshop is with the Layer Comps panel. From Photoshop's Window menu, choose Layer Comps, and the Layer Comps panel will open. Layer Comps work very much like animation frames in Photoshop—each new layer comp will show only the layers in the Layers panel that are visible for that comp. Layer Comps doesn't have a Tween feature, so you can't see graduated versions. But there is a script, in File > Scripts, to make individual files from Layer Comps as well.

9

Irreverent Digital Tools

Most photographers know about the excellent digital photo tools for photo editing produced by industry giants like Adobe and the major camera companies. But there are many other digital tools that photographers can use to help them in their work—some of which aren't marketed through traditional channels or advertised as widely as their competition, or are hidden in the depths of your own computer. In this chapter, I feature some of the digital tools I like and use, as I've tried to do throughout the book.

Some of these tools are made by traditional photo companies, some by independent developers, some by small businesses, and some by individuals. If you are willing to explore, there is a wide variety of digital photo tools out there. For the iPhone alone, new photographic "apps" are being introduced frequently. And, while most of these tools are available for Windows and Mac, to be fair on all counts, I've included one Windows-only and one Mac-only tool as well. (See Figure 9.1.)

ZIP Compression

Let's begin with a bit of software that, if you own a fairly recent computer, you have built in to your operating system, whether you use Windows or Mac. Windows users may be more familiar with ZIP compression because the capability to compress files in ZIP format has been around for a long time. Mac users may not even know they have ZIP compression because the ability to compress files in ZIP format hasn't been built in nearly as long, and doesn't get as much publicity as it should. (See Figures 9.2 and 9.3.) (If you have an older Mac OS, the menu item to zip your files might be Create Archive instead.)

Figure 9.1
I edited this photo on my iPhone with the Photo fx filter called Pro Mist. Pro Mist is just one of the many digital effects filters in the iPhone app. Photo fx and Tiffen's other iPhone filter set, Cool fx, are discussed later in this chapter.

Copyright © Steve Weinrebe

Figure 9.2
In Windows, you just right-click on a file or folder, or group of selected files or folders, and choose Send To > Compressed (zipped) Folder. To decompress it, right-click and choose Extract All.

Copyright © Steve Weinrebe

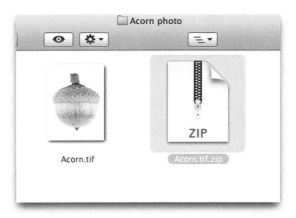

Figure 9.3 On a Mac, you just right-click, or Control-click, on a file or folder, or group of selected files or folders, and choose Compress "filename". To decompress it, right-click the file and choose Open.
Copyright © Steve Weinrebe

Figure 9.4 In this Mac folder view, you can see the ZIP-compressed version of a file. This 10MB original is now 3MB, small enough that I can attach it to an email.
Copyright © Steve Weinrebe

What attributes make ZIP compression so perfect for photographers? For one, it's lossless. That means that the image file is unaltered. You can compress photos to reduce the file size and share it via email. The recipient can then decompress the file and open the image without any alteration of the image data. But that's only half the reason—the other reason is that it's cross platform. I've been a Mac user for a long time, but I use Windows computers as well. My wife uses a Windows computer, and I have some friends who use Macs and some friends who use Windows. That also means that I email photos to both Mac and Windows computers owned by my family and friends.

To be sure, most people email a JPEG file, and I'll talk more about that in a moment. The cross-platform advantage is that I can ZIP compress a file on my Mac and email or upload the file for a Windows user, and they can recognize the file format and decompress the file on their end. (See Figure 9.4.)

Tip

Another cross-platform advantage to ZIP compression involves data protection. Sometimes, when you're transmitting files through a company's server, an image file can turn into gobbledygook—that is, the file is converted into a text file containing lines of nonsensical alpha-numeric text. More than once, customers have contacted me to report that all they received was a mile-long email with unrecognizable text in it. In such a case, resending the image as a ZIP compressed file can usually solve the problem.

JPEG compression has become a standard format for sending photos. After all, it's the file format most cameras shoot by default, unless you intentionally go into the camera menu to search for an alternative file type that the camera may also support. But JPEG compression, unlike lossless ZIP compression, is what's called lossy compression. That means that when you create a JPEG, picture data is thrown out. The lower the quality of the JPEG compression, the more data is thrown out. That data is thrown out for good. If you make changes to a JPEG image in photo-editing software and then save the image as a JPEG again, even more information is thrown out. The danger of circulating JPEG files for professional or even some consumer use is that if someone makes changes to your image and resaves the image as a JPEG, there is now a degraded version of your image being circulated—a version that might have JPEG artifacts, which look like little square blocks of pixels, as well as small discolorations and distortion around edges in photos.

Tip

If you want to circulate a photo using a file type that is not compressed by lossy compression like JPEG, try the ever-popular TIFF file (the .tif file extension). Students often ask me what the advantage of TIFF files is and why to ever use them. Besides that TIFF files are widely supported by operating systems and by image-editing software, the TIFF file format actually has a built-in lossless compression scheme called LZW compression. When you're saving a TIFF file, choose LZW compression and the file size on disk will be dramatically reduced. Photoshop users can even use this compression with layered files. The TIFF file that has been saved using LZW compression can still be turned into a ZIP file for emailing. It won't be as small as a JPEG, but if it's within the limits of your maximum mail size, you won't have a problem. (See Figure 9.5.)

Figure 9.5 When you save a TIFF file in Photoshop, this dialog box appears with the choice to check LZW compression. LZW compression is lossless and won't harm the data in your image.
Copyright © Steve Weinrebe

VueScan

Like so many others with older scanners, my slide scanner was orphaned when the company that made it went out of business. I liked the scanner and it did a great job, but the software only worked on an old operating system. I actually have an old computer kicking around for such uses, but scanning from the old machine leads to other problems such as connectivity, and incompatible media. In short, that old slide scanner had reached the end of its useful life. Then I found a program called VueScan, which supports that old scanner on a current operating system. In fact, VueScan not only brought my old slide scanner back to life, VueScan turned it into a device capable of RAW file capture—that wonderful imaging standard that captures all available information and stores that information into the image for manipulation in a RAW image editor. (See Figure 9.6.)

Figure 9.6
This image was originally a slide, scanned into VueScan as a DNG file. I then edited the RAW image in Camera Raw.

*Copyright ©
Steve Weinrebe*

VueScan is the brainchild of the software developer Ed Hamrick. Indeed, the website for VueScan is his name, www.hamrick.com. VueScan comes in two flavors, a Standard edition and a Professional edition, and is available for Windows, Mac, and Linux.

Photographers should buy the Professional edition, which, at the time of this writing, is well under $100. In fact, if you are a photographer with a more recent scanner and working scanner software, you'll benefit from VueScan as well for the simple reason that VueScan scans RAW files in DNG format (file abbreviation .dng). The advantage of making a scan in DNG format is that you can retrieve all the data the scanner's sensor captures in the widely supported DNG format and then open that scanned DNG file in a RAW editor such as Adobe Camera Raw or Lightroom. You can then edit the scanned image with much more dynamic range than when working with a scanned JPEG. You can use VueScan to scan RAW images, saved in DNG file format, to open in a RAW editor like Adobe Camera Raw or Lightroom. When doing so, I don't bother to make brightness and color adjustments in the scanner software, because all the information capable of being captured is saved into the RAW image for adjusting in a RAW editor. (See Figure 9.7.)

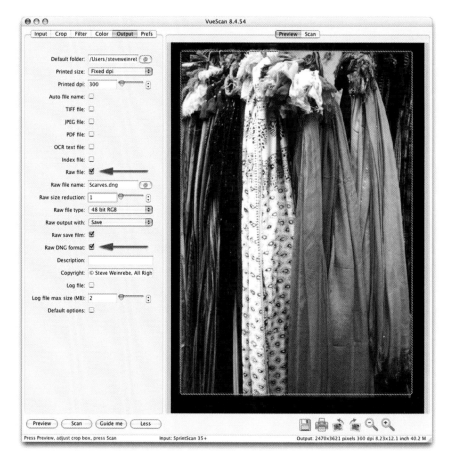

Figure 9.7

VueScan is scanner software for Mac, Windows, or Linux that supports many scanners, including scanners that are no longer supported by their manufacturers.

Copyright © Steve Weinrebe

Figure 9.8 shows an image I scanned as a DNG in VueScan. Then, I opened the DNG file in Camera Raw and made adjustments to White Balance, Exposure, highlight Recovery, and the Point Curve. I added some color saturation with Vibrance, and adjusted individual colors in the Hue/Saturation tab. Finally, I opened the image in Photoshop to make some pixel-based edits like healing dust spots.

If you don't want to scan your images as RAW images, you can scan them as JPEG or TIFF files. You can choose which program to open the scanned images in, so when your image is scanned, it can open right into Photoshop, for example. If you do scan slides or prints to TIFF files, be sure to scan them as 16-bit images, not as 8-bit, so that you have the extra tonal information to work with.

But trust me, you do want to scan RAW images. That's the case whether you are using VueScan for scanning slides and other sized transparencies or scanning flat art. I've worked with hundreds of scanned images and get the best results by scanning the images as DNG files and then editing in Camera Raw. That's a time saver as well because you don't have to spend time adjusting color and tone in the scanner software. Just scan all the information that can be captured from the scanner's hardware into the DNG file and mold your image into shape in the RAW editor you're familiar with.

Figure 9.8

This photo-graph of scarves in India was scanned as a DNG in VueScan and then edited.

Copyright ©
Steve Weinrebe

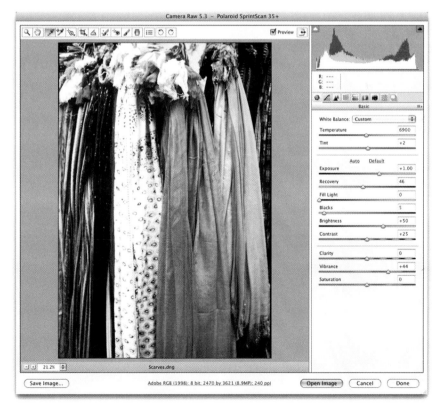

I mentioned flat art and, sure enough, I have an old flatbed scanner as well—one that was top of the line in its day. I have had the same excellent experience using VueScan with the flatbed scanner, scanning prints into DNG files for processing in Camera Raw or Lightroom.

VueScan supports a tremendous number of scanners; you can search www.hamrick.com to see if your scanner is supported. Whether you have thousands upon thousands of slides or prints that you'd like to edit in Photoshop or you like to work with a hybrid workflow by shooting film and scanning the film to edit digitally, VueScan's DNG capture capability alone makes it a tool worth having.

Tip

Don't be put off if your DNG scan, from VueScan, looks dark, and don't bother to make a lot of brightness and color adjustments before you scan the RAW image. All the image data that your scanner is capable of capturing is available in the RAW file, and you'll see that when you lighten your image using the tools in your RAW image editor, such as Lightroom or Camera Raw. Using the RAW file lets you work nondestructively in your editing workflow because changes to the file in Lightroom or Camera Raw don't permanently affect the RAW file and you can always go back to that RAW DNG file and make different adjustments without harming the original.

Knoll Light Factory

When I teach Photoshop, I only discuss the features that are installed with the software. But when I use Photoshop to work on my own photography, I get to play with some interesting third-party tools that act as digital filters within Photoshop. I'm especially a great fan of filters that enhance photographs or help accomplish something photographic that would have been difficult to do at the time of the image capture. Knoll Light Factory, a Photoshop plug-in filter, does exactly that by giving photographers a post-production master tool for adding lens flare to images. Once installed, Knoll Light Factory appears in Photoshop's Filters menu.

In Figure 9.9, I used the Knoll Light Factory filter preset called Summer Emergence. The filter's interface includes more than enough options to let you achieve the desired look.

Lens flare is historically an aberration caused by light reflecting between the glass elements of a lens, where the internal glass reflections resolve on the focal plane and become part of the photograph. Because modern lenses have very sophisticated anti-glare coatings on both sides of each piece of glass that makes up the lens, flare is rarely seen in photos. Those anti-glare coatings have their limits, though, and flare can appear, even

Figure 9.9

I staked out my turf for this scene waiting for a spectacular sunset, but I was cheated when the sun went behind clouds. Knoll Light Factory, a Photoshop plug-in filter, came to the rescue with post-production, user-adjustable lens flare.

Copyright © Steve Weinrebe

with very good lenses, when there is an extremely bright light in the photo—especially a point source like the sun or a reflection from the sun. Even a bright light like a photoflash or car headlight can cause flare depending on the lens and the exposure.

But creative photographers, videographers, and filmmakers have embraced lens flare as a way to add a visual dynamic, tension, and excitement to an otherwise static image (there is a video plug-in version of Knoll Light Factory as well, that works with After Effects, Final Cut Pro, Motion, Avid, and Premiere Pro). By adding lens flare, the scene becomes obviously seen through glass (hence the flare). Using lens flare in an image, if handled correctly, can draw the viewers in, making them feel more like voyeurs, in other words creating an intimacy that lets the viewers feel they are looking at the scene through their own private viewing glass. The flare becomes a compositional element as well. (See Figure 9.10.)

Knoll Light Factory (version 3.0 as of this writing) gives photographers 110 preset types of lens flare to choose from, and then many options to manipulate and customize each type of flare. You can click and drag the flare around the Preview window, and the angles of the flare's elements, circles, and lines of reflected colors move proportionately. You can even create a layer in Photoshop to use as a mask to tuck the hot spot of the flare behind an object—and effectively make a scene look like the sun was peeking into the frame when in fact it wasn't. The Preview window shows the current flare, and the user can simply click and drag on the flare in the preview to move the flare around in the image. (See Figure 9.11.)

Figure 9.10 The sun passed behind clouds, dulling the original image on the left. Introducing lens flare into the photo, with Knoll Light Factory, adds excitement and tension to the image. This filter preset, called HAL, is just one of over a hundred customizable lens flare options.
Copyright © Steve Weinrebe

Figure 9.11
The Knoll Light Factory Filter dialog box offers 110 lens flare presets and lots of options for customizing and manipulating each preset. Here, I positioned the central point of the flare just left of the tree to simulate a sunset.
Copyright © Steve Weinrebe

You could use Knoll Light Factory's filter in any photo, but it will make most sense if you use lens flare in an image where the sun is in the scene, peeking out from the edge of the frame or from behind a tree, building, person, or other element. In that case, your excellent camera lens might have actually subdued any glare, and all you have is a really bright highlight in part of the photo. Use Knoll Light Factory to add lens flare emanating out from that highlight and, in a controlled and often colorful way, out into the photo.

Because both the shape of the lens and the shape of the shutter can affect the look of real lens flare, you have control over all those elements in the filter's interface. Because lens coatings have a color to them, real lens flare often takes on the rainbow hues of soap bubbles, and you have control over those color effects as well. Fortunately, Knoll Light Factory comes with excellent documentation to get you up and running, and you'll soon be having great fun exploring all the lens flare options.

Tip

Like other Photoshop filters, Knoll Light Factory will alter the pixels in your image. It's a good idea to duplicate the Background layer in Photoshop's Layers panel, by right-clicking on the layer and choosing Duplicate Layer, before running the filter. This way, you always have one layer that hasn't been altered. Better yet, if you have a recent version of Photoshop (CS3 or beyond), you have the ability to apply Smart Filters. Before running the filter, choose Filters > Convert for Smart Filters. This will turn your layer (or multiple highlighted layers) into a Smart Object. When you apply Knoll Light Factory, or any other filter, to a Smart Object, the filter will appear in a list below the Smart Object in the Layers panel. All you need to do to change the filter's parameters is double-click on the filter's name in the Layers panel. If you want to delete the filter, you can simply drag the Smart Filter to the little trash can at the bottom of the Layers panel.

Xara Xtreme

So, you'd like an image editor that you can use to manipulate both web-resolution and print-resolution photos, to work with vector shapes and text, to create and manipulate 3D type, and to create web pages with Flash animations—and you want all that for under $100. Well, the answer to your wishes might be Xara Xtreme, because the software really does that much, and more, and costs that little. The only reason it might cost you more is if you are a graphic designer and require a few more bells and whistles like four-color editing and Pantone colors, in which case you'll need Xara Xtreme Pro, which costs well under $300—still a tremendous bargain. (See Figure 9.12.)

Xara Xtreme (version 5 as of this writing) is a Windows program made by the British company Xara. You can download it as a trial or purchase it from the company's website, Xara.com. Taken as one, Xara Xtreme feels like two or three programs interacting together. With deceptive simplicity, you can drop in photos and drag them out to 3D objects; add type and convert that to 3D with multiple choices for edge bevels, gloss, and color; combine all this with vector-based shapes, and more. Although there is some photo-editing capability, Xara Xtreme isn't a full-blown photo editor. For that reason, Xara Xtreme has a menu item that allows users to edit photos in their favorite photo editor, such as Photoshop, and then easily return to Xara Xtreme.

Figure 9.12

I dropped this photo into Xara Xtreme, right from a folder, and added 3D, color, shadow, and gradient features with drag-and-drop ease. Xara Xtreme updates changes in real-time, mostly without dialog boxes and menus.

Copyright © Steve Weinrebe

Adding 3D to a photo or to type is easy in Xara Xtreme, as shown in Figure 9.13. First, you choose the 3D tool, and then drag onto the side of the image to extend it outward in 3D. You can choose from a menu of 3D shapes, edges, and bevels, and rotate the 3D view of the image as well. Lights and reflections are all equally easy to manipulate with the simple interface.

For effects with photos, Xara Xtreme really shines. Effects such as drop shadow are added, not with a dialog box, but with a tool that can be dragged in the photo. Click the Shadow tool, drag on an element in the page like a photo or type, and a drop shadow drags out from behind it. Sliders let you add softness and density to the shadow. Then just click on another tool and go about your work. (See Figure 9.14.)

Elements in a Xara Xtreme composition are all floating and embedded into the file, if saved as a Xara format file (.xar file extension). If you resize an image down to a fraction of its size and save as a Xara Xtreme file, the entire original is embedded into the file so you can open it up another day and enlarge the photo element without any data interpolation.

Tinting photos is a breeze as well. Along the bottom of the Xara Xtreme interface is a color ramp in the form of color chips. To tint a photo, drag a color chip into the photo—it's that simple. Click the Color Editor button to the left of the color chips and HSV (Hue, Saturation, and Value, which is essentially the same as Hue, Saturation, and

Figure 9.13

Adding 3D to a photo or to type is easy in Xara Xtreme.

*Copyright ©
Steve Weinrebe*

Figure 9.14

Adding a drop shadow to an object is as simple as clicking the Shadow tool and dragging on the object. Sliders above the image window control blur and the transparency of the shadow.

*Copyright ©
Steve Weinrebe*

Brightness). When flat objects or type are turned into 3D objects, the 3D object's color, as well as its 3D lights, can be just as easily altered. In Xara Xtreme, you can even change the font and font size of the 3D type. You can alter the color of the type by using the Color Editor or dragging color chips onto the type from the color ramp at the bottom of the workspace. (See Figure 9.15.)

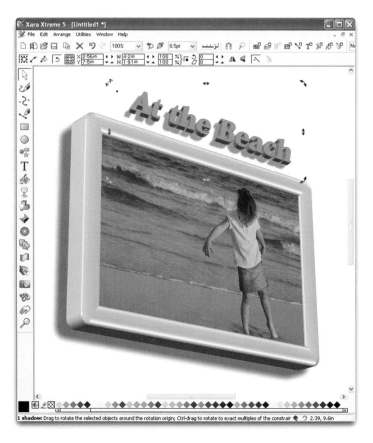

Figure 9.15
When I was finished with the artwork of the picture frame, I added type and extruded the type into a 3D shape with the 3D tool.

Copyright © Steve Weinrebe

I've concentrated here on some amazing effects that can be applied to photos and type in Xara Xtreme, but there is a treasure trove of features to work with in Xara Xtreme. Of special interest to web developers is the WYSIWYG web-page creation, using text, shapes, and photos. You can create Flash animations and GIF animations, including rollovers, in Xara Xtreme as well.

Cool fx and Photo fx

I wrote about the convergence of mediums in Chapter 7, "Irreverent Video Tools." Convergence has affected both hardware and software, and digital photographers now have a tremendous number of options. Mid-range cameras, traditionally designed for

the amateur, now capture not only professional-quality photos but shoot video as well. There's a flip side to that story too. The lower-end point-and-shoot camera (which in a way started the whole convergence process by adapting to both still and video early on) has migrated backward into mobile phones. (See Figure 9.16.)

Figure 9.16
For this photo I added a digital color filter called "Bleach Warm 1," right on my iPhone in Cool fx.
Copyright ©
Steve Weinrebe

The future will most certainly see great strides in both mid- to high-range cameras and the lowliest devices incorporating cameras. The irony will be that, as the cameras in utility items like phones get better and better, the notion of a standalone camera for still photo taking may become a thing of the past. Like most people, I own a point-and-shoot camera, but I reach for it less and less, and rely more on the mobile phone camera in my pocket. With iPhone products like Cool fx and Photo fx, made by the venerable photo-filter company Tiffen, I have even more reason to reach for my phone to take snapshots.

Although these apps (applications available in Apple's iTunes App Store) are exceedingly inexpensive, pocket change really, and are largely special-effects filters for photos, they incorporate some features that are more the province of powerful and comprehensive image-editing programs—features like cropping and adding vignette.

You can take original photos from within the interface or you can use photos from your photo library on the iPhone or iPod Touch. In Cool fx, filters come in five categories:

- Black-and-White (including a wonderful Old Newspaper filter for a yellowed black-and-white newspaper look)

- Color

- Diffusion

- Grain

- Temperature (for color temperature effects)

Within each category, Cool fx shows small thumbnails on the iPhone's screen of how the image will look when different filters are applied. (See Figure 9.17.)

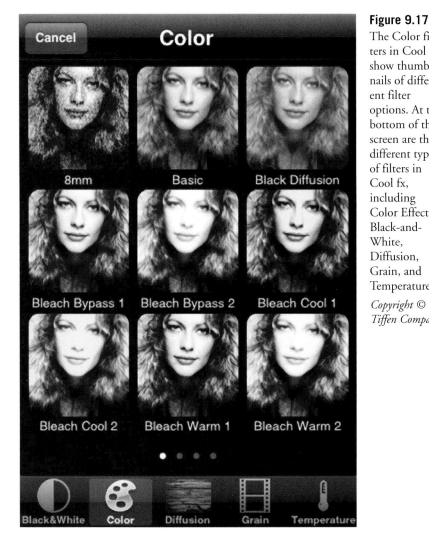

Figure 9.17
The Color filters in Cool fx show thumbnails of different filter options. At the bottom of the screen are the different types of filters in Cool fx, including Color Effects, Black-and-White, Diffusion, Grain, and Temperature.

Copyright © The Tiffen Company

Tap on one of the thumbnail images, and the preview fills the screen with sliders to adjust the parameters of the effect. Also, a toolbar appears beneath the preview. The toolbar is consistent across the filter types and includes cropping, vignette, a before-after button, a button to hide the adjustment sliders for a better view of the preview image, a Save button to save a version of the image with the filter applied, a Help button, and of course a Cancel button. The cropping feature alone is adjustable and works with the simple gestures that make the iPhone so user friendly. (See Figures 9.18 and 9.19.)

Tiffen's other iPhone app, Photo fx, has a similar interface and includes a variety of digital filters that mimic many traditional photo techniques, including a Night Vision filter and an Infrared filter. There is some overlap between the two filter sets. But there are filters unique to Photo fx (like the Depth of Field filter shown in Figure 9.20) that

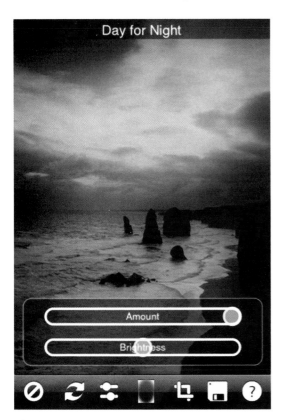

Figure 9.18 When you tap the filter preview's thumbnail, the preview fills the screen. You can drag the sliders to adjust the filter, as shown with the Day for Night filter pictured here.

Copyright © The Tiffen Company

Figure 9.19 After applying one of Cool fx's color filters to this image, one that both brightened and diffused the image, I cropped it using the Cool fx crop tool. After doing so, you can save the image as a copy, or add more filters on top of the existing filter.

Copyright © Steve Weinrebe

Figure 9.20
Tiffen's other iPhone app, Photo fx, includes many special effects filters that mimic traditional photo filters and techniques. For this photo shot with my phone, I used the Photo fx Depth of Field filter, which lets you selectively blur areas of the image to make them look out of focus.

Copyright © Steve Weinrebe

make this filter set well worth having. Depth of Field creates a selective focus effect, and you can choose which portion of your image to keep in focus and which portion to blur, as well as how much blur to add.

You aren't restricted to using these filters on iPhoto snapshots. Because you can load any photos onto your iPhone or iPod Touch using iTunes, you can turn your mobile phone into a mini photo lab for all your images with Cool fx and Photo fx.

Tip

When you launch either Cool fx or Photo fx, you'll see an Options button or icon. If you want the highest-resolution image possible to be output by the filters, be sure to go into the Options and choose Full for the maximum output size. The default output size will convert your photo to low resolution, suitable for email. If you start out with full resolution, you can always convert the photo into a smaller one by using an image editor like Photoshop.

The Macintosh ColorSync Utility

I try to have no operating system bias. I teach all the time on both Windows and Mac and have several of both for use in training. While I use a Mac at my desk, my wife uses Windows, and my children use either depending which is free to use, or what they are sitting in front of. But there have always been some elements of the Macintosh operating system that are very friendly toward the use of color, and an example of that is the ColorSync utility built into the Mac operating system. (See Figure 9.21.)

Figure 9.21

The Macintosh ColorSync utility can be found in the Utilities folder in Applications. The tool is a good way to determine which color profiles you have and to model them in 3D.

Copyright © Steve Weinrebe

Although the ColorSync utility includes advanced features, you should use it as a learning tool. Specifically, it will teach you about color spaces, a.k.a. gamuts, that comprise all the colors that a device is capable of reproducing from nature.

The eye can see a much greater range of color than can be captured by a digital camera. Digital cameras generally capture more color than can be viewed on a computer display and on the Internet, and all the above can display more color than can be viewed in a photographic print or on the printed page of a book. These are important concepts for a photographer to understand, and the ColorSync utility is a great place to go to learn about color spaces.

> ## Tip
>
> If you don't calibrate your display, you should, because otherwise you have no idea whether the colors you are looking at on your computer screen are accurate. A hardware-calibration device is your best bet, because trying to calibrate a computer display with your eye is simply guesswork. Hardware-calibration devices can be purchased for well under $100. If you are a graphic designer or professional photographer whose career depends on accurate color, you may want to spend a little more, but if you are a hobbyist photographer, a less expensive model should be sufficient. Regardless, calibration devices, like many digital tools, now cost only a fraction of what they cost several years ago. And they last, so you'll get your money's worth.

With the ColorSync utility open, click on the Profiles tab at the top of the dialog box, and a list of installed color profiles will appear in a column at the left of the dialog box. Click on Adobe RGB (1998) in the System group, and a color model of the Adobe RGB color space will appear at the right of the dialog box, as seen in Figure 9.21. It looks like a 2D representation, but if you click and drag on it, the color space will rotate and spin in any direction you drag it. (See Figure 9.22.)

Figure 9.22

The visual preview in ColorSync may look two-dimensional. But click and drag to rotate the color space; you can see it from all angles. This can help you determine whether any colors are clipped, or left out, of the color space.

Copyright © Steve Weinrebe

In itself, the RGB color space may not mean much to you, but the terrific learning feature of the ColorSync utility is that it allows you to compare color spaces. To do this, click on the little black triangle in the upper-left corner of the color space preview window, and choose Hold for Comparison. Once you do that, you can click on any other profile and see how that color space compares to the color space you are holding for comparison.

Try clicking on the sRGB color space, a web standard that is the default color space in most digital cameras and image editors (unless you change the default). You'll see that the sRGB color space is more limited in the range of colors it can reproduce than the Adobe RGB color space. For that reason, if you do more with your photography than just put it up on websites; for instance if you print your photography with a good photo printer, you'll want to check if your digital camera can tag (attach) the Adobe RGB color space to your photos instead of sRGB. Most good digital SLR cameras can apply the Adobe RGB color space to your photos, and you'll find the option, if it's there, in the menu on your camera. (See Figure 9.23.)

Next, try comparing a CMYK color space to Adobe RGB. This is especially instructive because the CMYK color space used for offset printing is much smaller than the Adobe RGB color space. (See Figure 9.24.)

If you have an inkjet printer, you'll likely see the color profiles for that printer in the list, and you can compare that profile as well. Inkjet printers often have more than just four inks so the color space, or gamut of colors, is larger than CMYK alone, but it's a

Figure 9.23
In the Mac ColorSync utility, you can easily see how much smaller the sRGB color space is compared to the Adobe RGB color space. If you print your photography, check your camera's menu for an option to switch from sRGB to Adobe RGB.
Copyright © Steve Weinrebe

Figure 9.24
The CMYK color space is much smaller than RGB. For that reason, you should explore the differences and see which colors don't translate well into print. If you have an inkjet printer, compare its color space to your camera's.

*Copyright ©
Steve Weinrebe*

good idea to understand how much smaller your printer's color space is compared to what your eye sees and what your camera can capture.

Look in the ColorSync utility's list for your camera's ColorSync profile as well. If you don't find your camera listed, look for the install disk that came with your camera, or try searching the camera manufacturer's website for color profiles. Then compare those profiles to your printer's profile in the ColorSync utility.

Tip

You can always swap a photo's attached, or tagged, profile in Adobe Photoshop by choosing Edit > Convert to Profile. If you are sending your photos to print, ask the printers or photo retailers for their color profiles that they can email to you, or that you can download from their websites, in order to tag your image before you deliver or upload the photos. Doing so will result in more accurate print reproduction.

10

Irreverent Tools for All Photographers

Far be it from me to say I've given you all the irreverent tools that a photographer needs to accomplish great photography. In fact, the list is endless because photographers are creative and innovative by nature. I know the instant this volume goes to press I'll think of even more tools that should have been added, and my own list has been compressed for reasons of space or suitability for a wide audience. Over time, I hope to hear from readers with descriptions of, and experiences with, their own irreverent tools.

I really enjoy seeing how other photographers work, and I've noticed that photographers often have little areas dedicated to one task or another. There is always a place where cameras and lenses are kept out of harm's way; an area where lighting equipment, stands, umbrellas, and softboxes are stored (sometimes neatly and sometimes haphazardly); a computer area full of, ironically, papers, folders, and printed manuals; and a workbench and some cabinets. If you don't have a workbench and cabinets in a studio or office, you might have one in your garage, or the elements of a workbench in a kitchen drawer waiting to be used at your kitchen counter or dining table.

Wherever you keep the odds and ends for the just-in-case moments of photographic inspiration, you'll be well served to keep at hand some miscellaneous tools. These are tools that don't necessarily fit into the categories of photography that I've already discussed in this book, but that are useful and worth keeping in your photographer's toolbox. (See Figure 10.1.)

Figure 10.1

How I created the effect in this photo—homage to surrealist artist René Magritte, is beside the point—although I will say I didn't do any manipulation to the photo after it was taken. But the hidden photo tool here is clear fishing line, which I used to suspend the umbrella from a boom.

Copyright ©
Steve Weinrebe

Gorilla Glue and Gorilla Tape

If you took a look in my cabinet of glues and adhesives, you'd probably say that I had enough. But most glue works great only on paper, wood, or plastic. The problem with most types of glue is that they don't bond to some other materials like stone, metal, or rough, textured ceramic. If the other glues do bond some of these materials, in my experience, the bond doesn't last. That's why Gorilla Glue make such an excellent photo tool, because photographers often have to bond an oddball material together; something that traditional glues cannot handle. (See Figure 10.2.)

Gorilla Glue is waterproof as well, making it suitable for applications where the item glued might get wet, or might be outdoors in moisture or humidity. In fact, getting wet is part of the process of applying Gorilla Glue. As the instructions state, you should dampen one or both surfaces before applying the glue. Unlike many other glues, Gorilla Glue cures in three to four hours.

Among the many materials Gorilla Glue will bond, polystyrene foam is one of them. That makes Gorilla Glue an excellent adhesive for gluing that staple of photo tools—foam board. Because foam board is easy to cut, rigid, matte white, and has all the properties I discussed in Chapter 2, a glue to bond foam board can be a very handy tool. With Gorilla Glue, foam board can be made into any odd-shaped construction, such as custom reflectors. (See Figures 10.3 and 10.4.)

Figure 10.2 Gorilla Glue bonds most materials, including those that other glues have difficulty bonding, such as wood, stone, metal, and ceramic. Gorilla Glue is waterproof, making it suitable for outdoors applications, or for gluing anything that might get wet.

Copyright © Steve Weinrebe

Figure 10.3 The freestanding reflector used in this still-life was glued together using Gorilla Glue. Because Gorilla Glue can easily bond pieces of foam board together, constructions can be made with foam board that would be difficult to make simply by using tape.

Copyright © Steve Weinrebe

Figure 10.4

This still-life of a handmade champagne glass was taken using a custom reflector glued together with Gorilla Glue. In post-production, I applied a Knoll Light Factory lens flare filter to enhance an already existing hot spot, and to add color and dimension to the image (as discussed in Chapter 9).

Copyright © Steve Weinrebe

Gorilla Tape is truly useful because it adheres to whatever it's applied to with exceptional strength. Because it has such incredible sticking power, use it with caution. Gorilla Tape is strong enough to adhere to brick and stucco, and it shouldn't be applied to anything exceptionally fragile (including walls and skin), unless you are sure you can peel it off without damaging the surface that it's stuck to. In other words, this tape isn't for Grandma's lace curtains, it's for truly heavy-duty applications. (See Figure 10.5.)

I mentioned one such heavy-duty application in Chapter 7, "Irreverent Video Tools." In that chapter, I demonstrated how to use plastic gutters as a track for a dolly when shooting a video-tracking shot. That's an application that may be used outdoors, but pavement isn't something that's easy to tape the gutters down to. That's an example of how strong Gorilla Tape is; it can be used to tape the gutter down to asphalt or cement to hold the gutter tracks in place. (See Figure 10.6.)

Figure 10.5 Gorilla Tape is an extremely strong adhesive tape and can bond to surfaces other tapes wouldn't bond to, like asphalt.
Copyright © Steve Weinrebe

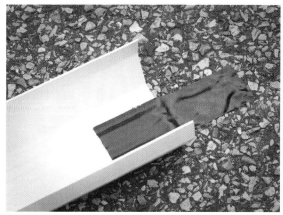

Figure 10.6 Gorilla Tape is strong enough to tape this gutter down to pavement so that it can be used as a track for a dolly's wheels, for the video-tracking shot described in Chapter 7.
Copyright © Steve Weinrebe

Aviation Snips

Aviation snips, a.k.a. tin snips or sheet metal shears, are a potent tool for cutting. Because of that, you might think that aviation snips are too strong for most photo-oriented materials. But the reality is very much the opposite, and tin snips work great for cutting a wide variety of materials a photographer might use, including foam board and heavy-duty cardboard. (See Figure 10.7.)

There are different types of aviation snips for straight and angled cuts. You want a straight-cutting set of snips, which have a telltale yellow-colored handle. A good set of aviation snips will have a form-fitting handle and be comfortable in your hand. This is especially important because aviation snips cut in very small increments, unlike a large pair of scissors that might cut several inches at a time. But it's not the size of the cut that counts; it's the incredible force of the cutting edge that allows aviation snips to cut through metal.

Sheet metal can have some limited use as reflector material, and can be seen in the backing of many types of lighting, including fluorescent fixtures for video sets. But sheet metal isn't a typical material used for photography if only because it is hard to cut and the sharp edges, once cut, can be like razor blades. Other materials, though, that are difficult to cut typically do fit the needs of photographers. Foam board is used extensively in photography as reflector material, for set building, for tabletops, and as backing for cloth and other materials that might be used as a photo background or reflector. Cardboard, especially corrugated cardboard, is also a good material to use as a backing for background or reflector materials.

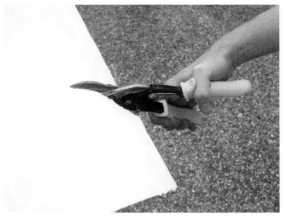

Figure 10.7 Aviation snips can cut through a variety of materials besides tin, including foam board and cardboard.

Copyright © Steve Weinrebe

Figure 10.8 Aviation snips can cut an irregular shape out of foam board or cardboard with ease. Each individual cut is small, due to the small throat of the scissors area, which makes it even easier for you to cut circles or turn tight corners.

Copyright © Steve Weinrebe

Cutting these materials is a challenge. A utility knife, a.k.a. matte knife, can cut foam board and cardboard, but you need a good straight-edge ruler to align the knife and a cutting surface to prevent deep scratches in whatever you are cutting the foam board or cardboard on. Aviation snips cut these materials like they're cutting through butter. That may sound like overkill, but if you want to cut a circle or an irregular shape out of foam board or cardboard, aviation snips are a good choice. (See Figure 10.8.)

Tip

If you need to cut a circle out of foam board or cardboard, draw the circle so that the outside of the circle lines up against two sides of one of the sheet's corners. That way, when you're cutting with the aviation snips, you don't have to cut far into the sheet to get to the circle that you want to cut out. If you need to cut a circular hole out of the middle of a sheet of rigid material like foam board, cut a hole inside the circle with a utility knife first, and then cut outward with the aviation snips, from the hole to the edges of the circle and around the diameter.

Compass

I have heard that Leonardo da Vinci could draw a perfect circle freehand. I'm no da Vinci, and unless you are, you'll be well served to keep a compass, a.k.a. pair of compasses, around for just such a purpose. (See Figure 10.9.)

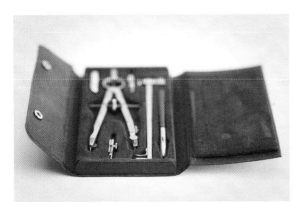

Figure 10.9 You can draw a perfect circle with a compass by anchoring the sharp point at the center, and then rotating the pencil side to draw the circumference. This compass set includes different types of tips, and an extension for larger circles beyond the size that the compass can extend to.
Copyright © Steve Weinrebe

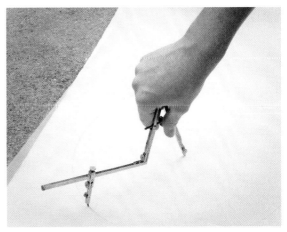

Figure 10.10 A compass is a perfect tool to draw a circle on diffusion material. The extension allows you to draw larger circles than the compass can accommodate. Here, the compass extension was added to draw a large circle to fit over a light. Once the circle is drawn, it's easy to cut along the pencil line.
Copyright © Steve Weinrebe

If you want to cut a color theatrical gel to fit over a round spotlight or light modifier, for instance, or cut some diffusion material in a circle to soften a light, a perfect circle will look and work better than a choppy oblong. Perhaps you need a circular insert of foam for a light-stand case, or a round reflector to place under or behind a product for a product still-life photo. For these and any other reasons, you may need to cut a circle out of some material. A compass is the tool to use.

To draw a circle with a compass, position the sharp metal point to anchor the compass on the material you're drawing on, and then rotate the pencil side to draw the circumference of the circle. Whatever diameter you need, you measure the width of the compass to half that width, because the compass width becomes the radius of the circle. (See Figure 10.10.)

Tip

To cut a very large circle, larger than the compass can accommodate even with the extension, tie one end of a piece of string to a nail and the other end to a pencil. The length of the string will be the radius of the circle. Hold the nail at the center of the circle and, while holding the string taught, rotate the pencil around the circumference to draw a circle. A large string compass is especially useful if you want to cut a piece of reflective material to make your own reflector disc, or to replace the material in a collapsible reflector disc that is past its useful life.

Clear Fishing Line

Even though fish have excellent eyesight, fish don't know clear fishing line is there, because they just cannot see it. You won't either, and the beauty of that is clear fishing line tends to disappear when present in a photograph. But there are two other attributes of clear fishing line that make it a must-have addition to a photographer's toolbox—clear fishing line is exceedingly unbreakable, and it is easy to tie. And of course, it is cheap, useful, and lasts forever—the true markings of an irreverent photo tool. (See Figure 10.1, featuring an umbrella suspended by fishing line, and Figure 10.11.)

What may not be entirely obvious in Figure 10.1, homage to the surrealist artist René Magritte, is that the subject needed to turn, but the umbrella needed to stay put. In order to accomplish that look, I suspended the umbrella from a boom. I drilled a small hole in the tip of the umbrella to tie the fishing line to, and tied the other end to a boom, stretching into the set and high above the image frame.

Clear fishing line tends to blend in with its background, and when you shop for it, look for clear monofilament. Monofilament means that the line is a single clear strand, not a braided strand, which is less translucent. I use a line that has a "30-pound test" strength rating, which will read as #30 on the packaging. That means that the line can hold up to 30 pounds of weight without breaking. That's a lot, and because of that, you'll want to have a pair of scissors on hand to cut the line.

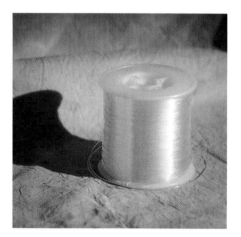

Tip

Gray and white thread is also useful to keep on hand. Clear fishing line disappears against most backgrounds very well, but sometimes against a well-lighted gray background, you are better off using gray thread to suspend something into the set. Likewise, if you are shooting into a white background, white thread will look invisible. Use a good nylon thread for the most strength. If you have problems with clear fishing line showing up in photos and you don't want to use thread, try a lower pound test rated fishing line, which will be thinner, and so more easily recede into the background.

Figure 10.11 Clear fishing line is almost impossible to see in a photograph, yet it's exceptionally strong and ties to things easily. Use it to tie or suspend objects in photo sets.

Use clear fishing line anytime you want to suspend something in a photo set and make it look like it's hanging in space. You can achieve some unusual effects this way, or just accomplish something that looks normal, like a leaf floating to the ground, with the control of having the leaf exactly where you want it for the shot.

Another application for which I use clear fishing line is to suspend flat reflectors, such as foam board, over a set. Similar to the way an awning hangs, the fishing line supports the outward portion of the flat board. For foam board, I punch a small hole in the corners and tie the line to it. The rear part of the board can rest on the backdrop or a pair of light stands, but the front part needs to hang from two strands of fishing line that are tied to something higher up, whether hooks on the wall or the tops of a pair of taller stands. In this way, you can suspend a reflector in a critical spot in a still-life set. Similarly, you could use a black board, called a flag, to block the light in select areas of the scene. (See Figure 10.12.)

Figure 10.12 Clear fishing line can be used, as seen here, to suspend a reflector over a critical spot in a photo set. Similar to the way an awning hangs, you anchor one side of the reflector with light stands, or in this case background stands, and suspend the other side of the reflector with fishing line. This technique works equally well when using a black board, called a flag, to block light in the set.
Copyright © Steve Weinrebe

Cable Clamps

Throw away those twist ties and pieces of string, because there is a better way to bundle cables together and be able to release them quickly, and the tool is called Cable Cuff or Cable Clamp, depending on where you buy it. (See Figure 10.13.)

You can see the wide variety of sizes and colors of Cable Clamps at www.cableclamp.com. Besides other colors, Cable Clamps come in black, which photographers might gravitate toward. For many uses, I like the orange Cable Cuff model. Anything black tends to disappear into the sea of small black items in my cabinets, drawers, and gear cases, and the orange Cable Cuff is easy to spot when I need one.

I use Cable Cuffs and Cable Clamps all over the studio and, I confess, my home. For example, I have one behind my desk for all the component wires spilling off the back of my desk down to my computer. I also use one on a large spotlight that has a large heavy cloth-wrapped cable. The spotlight's cable doesn't wrap onto itself like a lamp cord might, and I use a Cable Cuff to hold the cable coiled up onto the frame of the light. (See Figure 10.14.)

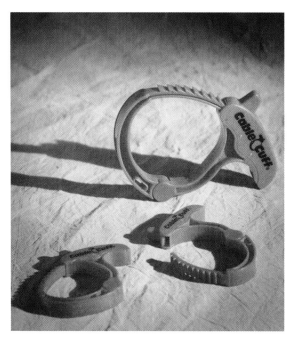

Figure 10.13 Cable Clamps are sold at hardware retailers and do a great job gathering multiple wires, or thick and heavy cables, together and holding them tightly wrapped. The clamps are sold at Home Depot by the name Cable Cuff, and elsewhere as Cable Clamp.
Copyright © Steve Weinrebe

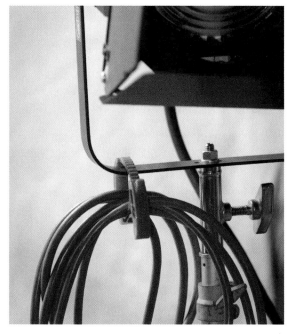

Figure 10.14 I use a Cable Cuff to hold this light's coiled cord when the light is not plugged in, as pictured here. With the cord held in place like this, it's a lot easier to move the light around. I also use Cable Cuff to hold bundles of wires hanging from computer components.
Copyright © Steve Weinrebe

> **Tip**
>
> Hook-and-loop fastening ties can be very helpful for holding bundles of cords together as well. Small hook-and-loop fasteners for just this purpose are sold at hardware stores, electronics stores, and other retailers.

Forearm

I suppose it was only a matter of time before I included a body part as a photo tool. The forearm is the perfect tool to help wrap electrical extension cords with lengths from 10 to 50 feet. The length of the forearm is just about right, and you have the elbow on one end to anchor the cord as you loop it, and the U shape of your thumb and forefinger to hold the cord in place as you wind it around and around your forearm. In the end, if you follow these steps, you'll have a neatly wrapped extension cord. (See Figure 10.15.)

I've found that 25-foot extension cords are the most useful to keep around the studio or to travel on location with, but it's a good idea to keep some shorter and longer cords around as well. When you buy an extension cord, it will come neatly wrapped in a coil, but that may be the last time you ever see the cord wrapped so well. If you routinely use extension cords, as many photographers do, you'll be well served to wrap them properly when you're done. If you don't, extension cords tend to get tangled and knotted, and you'll spend a great deal of time untangling them. Knots in extension cords are dangerous too, because knotted areas are prone to cracking or fraying.

In fact, my dad, who wasn't an electrician but knew how to wrap an extension cord, showed me this cord-wrapping technique and it has served me well for the many hundreds, and probably thousands, of times I have had to put away or pack an extension cord over the years.

The steps to proper cord wrapping are relatively simple, yet I've been amazed at how many other photographers and photo assistants I've seen simply coil an extension cord loosely, and pile it with other loosely-coiled cords—a recipe for tangles and knots. The cord used in Figures 10.16 through 10.18 is a well-used cord that has been wrapped (and unwrapped) hundreds of times and has never become tangled.

Make sure you are starting with an untangled extension cord. Then pinch one end of the cord between your left hand's thumb and forefinger (swap all this if you're a lefty). With your right hand, wrap the cord around your left forearm down around your left elbow, back up between your left thumb and forefinger, and down and around your elbow again. (See Figure 10.16.)

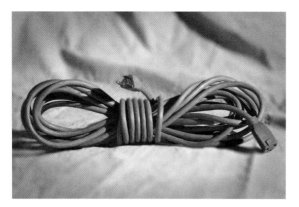

Figure 10.15 This electrical extension cord was wrapped tightly and neatly using my forearm. When wrapped this way, the cord won't unravel, and it can be stored or packed neatly.

Copyright © Steve Weinrebe

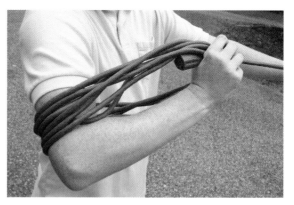

Figure 10.16 Step 1 in properly wrapping a cord is to coil it around your left forearm, using your right hand to wind the cord around and around, from between your left thumb and forefinger, down around your left elbow. Stop when you have about six feet left over from a 25-foot extension cord, or a little less for a shorter cord like a 10- or 12-foot cord.

Copyright © Steve Weinrebe

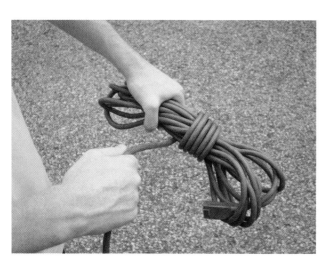

Figure 10.17 Step 2 in cord wrapping is to take the coiled cord off your forearm and, holding the bundle together with your left hand, wrap approximately five to ten loops around the middle of the bundle to keep it tightly closed. The more times you wrap the cord around the middle, the more tightly the middle will be held.

Copyright © Steve Weinrebe

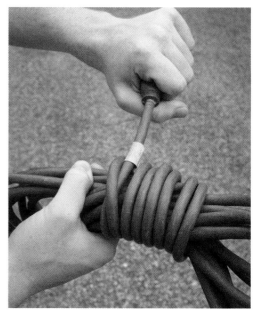

Figure 10.18 For step 3, once you've coiled the cord around your forearm and wrapped the last section of cord around the middle, slip the end of the cord under the last wraparound. This simple knot will hold the bundled extension cord closed until you are ready to use it.

Copyright © Steve Weinrebe

Then, when you have about six feet of cord left over, or a little less if you're wrapping a 10- or 12-foot extension cord, slip the coiled cord off your forearm. Hold the coil of cord tightly together near the middle with your left hand and wind the extra bit of cord around the middle of the bundle, perpendicular to the way the cord was first coiled, so that the whole bundle looks like a large bow. You'll want to have enough cord to make approximately five to ten loops around the middle of the bundle. Fewer loops and the whole bundle might come loose. (See Figure 10.17.)

Finally, when the end of the extension cord is all that's left, slip it under the last loop to hold the end in place. Pull to make sure this last simple, and easily undoable, knot is tight, and you're done. (See Figure 10.18.)

You may need to practice wrapping cords this way a few times, but once you get it down, you'll be able to do it in your sleep. If your cords are not wrapped perfectly, don't worry; the symmetry police aren't going to come get you. It's most important that you can hang them from a hook, drop them, or toss the wrapped extension cord into a camera case without the cord unraveling.

> **Tip**
>
> For short extension cords, like a six-foot household extension cord, use the same method described here except, instead of your left forearm, use the distance between your left thumb and pinkie finger to coil the bulk of the cord, leaving six to eight inches unwrapped. Then slip the coil off your hand holding the middle of the coil tightly together, and wrap the left over six to eight inches around the middle of the cord. Slip the end of the small extension cord under the last loop, just as described. In a similar way as with the large extension cord, you'll have a tightly wrapped small extension cord that won't become unraveled.

Wooden Clamps

Many years ago, a friend gave me a trunk of tools that included some wooden clamps. Wooden clamps can be bought new, usually with metal spindles, but I have a few vintage, all-wood versions that I use in the studio, and I have seen vintage wooden clamps sell very inexpensively on auction websites. Wooden clamps are a little large to carry in a location kit, but for studio use they are excellent tools. And when not being used, wooden clamps look great just hanging on the studio wall. (See Figure 10.19.)

A wooden clamp's advantage for photographers, and of course woodworkers, is that it has both a wide and deep reach compared to a pipe or bar clamp, or a metal clamp. Besides that, they won't scratch most surfaces. The clamping pressure can be fine-tuned very easily by turning the outside screw, which compresses the front of the clamp. (See Figure 10.20.)

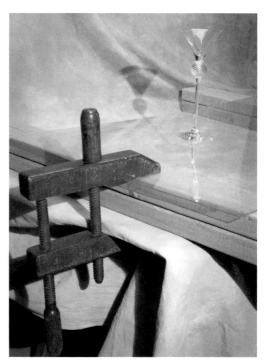

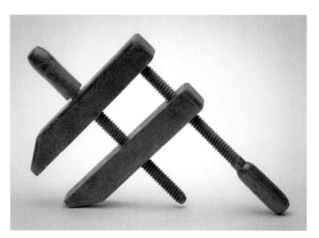

Figure 10.19 A wooden clamp is a large clamp that can be opened very wide and has a deep reach. Because wood won't scratch most surfaces, it's an excellent tool to clamp down just about anything in photo sets.
Copyright © Steve Weinrebe

Figure 10.20 Open the wooden clamp just large enough to slip it over whatever you want to hold together, and then turn the outside screw handle. When doing so, the front of the clamp compresses. For this set, I used a wooden clamp to hold a sheet of clear plastic in place for a shadowless still-life setup.
Copyright © Steve Weinrebe

Wooden clamps can also be used to hold an object in place for photography, kind of like a large version of a hemostat (discussed in Chapter 4). Because a wooden clamp is heavy and flat, it can lay sideways on a tabletop. Anything clamped within its jaws will be held tight. So, if you have an item you want to hold still in a set, such as something off balance that doesn't want to stand up to be photographed, consider using a wooden clamp to keep it upright. Of course, you'll want to crop the clamp out of your photo, so consider that when you decide whether to use a wooden clamp to hold something in place, or one of the many other tools I've featured in this book for a similar purpose. (See Figures 10.21 and 10.22.)

Figure 10.21

A wooden clamp can be used to hold an object or prop upright in a photo set. Because the clamp is flat and heavy, you can lay it down on a tabletop and use the jaws of the clamp to hold the item you want to photograph, just as the wooden clamp pictured here is holding the mask in place.

Copyright © Steve Weinrebe

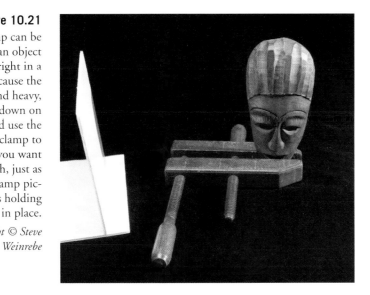

Figure 10.22

I wanted to photograph only a portion of this mask, because the nose, eyes, and hair held the interest for me. I used a wooden clamp to hold the mask in place for the photograph.

Notepad and Pen

Just as with dreams, if you don't record a great idea the moment you have it, the essence and details of the idea can fade away or be entirely forgotten. In fact, I have my best ideas when lying in bed at night. For that reason, I always keep a small notepad, and a pencil or pen, on my night table or in the night table's drawer. (See Figure 10.23.)

Figure 10.23
Keep a notepad and pen in your night table's drawer so that you can record ideas for photos that come to you while falling asleep, or in the middle of the night. If you don't write them down right away, you may forget details of an idea, or forget the idea altogether.

Copyright © Steve Weinrebe

If you are a creative person and have the habit of taking pictures regularly, you will often see photographs in your head that haven't been taken yet. You see the pictures in your mind and then think about how to make them. You might think of a great location or prop, or a way to light portraits that you'd like to experiment with, or an interesting arrangement to pose two or three people for a portrait (always a challenge). If you are a commercial photographer creating portfolio shots to show customers what you are capable of, you might have a sudden brainstorm for your next portfolio piece.

Ideas for photos usually come at unexpected times. When you're at rest and your mind isn't being bombarded by external visual information such as from a television or your computer, thoughts, events, and things you've seen become distilled. What's important rises to the surface.

Sometimes I wake up to my scribbles from the middle of the night, scribbles that are hard to decipher because I wrote them in the dark at 2 AM. But I've learned that even those scribbles will contain the essence of an inspiration that often turns into a photograph or photographic technique. If it had to come in the middle of the night, so be it; but if I don't write it down, I usually remember only that I had a great idea and not the actual details. (See Figure 10.24.)

Figure 10.24

If you have an idea for your photography—whether it is in bed at night, while in the shower, or while exercising or driving—write it down on a note or record it into a voice recorder. You can send yourself an email or leave a voicemail message if need be. I came up with this dreamlike image, for a series I've been working on, late at night and scribbled only a few words on a piece of notepaper. But that was enough to remember and develop the idea into a photograph.

Copyright © Steve Weinrebe

For the same reason, I keep a voice recorder in my car. I leave it in the car's console and I have recorded many photographic ideas on it. Although my phone also acts as a voice recorder, I like a dedicated recorder because it is easier and safer to use while driving. If you don't have a voice recorder, call your answering machine and leave a message describing the idea so you can write it down when you return home. I've done that many times when traveling and I get an idea that I don't want to forget. Or send yourself an email or text message. Beware using a phone to write notes or send messages in the middle of the night though, because the light from the phone may wake you up so much so that you can't get back to sleep. That's happened to me, and it's been worth mastering the art of writing in the dark to prevent sleepless nights.

An idea doesn't have to be implemented right away. It's a good idea to gang together a few ideas or techniques that you've thought of, and then set about making pictures that put the ideas into reality. Don't let those ideas slip away, though, just because that glimpse of something great, just before you fall asleep at night, didn't get solidified onto paper.

Irreverent Fun

Don't think for a minute that fun can't be a potent photo tool. Of course, there is nothing irreverent about having fun in and of itself. It's what you use for fun and entertainment during photo shoots, and those long photo-editing sessions at your computer, that can certainly be irreverent. (See Figure 10.25.)

Personally, I'm a fan of music and have satellite radio or Internet radio piping through large stereo speakers at all times. To create the effect that the music is following you around when you visit, I have an FM transmitter attached to the stereo so that the music plays from other radios within the transmitter's reach (and within the limits of broadcast regulations). Another photographer I recently met serenades his clients with rock music performed live by himself and his crew—before, during, and after a photo shoot.

True Story

An advertising agency I once worked for had turned its office hallway into a putting green and miniature golf course, complete with artificial turf. This was a top agency and worked hard, but they also knew how to have fun. That combination of hard work and fun drew a lot of clients to the ad agency. I learned a valuable lesson freelancing as a photographer for that agency. The experience taught me that hard work and fun are not mutually exclusive and, although I'm not a golfer (yet), introducing fun into photography is a worthwhile goal.

Figure 10.25
Fun and entertainment can be potent tools for taking pictures, for the simple reason that entertainment often induces creativity. Music, for example, won't get in the way of your camera, but it may well set a mood that spurs ideas. Especially when you're photographing people, music can have a profound influence on the rhythm of your shooting, and the subject's movements.

Copyright © Steve Weinrebe

I've known many photographers who have collections of one sort or another, such as vintage photography, paintings, antiques, and so forth. Sometimes, those collections are laid out as vast installations in their studio so that visitors can entertain themselves by walking around and viewing the collection. Of course, a photographer's own photography is often on display in a studio. But I believe you have to separate marketing from entertaining, although often they are intertwined.

If you have people in your photographs, irreverent entertainment is especially helpful. It's the unexpected surprise that usually has your subject, or subjects, rolling on the floor laughing. For example, I know a photographer who juggles for his subjects (although I've never been able to master the skill). On a similar note, I was getting a tour of a photographic print shop recently when one of the employees came over to hand me a business card. When he opened his wallet, it burst into flames, and he burst into laughter. He followed up with a dozen dazzling magic tricks while I was being shown the large inkjet and dye-sublimation printers.

Photographers, like comedians and politicians, very often have an audience while they work, whether the audience includes models, customers, friends, or family. Borrowing from a page in the book of comedians and politicians (not to equate the two in any way), make note that you too can be a master at irreverent entertainment, and that you can have fun and still take great pictures.

Index

We've got your shot covered.

Course Technology PTR has the resources dedicated photographers need. Written by experienced professional photographers, our books are filled with the expert tips, techniques, and information you need to master your passion for digital photography.

Selections from Bestselling Camera Guide Author David Busch

David Busch's Pentax K200D Guide to Digital SLR Photography
1-59863-802-5 • $29.99

David Busch's Nikon D300 Guide to Digital SLR Photography
1-59863-534-4 • $29.99

David Busch's Nikon D60 Guide to Digital SLR Photography
1-59863-577-8 • $29.99

David Busch's Canon EOS 50D Guide to Digital SLR Photography
1-59863-904-8 • $29.99

David Busch's Canon EOS Rebel XS/1000D Guide to Digital SLR Photography
1-59863-903-X • $29.99

Canon EOS 40D Guide to Digital SLR Photography
1-59863-510-7 • $29.99

David Busch's Canon EOS Rebel XSi/450D Guide to Digital SLR Photography
1-59863-578-6 • $29.99

David Busch's Sony α DSLR-A350/A300/A200 Guide to Digital SLR Photography
1-59863-801-7 • $29.99

The 50 Greatest Photo Opportunities

The 50 Greatest Photo Opportunities in New York City
1-59863-799-1 • $29.99

The 50 Greatest Photo Opportunities in San Francisco
1-59863-800-9 • $29.99

David Busch's Quick Snap Guide to Lighting
1-59863-548-4 • $29.99

David Busch's Quick Snap Guide to Using Digital SLR Lenses
1-59863-455-0 • $29.99

Other Great Titles

Picture Yourself Getting the Most Out of Your Digital SLR Camera
1-59863-529-8 • $24.99

The Official Photodex Guide to ProShow
1-59863-408-9 • $34.99

301 Inkjet Tips and Techniques
1-59863-204-3 • $49.99

More Than One Way to Skin a Cat
1-59863-472-0 • $34.99

Mastering Digital Black and White
1-59863-375-9 • $39.99

The Digital Photographer's Software Guide
1-59863-543-3 • $29.99